PLURALISING PASTS

Pluralising Pasts

Heritage, Identity and Place
in Multicultural Societies

G. J. Ashworth, Brian Graham and J. E. Tunbridge

Pluto Press
London • Ann Arbor, MI

First published 2007 by Pluto Press
345 Archway Road, London N6 5AA
and 839 Greene Street, Ann Arbor, MI 48106

www.plutobooks.com

British Library Cataloguing in Publication Data
A catalogue record for this book is available from the British Library

Hardback
ISBN-13 978 0 7453 2286 5
ISBN-10 0 7453 2286 7

Paperback
ISBN-13 978 0 7453 2285 8
ISBN-10 0 7453 2285 9

Library of Congress Cataloging in Publication Data applied for

10 9 8 7 6 5 4 3 2 1

Designed and produced for Pluto Press by
Curran Publishing Services, Norwich
Printed and bound in the European Union by
Antony Rowe Ltd, Chippenham and Eastbourne, England

CONTENTS

CONTENTS

LIST OF FIGURES

All photographs are by John Tunbridge and remain valid at time of publication.

ACKNOWLEDGEMENTS

We would like to express our gratitude to Kilian McDaid and Nigel McDowell of the University of Ulster for their invaluable help in preparing the figures for publication. Figure 8.5 is based with permission on an original diagram published by Roy Jones and Brian Shaw and we are indebted to them for their help. Figure 10.1 is based on a map published in Tunbridge and Ashworth (1996) and acknowledgement is due to C. Earl, Carleton University, Ottawa.

PREFACE

In our earlier book, *A Geography of Heritage: Place, Culture and Economy* (Arnold, 2000), we raised the topic of the ways in which societies use heritage in the creation and management of collective identity. This is expressed through the shaping of senses of belonging as defined and described through representations of place. We had then, however, neither the space nor indeed the detailed knowledge of practice to pursue this idea at the depth its importance to contemporary society deserves. In particular we have become increasingly aware of the growing diversity and fragmentation of the societies in which we live and work, and the search for policies that reflect such diversity as well as mitigate its perceived shortcomings. This is endowing heritage with a new set of tasks and responsibilities, few of which can be easily reconciled. We wished to investigate the ways in which plural representations of the past are mirrored in the creation of plural heritages and place identities, in the service of various policy models and aspirations of plural societies, through a range of case studies drawn from societies around the world.

As to global coverage, the authors are fortunate not only in living and working in three different countries in two continents but also in that our longstanding research interests have extended over diverse parts of the world. However, we are aware that some regions and countries have inevitably received scant or no consideration. A reader from such a place may feel slighted by such neglect, but also, we would hope, be stimulated to fill these omissions by suggesting different and maybe more apposite applications of our models or variations upon them. If this occurs we would be gratified and feel our intentions had been fulfilled.

It might also be reasonable to enquire where we stand on the issues we raise, and even which model we favour or reject. However, our investigation into the relationships between heritage, identity and place have not been resolved into a Manichean division between best and worst practice. The tensions and conflicts inherent within heritage policy and practice in plural societies are a force for fragmentation as much as

cohesion, a cause of alienation and exclusion as much as unity and inclusion. The term 'multicultural heritage(s)' is one that is used frequently in the discussion, but multiculturalism is seen as being a distinct form of plurality and one that does not define it. The book is concerned, too, with models of society that are neither liberal nor democratic and with models of social integration that can be regressive as well as progressive. Hence, much of the body of heritage practice and policy that is discussed would not be called 'multicultural' by those favouring or opposing multicultural policies. In foregrounding heritage, however, the book considers it as a profoundly important element in the articulation of multiculturalism and pluralism while a global understanding of the relationship between heritage and plurality also helps understand the constraints to multiculturalism and the resistances that it provokes.

Therefore it is not only unlikely that a consensus exists among us, but also, and more important, each of us would answer that the 'best-buy' model depends upon the place, time and intention of the society applying it. We did not set out either to warn against or to proselytise for any particular vision of society. Our intention was to explore the possibilities, implications and consequences of relating heritage to public policy in plural societies, as exemplified by practice around the world, so that the current active debate can proceed in a more informed manner than is often currently the case.

Groningen, Netherlands
Coleraine, Northern Ireland
Ottawa, Canada
(December 2006)

1 INTRODUCTION: HERITAGE AND PLURALITY

This book focuses on the ways in which contemporary societies use heritage in the creation and management of collective identities, most especially as expressed through the shaping of senses of belonging defined and transmitted through representations of place. These processes occur within a range of overlapping scales extending from the global through the national and regional to the local and individual. The increasing diversity and fragmentation of societies and the search for policies that respond to such diversity, while simultaneously if contradictorily fostering cohesion, are endowing heritage with a new set of tasks and responsibilities, few of which can easily be reconciled with each other. The ways in which plural representations of the past are implicated in the creation of plural heritages and place identities, and in the service of various policy models and aspirations of plural societies, are investigated here, both as conceptual issues, and through the medium of range of case studies drawn from societies around the world. While the book does have a policy orientation, our primary concern, however, is to address the conceptualisation of heritage in plural societies rather than the formulation of policies *per se*.

The past, transformed into heritage, is a ubiquitous resource with many contemporary cultural, economic and political functions. For more than 30 years, these present-day uses of the past have generated an important and growing 'heritage industry'. Similarly, despite the contemporary theoretical conceptualisation of identity as a multiplicity of belongings, the need of individuals to belong to territorially defined social groups seems no less important now than when it was a defining characteristic of the nineteenth-century nation-state. What has changed, however, is that those identifications with representations of space and place have become more complex as

globalisation has been accompanied by a re-territorialisation that seemingly privileges the regional and local at the expense of the national.

Some of these dimensions of heritage, and the ways in which it is entwined with other concepts, including memory, commemoration and tradition, were analysed and exemplified in an earlier book by the same authors, *A Geography of Heritage: Power, Culture, Economy* (Graham *et al.*, 2000). This present book focuses specifically on one fundamental attribute of heritage that underlay much of the previous investigation, namely its explicit role as a – perhaps *the* – key factor in creating representations of place as a core attribute of identity, and the ways in which this presents both constraint and opportunity in plural, diverse and fragmented societies. Heritage as process and practice fulfils a multiplicity of roles in contemporary societies. The roles of heritage planning and management include: the fostering and strengthening of the identification of peoples with their governments and jurisdictions at various spatial scales; the identification of individuals with social groups; and the construction of images of place for promotion in various markets. Thus heritage is being loaded with expectations that extend from political legitimation through social cohesion and inclusiveness to encompass the commodification and marketing of place products, not least but also not only for tourism. The inevitable outcome is that conflicts of interest are an inseparable accompaniment to heritage as practice and process. While fully cognisant of the economic imperative attached to heritage through cultural tourism, our particular focus here is on the tensions that arise from the nexus of heritage, identity and place. Although the interplay between these is discussed at length in Part I of the book, it is necessary here to establish our ground by making some introductory definitional comments about each of these key concepts.

HERITAGE

Even within a single society, pasts, heritages and identities should be considered as plurals. Not only does heritage have many uses but it also has multiple producers, both public–private, official–non-official and insider–outsider, each having varied and multiple objectives in the creation and management of heritage (Ashworth and Graham, 2005). In addition societies, notably in Western countries, are becoming more self-consciously socially and culturally diverse, a fragmentation which raises issues as to how this heterogeneity should be reflected in heritage selection, interpretation

[2]

and management. As Littler and Naidoo (2004) argue, the definition of heritage has 'morphed' over time. In this present context, we define the concept as the use of the past as a cultural, political and economic resource for the present, our concern being with the very selective ways in which material artefacts, mythologies, memories and traditions become resources for the present.

Thus the study of heritage does not involve a direct engagement with the study of the past. Instead, the contents, interpretations and representations of the heritage resource are selected according to the demands of the present and, in turn, bequeathed to an imagined future. It follows, therefore, that heritage is less about tangible material artefacts or other intangible forms of the past than about the meanings placed upon them and the representations which are created from them (Graham *et al.*, 2000; Graham, 2002). It is meaning that gives value, either cultural or financial, to heritage and explains why certain artefacts, traditions and memories have been selected from the near infinity of the past. Meanings are marked out by identity, and are produced and exchanged through social interaction in a variety of media; they are also created through consumption. These meanings further regulate and organise our conduct and practices by helping set rules, norms and conventions:

> It is us – in society, within human culture – who make things mean, who signify. Meanings, consequently, will always change, from one culture or period to another.
>
> (Hall, 1997: 61)

In sum, therefore, heritage is present-centred and is created, shaped and managed by, and in response to, the demands of the present. As such, it is open to constant revision and change and is also both a source and a repercussion of social conflict.

This idea of present-centredness is a recurrent theme in the recent literature on heritage and has profound implications for the study of the concept in plural societies. For Lowenthal (1998: xv), 'in domesticating the past we enlist [heritage] for present causes ... [it] clarifies pasts so as to infuse them with present purposes', one result being that, 'heritage vice becomes inseparable from heritage virtue while under the aegis of national patrimony looms a multinational enterprise' (Lowenthal, 1998: 5). This present-centred perspective is reiterated by Peckham (2003) who, citing Halbwachs (1992), argues that heritage is

often used as a form of collective memory, a social construct shaped by the political, economic and social concerns of the present. Inevitably, heritage is characterised inherently by a dissonance created through its simultaneous multiple commodification as cultural and economic capital.

Despite the simultaneous growth since the 1960s of many manifestations of individual heritage such as genealogy, Lowenthal (1998) claims that heritage has moved from the private to the public realm and that, more and more, it denotes that which we hold jointly. He observes, too, the legacy of 'oppression' in validating present identity and the national being replaced or supplemented by the local and ethnic so that mainstream heritage agencies 'now find it hard to limn a national saga without causing ethnic or religious offence' (1998: 83). Heritage conflict has thus become a global issue because it is so deeply implicated in the processes of social inclusion and exclusion that define societies characterised by ever more complex forms of cultural diversity. While its origins can be linked to the nineteenth-century rise of ethno-nationalism and Romantic notions of attachment to place, heritage can also function as a form of resistance to such hegemonic discourses and a marker of plurality in multicultural societies.

IDENTITY AND PLACE

Individuals have always been capable of identifying with different social groups and spatial scales. Few of these differences cause conflict and many – as in the so-called 'Russian doll model' – are even comfortably complementary. Contemporary societies, however, are experiencing both more diversity and greater fragmentation. Thus many pasts become transformed through many heritages into many identities, only some of which are associated with place. These narratives of belonging may support, coexist with or conflict with each other. Thus identity can be visualised as a multi-faceted phenomenon that embraces a range of human attributes, including language, religion, ethnicity, nationalism and shared interpretations of the past (Guibernau, 1996). It is constructed into discourses of inclusion and exclusion, of those who qualify for membership, and those who do not. Identity refers to the processes, categories and knowledges through which communities are defined as such, and the ways in which they are rendered specific and differentiated (Donald and Rattansi, 1992). Central to the concept of identity is the idea of the Other – groups, both

internal and external to a state – with competing and often conflicting beliefs, values and aspirations (Said, 1978). The attributes of Otherness are thus fundamental to representations of identity, which are constructed in counter-distinction to them. As Douglas argues:

> the function of identity lies in providing the basis for making choices and facilitating relationships with others while positively reinforcing these choices. ... In emphasising sameness, group membership provides the basis for supportive social interaction, coherence and consensus. As identity is expressed and experienced through communal membership, awareness will develop of the Other. ... Recognition of Otherness will help reinforce self-identity, but may also lead to distrust, avoidance, exclusion and distancing from groups so-defined.
>
> Douglas (1997: 151–2)

However this could be and, on occasion, has been read as meaning that identity is fixed and stable. Rather, it too is linked to 'senses of time' and atavistic fears in that it is not 'secured by a lifelong guarantee' and is 'eminently negotiable and revocable' (Bauman, 2004: 11).

HERITAGE, IDENTITY AND PLACE

In defining such ideas of inclusion and exclusion, people call upon an affinity with places or, at least, with representations of places which, in turn, are used to legitimate their claims to territory. By definition, these are representations of imaginary places, but they still constitute a powerful part of the individual and social practices that people consciously use to transform the material world into cultural and economic realms of meaning and lived experience. In sum, the functions of place identity include: the fostering and strengthening of the identification of peoples with their governments and jurisdictions at various spatial scales; the promotion of political ideologies that justify the right to exercise power over others; the identification of individuals with social groups; and the construction of images of place for promotion in various markets for various purposes. Senses of place are therefore the products of the creative imagination of the individual and of society, while place identities are not passively received but are ascribed to places by people. While commonplace, such statements need re-stating here for two reasons.

First, as occurs with nationalist ideologies, people often essentialise identities as intrinsic qualities of landscapes and cityscapes. According to Lowenthal (1985), the past validates the present by conveying an idea of timeless values and unbroken lineages and through restoring lost or subverted values. Thus, for example, there are archetypal national landscapes, which draw heavily on geographical imagery, memory and myth (Gruffudd, 1995). Continuously being transformed, these encapsulate distinct home places of 'imagined communities' (Anderson, 1991), comprising people who are bound by cultural and – more explicitly – political networks, all set within a territorial framework that is defined through whichever traditions are currently acceptable, as much as by its delimited geographical boundary.

Second, it is not enough merely to conclude that places are imagined entities. Rather, if individuals create place identities, then obviously different people, at different times, for different reasons, create different narratives of belonging. Senses and images of place, which are thus user-determined, polysemic and unstable, must also be related to senses of time if only because places are in a continuous state of becoming (Pred, 1984). Heritage operates as the key linkage in this process but as a dynamic rather than a fixed entity. Heritages can be invented or discarded as the demands of contemporary societies change, as is presently occurring in the former Central and Eastern Europe, where twentieth-century pasts shaped by Nazism, Marxist-Leninism and ethno-nationalism have to be reinvented to reflect the new present of European integration, reconciliation and atonement (Tunbridge, 1998). Thus heritage can be as much about forgetting as remembering the past.

THE COMPLICATING OF HERITAGE

It is readily apparent even from these brief introductory comments that the interaction of heritage, identity and place is complicated by the ways in which this trinity of what are themselves contested terms overlap with numerous others. We discuss this further in Chapter 2 but, at this stage, it is necessary to introduce and distinguish between four key sets of concepts that are intrinsic to the debate on heritage, identity and place that is at the core of this book. These are culture and the interlinked triad of assimilation, multiculturalism and pluralism.

Culture

To observe that, '"culture" is ... something of a muddle' Mitchell (2000: 14) is to reiterate an on-going argument that the concept is too elusive, too all-encompassing and even too inherently contradictory to be of use and, as such, even potentially dangerous (Duncan and Duncan, 2004). Nevertheless, 'culture [is] just too important a concept to leave languishing, precisely *because* ... culture *is* politics' (Mitchell, 2000: 36). Duncan and Duncan (2004: 394) see a need to rethink culture and the idea of cultural coherence in an age of heterogeneity, porous boundaries, complexity and far-reaching networks. Hence, they argue that 'the definition of culture should be, and should remain, broad and empirically unspecified.' For them, culture does have ontological status rather than merely being a belief, not least because it has practices – to which could be added knowledge – of which heritage is one. To Sewell (1999), therefore, culture exists only in and through practices. The problem is that these practices are legion. As Mitchell writes:

> Culture consists in practices, but is also a 'system of significa-tion'. ... [It] is a way people make sense of the world ... but it is also a system of power and domination. Culture is a means of differentiating the world, but it is also global and hegemonic. Culture is open and fluid, a 'text' ... always open to multiple readings and interpretations, but it is something with causative power ... and hence must be unitary and solid. ... Culture is a level, or sphere, or domain, or idiom; but it is also a way of life. Culture is clearly language – or 'text' or 'discourse' – but it is also the social, material construction of such things as 'race' or 'gender'. Culture ... is politics, but it is also the both ordinary and [paraphrasing Matthew Arnold's words] the best that [has been] is thought and known.
>
> (Mitchell, 2000: 64)

Heritage precisely mirrors culture to the extent that the terms could be interchangeable in this quotation – one reason why the expression 'cultural heritage' is tautological in the sense that all heritage is, perforce, cultural. In this exploration of fluid, overlapping and multiple meanings, it is important to remember, however, the caveat that 'cultures are relational, contested and sometimes deployed in dangerously essential terms' (Duncan and Duncan, 2004: 396).

Assimilation, multiculturalism and pluralism

Assimilation can be defined as the processes by which communities not merely intermix but through which one culture may be absorbed by another. It is often treated as a synonym of acculturation and integration and thus implies the obliteration of difference, a set of processes that may be articulated through space (Johnston *et al.*, 2000). As such, policies of assimilation are frequently used in counter-distinction to policies for multiculturalism and cultural pluralism, which work in different ways across different sites but, in their broadest sense, refer to the recognition or, at least, toleration of different cultural or ethnic groups within socially plural societies (Goldberg, 1994). Haylett (2001: 357) sees this definition, which embodies the belief that different cultural or ethnic groups have a right to remain distinct rather than assimilating to mainstream norms (Johnston *et al.*, 2000), as evoking ideas of cultural tolerance and equality. He argues, however, that often these latter are not substantially connected to the political and economic mechanisms that 'could make these aspirations meaningful or realisable'.

The term, 'plural society' has been employed in different ways but is used here in its broader sense, in that most societies are marked by cultural diversity, most commonly by ethnicity, race, language, class and religion. It could be interpreted as having some affinity with notions of multiculturalism, which accept plurality as opposed to an insistence on assimilation. But pluralism also invokes the idea of 'multiple cultures', of 'standing alone' or 'separate development', in which cultural identity becomes a strategy of resistance to hegemonic state identities. Again pluralism has been criticised for 'implying a degree of equality between different sections within such societies, obscuring the existence of deeply structured inequalities between them' (Johnston *et al.*, 2000: 587).

The term 'plural heritage(s)' is one that is employed frequently in the subsequent discussion. We are cautious about using the term, 'multiculturalism', as it often implies the existence, desirability or undesirability of a particular model of society and the official polices designed to bring this about. All societies, however, are to some extent plural because people are different if only in age, experience, background and preferences, and thus all societies are to this extent multicultural. The adding of 'ism' to the adjective describes a belief, vision, hope or misgiving to be supported or opposed. We are concerned with many different models of society whose only common feature is that they use heritage as defined above as an instrument for the attainment of quite different social, cultural and political objectives.

The adjectives 'liberal', 'democratic', 'regressive' or 'progressive' cannot be assigned automatically to any specific model. By foregrounding heritage, we emphasise it as a profoundly important element in the articulation of pluralism, while a global understanding of the relationship between heritage and plurality also helps understand the constraints on cultural policies and the resistances that they can provoke.

STRUCTURE OF THE BOOK

The central focus of this book, therefore, lies in a study of the relationships between heritage, identity and place. In pursuing the myriad issues associated with the interconnections between these concepts, we have adopted a tripartite structure. The three chapters in Part I are concerned with theoretical perspectives on the relationships between heritage, identity and place. In Chapter 2, we examine the key interrelationships between culture and identity that underpin the discussion of plural heritages, which forms the core of Chapter 3. The focus in Chapter 4 switches to questions of place identity and heritage. The single chapter (5) in Part II acts both as a synthesis of the principal interconnections that define the nexus of heritage, identity and place and also to introduce the typology of models of plural societies which is used to structure the five chapters in Part III. Here, drawing upon globally distributed case studies and a range of scales, we explore the uses and effectiveness of heritage as an instrument of public policy in plural societies, whether self-consciously so or not. Finally, the tensions and conflicts inherent within heritage policy and practice in plural societies are summarised in Chapter 11, which focuses on the role of heritage as, contradictorily, a force for cohesion but also fragmentation, and also considers the enduring importance of place identity in this context of diverse and hybrid societies.

PART I
THE CONCEPTUAL CONTEXT

2 CULTURE AND PLURAL IDENTITIES

In this chapter, we begin our investigation of pluralism as it is reflected in and articulated by heritage policies and practices. Our working assumption is that heritage provides one (although by no means the only) means of facilitating the operationalisation of pluralism and that, in so doing, it functions at a variety of scales, in public and private and through both official and unofficial channels of representation and power. First, we consider the nature of plural identities before extending the discussion into the broader realms of the relationships linking them with concepts of multiculturalism and with assimilation. The chapter then moves to a consideration of the relationships between identity and power through a discussion of the specific elements that act as resources for identity and which, ultimately, impact on the provision and interpretation of heritage.

PLURAL IDENTITIES AND MULTICULTURALISM

Contested definitions and interconnections

A substantial quantity of academic and politically polemical literature has been generated by the single word, 'multiculturalism'. Its relationship to pluralism, as we observed in Chapter 1, presents profound difficulties, a condition readily apparent in the literature. The heavy political loading that the term has acquired, and its use as shorthand in popular debate, is particularly unhelpful in this respect. It is not our task to summarise, let alone evaluate, this. We need, however, to sketch the principal dimensions being used in the definitions. An understanding of the policy cases discussed below necessitates, if not a precision of meaning, at least some understanding of the commonly encountered ambiguities.

Among others, Lewis and Neal (2005) acknowledge that there is a

struggle over the meaning of multiculturalism. Often, this is driven by liberal concerns over an insistence on 'parallel lives' and a concomitant failure to assert and prioritise key national values. While there is a core strand centred on the assumption that different cultural or ethnic groups have a right to remain distinct rather than assimilating to mainstream norms, the debate is complicated by at least four sets of overlapping factors. First, there is the point to which we have already alluded that there are a number of plural contexts, loosely labelled multiculturalisms, that are arranged along a continuum from complete assimilation to the equally hypothetical recognition of endless diversity. Second, the definition of multiculturalism also varies between political discourses and academic disciplines and across time and through space. Third, multiculturalism operates – like heritage and analogously to globalisation – at a number of scales ranging from local communities to global power blocs.

It is less easy to summarise the fourth set of complicating factors. The elusive nature of pluralism and multiculturalism is both reflected in and significantly problematised by the entwining and overlapping of their own unagreed lexicons with a succession of other contested terms, concepts and political issues. In addition to heritage itself, those implicated include: identity and otherness, identity politics or the 'differentialist turn' (Mitchell, 2004: 642), religion, ethnicity and 'ethnic cleansing', gender, language, race, sexuality, migration and immigrant integration, diaspora, community, nationalism, citizenship, human rights, globalisation, colonialism, transnational networks, continuity, power, modernisation, neo-liberalism, integration, homogeneity, inequality, inclusion and exclusion, hybridity, heterogeneity, diversity, public–private, individual–group, asylum, and minority rights. None of these linked terms is fixed in time and space; they are fluid and dynamic, and their elusive nature is further complicated by changing definitions in response to ever-mutating political and policy priorities. The requirements of multiculturalism vary from state to state and, in their precise terms, are historically and spatially specific, even if, for example, there is now an apparent neo-liberal ideological hegemony. Often abrupt external circumstances impact on those policies in specific societies and lead to sudden changes in the acceptability of particular constructs of multiculturalism, or in the demands of, and constraints imposed on, multicultural policy. Recent examples include the collapse of Marxist-Leninism in the late 1980s in Eastern and Central Europe and the cataclysmic wars in the former Yugoslavia during the 1990s. Again, there is the 'war on terror' or 'the long war' and its concomitant patriotism legislation that followed the 2001 '9/11' attacks on the United States. In turn,

these are interconnected – if not in any easily discernible cause–effect relationship – with increasing demands for separate development from Islamic minorities in some European countries.

Variations in policies

Not only does multiculturalism exist within the dimensions outlined above but the construction of policies so labelled is also subject to wide-ranging variations, including many that do not fall within our definition. We must especially distinguish between descriptive and prescriptive models and, second, between pluralistic and particularistic applications.

A descriptive multiculturalism is little more than recognition that society is in many ways, often self-evidently, plural and that it can be classified into groups based upon ethnic origins or important cultural traits. When stated in this way it is difficult to conceive of many societies that have had other than historically diverse origins yet such descriptions, often supported by statistical evidence, form the initial justifications for many policies labelled as multicultural. Prescriptive models proceed from an existing recognised demographic diversity to what should be done about it by governments and this shift from description to prescription frequently occurs without debate.

Second, multicultural policies can be pluralist or separatist in their prime objective. One perspective here regards the existing diversity as a resource, which should, so far as is possible, be made universally accessible to the assumed benefit of all. It is a policy based on a philosophy of saying 'yes' to the fact of diversity (Raz, 1994). This idea stresses inclusion in two senses: that all cultural groups should be encouraged to contribute to the whole, and also that any barriers of accessibility hindering the participation of any particular group in the benefits should be identified and removed. The second, contrasting perspective, separatism, seeks to discover and foster cohesion within the different groups through a strengthening of their differences. This is the distinction made by Ravitch (2003) between what she labels 'pluralistic multiculturalism', where each group freely contributes and presumably also participates, as against a 'particularistic multiculturalism' where the accent is upon preserving the distinction of each group from the others. The policy consequences for these approaches results in the distinction between what has been called 'soft' and 'hard' multiculturalism. Rather than a sharp dichotomy, this may be a spectrum that runs from an entrenchment of mutual solitudes, to a mere tolerant acceptance of the

existence of diversity, through a mutual respect for and understanding of such differences, to an active, if selective, participation in the possibilities that such diversity may offer. This latter 'soft' multiculturalism may be analogous to what might be called the 'multicultural supermarket' where ethnic food, music, design and the like are made available to all as consumption goods to be selectively enjoyed and celebrated often with little additional context. This is the so-called 'pizzas and polkas' multiculturalism.

By contrast a 'hard' multiculturalism is concerned more with preserving the integrity and authenticity of the distinctive group than with its relationship to the whole. The accent is not upon participation of outsiders in the group, or of insiders reaching beyond the group, but upon such matters as group integrity, the maintenance of cultural separatism and even group self-empowerment. It is notable that the phrases 'social inclusion' and 'social cohesion' are widely used as policy objectives in both soft and hard policy variants but with shifting meanings, depending upon who is to be included in what, and where the cohesive unity is to be sought.

THE CONTRADICTIONS AND CRITICISMS OF MULTICULTURALISM

All the policy models discussed in Part III are devised and applied within a context of contradictions and criticisms, but reactions to multicultural policies in particular may range from unease to outright rejection, and may emanate from diverse ideological positions, including ethno-nationalism, libertarianism, social democracy and even Marxism. Most well-researched cases occur in countries with a democratic tradition, independent legal systems and free expression, doubtless because a lack of coercion and the existence of legal protection is a *sine qua non* for the implementation of such models. The result of criticism is often modification and ambivalence in application. The main areas of such criticism need therefore to be briefly summarised.

Cultural relativism

The prefix 'multi' in front of cultural implies only that there is more than one culture: it is a quantitative measure which says nothing about the relative qualitative valuation or social role of the cultures, let alone anything

about the relationships between the constituent cultures in such a society. The 'how much and how many?' questions have two dimensions. First, there is the number of members needed to constitute a group, which could be resolved by a fairly arbitrary choice along a scale from an all-inclusive unity to an individual atomisation. Settler societies, for example, have recently found it expedient to redefine formerly proclaimed unities as proliferating diversities, as in the polyglot reconfiguration of Canada's United Empire Loyalists (Ashworth, 1996). Second, how important should the contribution of any such group be within a society in order to earn recognition in this way? Either some weighting is introduced which favours some groups over others, or all are presumed to make an equal contribution. Both policy options have difficulties. In the United States, for example, many of the national origins of its diverse population are celebrated through named days, either officially or not, but there are not enough days in the year to celebrate them all. A Columbus or St Patrick's Day carries the implication that Italian or Irish-Americans have made a more significant contribution to the state than those ethnicities not awarded such celebration.

The extreme example of non-weighting was reached perhaps by the Canadian province of Prince Edward Island, in reality a society that is, ethnically, remarkably homogenous. In a spirit of inclusivity, its provincial government produced a series of official histories labelled 'Our x heritage', with 'x' representing a particular national origin. Having completed the obvious ethnicities, they continued with the less obvious, including 'Our Lebanese Heritage', which cannot have referred to more than a tiny minority of the island's inhabitants. While the inequality option poses obvious difficulties, a problem with such all-inclusive policies is that they may be resisted by both the group concerned and by other groups. As in the case of the Cambodian minority in Lowell, Massachusetts (Stanton, 2005), the former may see it as tending to dilute, manipulate and even distort its group heritage through the trivialisation of identity, as in food fairs and similar festivals. Equally, other groups from larger or older ethnicities may fear the diminution of their contributions by the addition of smaller and newer ethnicities, a classic problem for the reconciliation of many of French ancestry to Canada's currently proclaimed multiculturalism. An especially sensitive, if numerically converse, case is post-apartheid South Africa, in which recognition has necessarily been accorded to the formerly marginalised non-white ethnicities at the risk of alienating

Afrikaner (Boer) and Anglophone minorities whose languages and identities formerly defined the state.

Many multicultural policies begin with general statements of an assumption of equality of esteem and worth, regardless of the answers to the above questions. This raises the issue of a cultural relativism. If all groups are to be equally empowered to express and practice their cultures, then what happens if these conflict, either with each other, or with more universal ideas in society as a whole? Objections to a whole-hearted application of multicultural models often stem from special-interest groups concerned with what they regard as universal values which should take precedence over those of society's constituent groups. The rulers of the nineteenth-century British Indian Raj would have recognised this as the 'suttee' problem, which raised the dilemma of central intervention in defence of imported universal values in opposition to established local religious custom. Amongst the most vociferous oppositions to a multiculturalism based upon tolerance of group differences in many present Western societies are feminist critiques of the customs and practices of some such groups, specifically in reaction to supposed Moslem attitudes and practices towards women (Okin, 1999). Other universal values perceived as being threatened by cultural relativism interpreted as mutual respect have included freedom of expression, which can mean the freedom to offend the susceptibilities of other groups. Notable conflicts over such perceived universal values have included: the Rushdie affair in the UK (1989); Sikh objections to Bhatt's play, *Behzti*, in Birmingham in 2004; the world-wide Moslem reactions to the Danish *Jyllands-Posten* cartoons in 2006; or even the claims that animal rights are violated by various husbandry and dietary practices of some religious groups.

These issues of cultural relativism versus universalism are also central to the debates on the 'ownership' of archaeological artefacts (Smith, 2004). One example concerns the long-running legal dispute in the United States over 'Kennewick man'. A skeleton discovered in 1996, and dated to around 10,000 years ago, is claimed by Native Americans as representative of their ancestors and thus worthy of appropriate treatment. Conversely, for archaeologists, the skeleton is a scientific specimen to be investigated and analysed. The use or disposal of cultural property, particularly in the museum context, has become a major issue which directly counterposes aboriginal group rights with the universal rights of the country and even the world scientific community (Zimmerman and Clinton, 1999; Smith, 2004).

Communitarianism

The relativism versus universalism issue parallels the argument between the hegemony of the community and that of the individual, which, in liberal democracies, centres on questions of equal rights for all versus those of minorities. Kymlicka (1995) uses the term 'communitarianism' for the principle of the elevation of the supremacy of the group and its values over those of the individual. This is an aspect of a wider conflict between individualism and collectivism. The 'enlightenment values' of individual rights and duties to and from the state as a social contract (as argued also by Fukuyama, 2005) are opposed by values accruing to groups. This is a long-running issue, echoing much of the nineteenth- and twentieth-century debates between liberalism and socialism. It has been resuscitated more recently by many commentators in arguments opposing the 'salad bowl' idea of a society being divided into identifiable cultural groups. An early critique by liberal philosophers, notably Ayn Rand (1957), feared that multicultural policies could lead to a 'culturally determined collectivism' through 'tribalisation' and 'Balkanisation' (the last presumably used in the sense of its political geographical consequences). Such a critique from the libertarian right is echoed from the other end of the ideological spectrum by those fearing that multicultural policies threaten to undermine universal values in liberal education (D'Souza, 1991), or be anti-egalitarian in the pursuit of social justice for the group (Brian Barry, 2001), leading to the totalitarianism of an imposed utopianism.

Bissoondath (1994) focuses upon official Canadian multiculturalism as an enforced stereotyping. Official policies assume that individuals can and will allocate themselves to a limited number of predefined and formally specified groups. This presupposes a single dimension in group formation, rather than the individual forming part of many different but potentially overlapping groups. It also takes for granted that individuals can be allocated to a clear group membership rather than straddling more than one and, indeed, would always wish to be so allocated. At best such policies ignore, through simplification, the complex, hybrid and multifaceted relations of the individual to society and, at worst, may confine the individual, whether willingly or not, to a cultural ghetto that does not reflect or represent these complexities.

The fear of such apocalyptic consequences is not confined to libertarian thinkers. In the United Kingdom (UK), the multiculturalism debate was sharpened by the intervention in 2004 of Trevor Phillips, who, as

chairman of the government agency, the Commission for Racial Equality, has been a noted campaigner for the redressing of the economic and social grievances of the deprived, especially those within ethnic minorities. He argues that existing government policies for recognising and encouraging multiculturalism are leading to a growing separation of society into groups, to the disadvantage of many individuals. The disadvantaged individual would be aided more by integration into the mainstream economic and social structure than by, in a memorable phrase, 'sleepwalking into apartheid'. Phillips believes that the label 'multiculturalism' should be dropped from official pronouncements (2005) as its practice no longer furthers the well-being of the individuals it has been intended to protect and assist. Brian Barry (2001) has similarly argued that multiculturalism obstructs the integration of minorities by politicising cultural group identities in the name of 'minority rights'. In acknowledging that it can be argued that the egalitarian liberal position is inhospitable to difference, and that liberal principles of equal treatment are bound up with the ideal of assimilation, Loobuyck (2005: 109) admits that: 'The charge is that the (implicit) aim of liberalism is to exclude or homogenise difference.'

Mitchell (2002), while accepting that multiculturalism goes beyond inclusion and difference, makes the valuable point that it is also concerned with the active achievement of diversity, which, as we will explore in Part III, provides a very useful perspective on heritage policy in some plural societies. However, this too is problematic. As Hague et al. point out, claims for cultural distinctiveness and the right to be different may effectively be seen as protection from homogenisation by groups intent on difference and promoting essentialist identities grounded in territorial claims to space. In a study of two such groups, the League of the South in the United States and the *Lega Nord* in Italy, they argue that both promote a Celtic nationalism as an acceptable recasting of the politics of white supremacy in which a rhetoric of cultural awareness is used to subvert 'political commitments to cultural equity and reassert white superiority' (2005: 167). Again, in Northern Ireland, the 1998 Peace Agreement exacerbated other problematic elements of Northern Irish politics, most notably the reification of the hegemonic status of the 'two traditions' paradigm through using the legacy of the past to make what could be seen as an 'exemption for one group ... into a universal right that applied to all' (Little, 2004: 81; Graham and Nash, 2006).

To reiterate, multiculturalism is generally assumed to be progressive but it also possesses regressive tendencies. Thus Nash argues that research in cultural geography and other disciplines 'must understand

and critically engage with the social, cultural and political construction and consequences of ideas of racial, cultural and embodied difference' at a time when 'ideas of multiculturalism can be deployed in racist [and other reactionary identity projects] ways in the service of neo-liberalism' (2003: 638). Further, Hague *et al.* (2005: 152) believe that US and many European discourses of multiculturalism envisage people as belonging to a single, bounded culture in which supposed cultural differences become 'the defining component of entitlement to status and authority'. This then develops into a way of writing ethnicities and cultures as the fundamental basis of contemporary Western society and therefore typically 'eliding other structuring elements such as gender, sexuality and class'.

Hague *et al.* cite Beckett and Macy who argue that: 'multiculturalism's simultaneous assertion of the right to be different and to be treated equally is inherently problematic. It can also be a tension, if not contradiction, with the central tenets of liberal democracy' (2001: 316). Thus within the multicultural project, there is a requirement for the other's sameness (assimilation) but on the other hand, in order to make the claim for multicultural sensitivity, there is a need to re-inscribe, within clear limits, the (acceptable) other as other (Fortier, 2005).

Practical arguments

Pragmatic issues such as the cost of official multicultural policies, and their propensity for duplicating facilities, may appear trivial but can be a major cause of popular irritation that leads to rejection. It may be salutary to recall the case of apartheid South Africa, not only as a warning of the outcome of an obsession with group identity but also as a reminder that its cost and duplication were a major strain upon the country's economy.

MIGRATION AND HYBRIDITY

Migration

Much of the debate about multiculturalism emerged in response to immigration, and specifically to the immigration of people with a distinctively different culture from that of the host community. Therefore many observers have viewed multicultural policies pragmatically as essentially necessary, temporary phases in the evolution of quite different

[21]

ultimate end-states. Loobuyck (2005: 110), for instance, argues that it is a constrained and temporary strategy, capable of being accommodated within the scope of an egalitarian liberalism 'that seeks maximum accommodation of differences in religious, cultural, or ethnic origin in a stable and morally defensible way, in private as well as public spheres'. He disputes, however, that special rights to minority groups should be required permanently, and only regards them as necessary to rectify an unwished for, unfair disadvantage and inequality. For him, multiculturalism refers simply to the empirical fact of diversity, and multicultural policy is a normative response to that fact. Eisenberg (2005) sites this advocacy of 'temporary' multicultural measures between the stance of strong liberal multiculturalists like Kymlicka (2001), who defend minority rights and for whom multiculturalism is the enduring way of thinking about our political societies, and sceptical liberal-egalitarian revivalists such as Brian Barry (2001) for whom 'multiculturalism is that which transcends liberalism to accommodate cultural and religious diversity' (Loobuyck, 2005: 109–10). In response, Eisenberg questions what constitutes a 'temporary measure' when, she claims, the reality is that all accommodations are in principle temporary until they are rendered redundant. She argues for the 'permanent need for multiculturalism within liberal societies' as a process of permanent scrutiny of actual and potential bias because multicultural 'egalitarianism provides the only defensible context in which cultural diversity is appropriately protected' (2005: 127).

Mitchell's definition of multiculturalism as the 'philosophy and politics related to a particular mode of immigrant incorporation as well as to the rights of minority groups in society to state recognition and protection' (2004: 642), encapsulates something of the limitations of multiculturalism within our broader concern with multiple, plural cultures. For example, as Mitchell implies, policies for pluralism have to go beyond a specific focus on immigrants to include indigenous groups (as in Belgium or Switzerland) who, while defined by culture and politics, already possess legally enforced equality and parity of esteem, representation and influence. The distinction between 'national minorities', which are accepted as 'indigenous' and accorded special protective status, and 'non-national' immigrant groups, which are accorded no such status and are expected to either assimilate with – or at least accept the public primacy of – the majority community, is enshrined in a number of international agreements.

Hybridity

In terms of the other concepts that intersect with multiculturalism, hybridity seems one of the most potent, not least because of its linkages with migration and transnationalism. Hutnyk (2005) points to Stuart Hall's argument that hybridity is transforming Britain and forcing change, whether welcome or not, while altering 'nationalist complacencies for the better'. Thus, as Littler (2005) argues, rethinking national heritage through hybridity means more than just including other stories by tacking them on to the national narrative, because the latter has also to be revised to acknowledge complex patterns of migration and diaspora. In Europe, for example, Lewis and Neal (2005) argue that the demand for migrant labour has shifted from the ex-colonies and guest-workers to a much more complex pattern of settlers, guest-workers, refugees, asylum-seekers, returnees and clandestine/illegal migrants. This increasingly hybrid society is a reflection of the interdependence of states around the globe and profound inequalities within and between states and regions.

Accordingly, Amin (2004) argues that the Christian–Enlightenment–Romantic conceptualisation of Europe (and its heritage) is strikingly exclusionary and backward looking. His alternative vision of an 'idea of Europe' sees it as migrant space rather than one of enduring value of 'Europeans'. For Amin, the core European project should be the binding of cultural pluralism and difference, in which Europeanness is a never-settled cultural invention. But in some ways this is to 'privilege' external immigration and diaspora as the defining entities of multiculturalism; the fragmentation of identity also reflects migration within (for example, rural–urban) as well as beyond individual states and also between the Member States of the European Union, which largely still share in that Christian–Enlightenment–Romantic conceptualisation of Europe. To insist that hybridity stems from external immigration alone is to essentialise multicultural diversity by equating it to race and ethnicity.

Lewis and Neal (2005) identify two concerns stemming from the hybridisation of societies in Europe, North America and Australia. First, there are the perceived effects of asylum-seeking/refugee/clandestine groups and persons on social cohesion and forms of social solidarity and, second, anxiety about the effects that strategies of a multiculturalism aimed at the further integration of minority ethnic or settled communities may have on earlier groups of immigrants. That is important because multiculturalism has emerged as the 'dominant political

and policy discourse in a number of these countries that have a particular relation at the centre of the colonial projects of the eighteenth and nineteenth centuries' (Lewis and Neal, 2005: 429).

Although we contend that multiculturalism cannot be defined solely through a concern with immigrant incorporation, this remains, of course, one of the key issues for postcolonial societies defined by 'progressive' geographies of fluidity in which 'claims to rootedness, belonging and attachments to place' are seen by Nash (2004: 121) as 'perpetuating regressive colonial geographies of bounded places and pure cultures'. She also observes that Gilroy (1997) has conceptualised 'diasporic consciousness as a sub-national and transnational, non-territorial collective identity formed out of the experience of displacement' (Nash, 2004: 120–1). Nash argues, however, that what we are concerned with here is a rethinking of the relationship between cultural origin and contemporary cultural location, a set of issues that has to extend beyond a single dimension to difference. Hence:

> Postcolonial geography attends to the differentiated nature of colonialism and to the hierarchical relationships and complex interconnections between places affected by the long history of European colonialism [but it also explores] the power-laden discourses and practices of both colonialism and nationalism and the interconnections, interdependencies and power relations between people structured through class and gender as well as ethnicity.
>
> (Nash, 2004: 124)

BEYOND MULTICULTURALISM

Assimilation–multiculturalism–assimilation

It is readily apparent, therefore, that our consideration of heritage in plural societies must extend beyond multiculturalism as such, which is one but not the only long-term strategy of addressing hybridity and diversity in contemporary societies. Concepts of assimilation are also profoundly important in the study of plural heritages. According to Mitchell (2004: 642), assimilation is concerned with allegiance to 'established norms and values. Cultural difference is acceptable but only in the spaces of private life.' Thus assimilatory strategies reinforce a

public–private split and separate out 'difference' which is allocated to the private sphere. She proposes a 'model' or 'continuum' for Western society, which can be summarised as shown in Table 2.1.

Lewis and Neal (2005) support this interpretation, arguing that the tensions created by asylum, labour needs and multicultural citizenship, which have become dominant since the late 1990s, have led to a redrawing of multicultural political and policy approaches. This has involved the revival of the traditional stress of policing national boundaries and excavation of older discourses of assimilationism through an emphasis on cultural integration, social cohesion and the notion of national identity. Mitchell's examples include the United States, with its programme of national assimilation bolstered by the patriotism legislation that followed '9/11'.

The swing to the neoliberal right is also readily apparent in Europe even if, as in Britain, there remains an official 'valorisation of multiculturalism' (Lewis and Neal, 2005: 430). Despite this, it might be argued that there is actually a retreat from multiculturalism in the United Kingdom which, in this respect, parallels other European states that have moved to the right or never did embrace this strategy as the framework through which to manage cultural plurality. In the Netherlands, for example, there has been a profound popular disillusion with a perceived past multiculturalism, and this is reflected among politicians who openly regard it as a failed policy (Etzinger, 2003). Both Denmark and Sweden now emphasise the idea of immigrants 'choosing' to join the respective majority culture (Buciek *et al.*, 2006). France has always pursued a policy of civic universalism which privileges assimilation and integration into what are regarded as universal values over multicultural citizenship, while

Table 2.1

Up to mid-1960s	Dominance of an assimilationist ideology of immigrant absorption into the host society.
Mid-1960s–early 1990s	The 'differentialist turn' is reflected in state-sponsored multicultural programmes.
1990s–present	A return to assimilation, the active achievement of diversity being abandoned in favour of a neo-liberal separation of public and private (an adjunct to the ideology of 'choice') and the 'return' of nationalism and its 'right' to exclude.

Germany follows a similar strategy. In Australia, cultural diversity is seen as a strength but not one to be gained at the price of accepting 'a diversity of cultural values'. Cultural heritages can be expressed only within 'an overriding commitment to Australia and the basic structures and values of Australian democracy' (Lewis and Neal, 2005: 430). This shift to the right marked by the global hegemony of neoliberalism and the emphasis on personal choice, means that those 'who choose not to assimilate' can be assumed to be 'signalling an unwillingness to participate in civil life and can therefore be excluded' without 'incurring damage to the core ideals of a universalist liberal project' (Mitchell, 2004: 644). There may, however, be something of a dissonance between 'high' politics and the *de facto* reality of everyday life in most liberal societies in which a non-interventionist and often quite superficial multiculturalism remains the norm.

Clearly, therefore, a particular state can move along Mitchell's continuum at different times depending on the specificities of the jurisdiction. As we discuss in Part III, the interplay between assimilation and multiculturalism means that heritage policies for plural societies may not necessarily be consistent through time, as any one state will pass through a succession of models in response to these broad changes. Yet, at the same time, there are limits to this diversity because culture also embodies notions of continuity. The broader implications are well summarised by Duncan and Duncan when they argue that: 'cultural geographers need methods to study and words to describe how fluid and heterogeneous phenomena such as cultures achieve and maintain recognisable degrees of coherence over time and across space without legitimising their exclusivity' (2004: 397).

Duncan and Duncan cite Benhabib (2002), who proposes a normative model of democracy embracing maximum cultural contestation within the public sphere, which underscores the inherent instability of cultures. In valorising heterogeneity and hybridity, Benhabib believes that cultural explanations can be critical and subversive – 'blurring and shifting' – rather than merely being conservative of traditional values. However, this is to deny the empirical evidence of the neoliberal world and the simultaneous role of culture as a force of political stability. Thus Mitchell identifies three dimensions to this ideological work of multiculturalism:

• 'to create a sense of a unified, tolerant and coherent nation, despite the multiple differences evident in the population of its citizenry' (Katharyne Mitchell, 2003: 391)

- to operate as a fundamental institutional and conceptual tool in providing a state with the enhanced ability to control difference
- to aid in the exportation of liberalism and hence capitalism abroad, a trend best exemplified by the world-ordering ambitions of the United States.

The issue of scale is also important here. Amin and Thrift (2002) argue that much of the discussion on belonging has focused on the clash between global (diasporic) and national, with far less emphasis being given to local modes of belonging (the Dutch 'Belvedere' policy case, discussed later, is a notable exception). Discourses on racism and multicultural dynamics have tended to focus on national articulations of political philosophy, leading to an underestimation of the importance of local microcultures of inclusion–exclusion. Thus Kymlicka (2003: 60) further problematises the debate in pointing out that 'the preference for global over local forms of interculturalism is quite explicit in many countries'. He identifies three areas of tension. First, what he terms the 'intercultural citizen' may prefer global interculturalism, while multicultural justice (at the hands of the state) is focused on local interculturalism. Second, the model of the intercultural citizen requires a level of intercultural exchange, which may unfairly burden some isolationist groups and implies that a 'valorisation of multiculturalism' may have to be legally enforced, as in France's civic universalism. Finally, the national model of the intercultural citizen requires a level of mutual understanding that it is either tokenistic (in that it recognises superficial cultural differences or exoticism) or utopian (in that there is a focus on deep cultural differences) while individual justice requires acknowledging the limits of mutual understanding and accepting 'the partial opaqueness of our differences' (Kymlicka, 2003: 166).

PLURALITY, CULTURE AND POWER

The issue of scale complicates the understanding of plural societies through the idea of levels of comprehension and representation and dichotomies between the local–global and unofficial–official. More-over, we have to acknowledge that the fluidity and fuzziness of culture mean that multiculturalism interconnects with a succession of other economic and social forces which are themselves potent sources of inequality. Yet, as Nash (2003: 639) argues, multicultural discourses

are often 'shorn of critical attention to inequality'. For Eisenberg (2005: 126), the debate is really concerned with the degree to which liberal values and institutions, when viewed as 'neutral and impartial', can 'create sources of inequality, marginalisation and disadvantage for peoples who do not share in the historical traditions and debates that give rise to and sustain these values'.

We turn now to examine the linkages between models of pluralism and the economic and other axes of inequality and differentiation that are implicated in the definition and provision of heritage (Graham *et al.*, 2000). Paralleling the swing from multiculturalism back to assimilation in a number of countries since the early 1990s, there has also been a significant change in the emphasis of research on multicultural societies from a focus on class and economy in the 1980s to one that is now far more concerned with race, ethnicity, religion, gender and sexuality as markers of differences.

Class, economy and resistance

As Gallaher (2000) argues, the issues of class seem to have disappeared from the landscape of a left politics preoccupied with race, gender and sexuality. If, however, discourses of multiculturalism (including assimilation) are still adjuncts to neoliberalism, albeit contested, then they remain class positioned and are implicated in the economic structuring of society and ideologies of redistribution. Nash (2003: 642) points to the 'ambiguous neoliberal deployment of discourses of multiculturalism and anti-racism', in which multiculturalism means the consumerist commodification of 'exotic' cultures while the geographies of segregation and racial privilege remain unchanged (de Oliver, 2001). In turn, multiculturalism becomes linked to redistributive justice because 'celebrations of cosmopolitan multiculturalism deflect attention from and deny the presence of class-based inequalities' (Nash, 2003: 643). In a penetrating analysis, Katharyne Mitchell (2003) argues that multiculturalism in education has shifted from a concern with the formation of tolerant and democratic national citizens, who can work with and through difference, to a strategic use of diversity for competitive advantage in the global marketplace. Hence, we have the advocacy of a 'strategic cosmopolitanism' that is motivated by ideas of global competitiveness and transnationalism. Earlier forms of multiculturalism are 'increasingly perceived by ... neoliberal politicians as either irrelevant or negative' in a post-Fordist age (Mitchell, 2003: 392).

[28]

One important way in which class is implicated in multiculturalism concerns reactionary representations of identity and the multiplicity of marginalised groups. Writing of the US Patriot movement, Gallaher (2000: 687) identifies poor working-class whites 'who can obviously not claim oppression through existing channels such as feminism, black power and gay rights, but who, despite their normative identities, suffer economic exploitation'. Elsewhere, she advances the argument that discourses of patriotism keep the patriots from addressing the economic basis of many of their grievances while buttressing ideas of cultural and racial superiority through 'safe' nationalistic coding (Gallaher, 2003). Again, Nash (2003: 643) points to the construction and then condemnation by some writers of a reactionary and racist white English working class 'while middle class modernity and multiculturalism are constructed in contrast' to that class. Haylett (2001), too, is concerned about the shift from the conceptualisation of a white working class as a racialised and irredeemable underclass to naming them as an 'excluded', culturally determined but recuperable 'other'. He argues that the problems posed to 'critical academics by ... unappealing ... "others" have been noted by geographers if not acted upon' and that there has been a 'dumping' of the white working class in academic writing (Graham and Shirlow, 2002). White working-class cultures are 'cast as emblematically racist', yet it is mainly within these cultures that multiculturalism is lived and negotiated on an everyday basis with more complex outcomes than racism alone (Haylett, 2001: 353).

It is in this type of arena of contestation that multiculturalism gives way to multiple cultures and cultural belonging can become a form of resistance. This latter is a diverse concept but one that often includes notions of opposition to perceived domination or oppression. Thus implicit within it is the idea of resistant subjects defined conventionally by race, gender or sexuality shaping their identities outside or beyond the realm of hegemonic groups. For Cresswell, an 'unintended consequence of making space a means of control [is] simultaneously [to] make it a site of meaningful resistance'. Consequently, resistance 'seeks to occupy, deploy and create alternative spatialities from those offered through oppression and exploitation' (Cresswell, 1996: 163).

Ethnicity and race

While class has been increasingly elided in the debate on plural and hybrid societies, in effect a form of marginalisation of 'undesirable' minorities, Nash (2003) observes the 'return' of 'race' in geography. But we have to

consider, too, that race is often seen as synonymous with ethnicity, the latter arguably being the most fundamental basis of perceived distinction between human groups. Although usage of the term is elastic and often vague, an ethnic group can be defined as a socially distinct community of people who share a common history and culture, and often language and religion as well (Sillitoe and White, 1992). While 'ethnicity' is very often used simply as a synonym for 'race', this definition points to a more flexible interpretation. Poole identifies three basic strands to ethnicity:

> the activity segregation which gives rise to the socially distinct community; the myth or actuality of a common perceived historical and cultural origin distinguishing the group from others; the delimitation of the group by key social or cultural markers such as language and religion.
>
> (Poole, 1997: 131–2)

As he observes, ethnic identity is not an attribute which is simply present or absent, because people may have it to varying degrees. As it can also change over time, ethnic identity is a feeling 'subject to ebb and flow' (Poole, 1997: 133). Ethnicity is of cardinal importance as a basis for social conflict. That the groups in question may be arbitrarily defined by their mutual perceptions does not significantly alter the reality that human competition and aggression for resources and status is very often defined and justified primarily in ethnic terms. Ethnicity may coincide with the other dimensions to social differentiation although, more often, human diversity is reflected in ethnic identities, which cut across other differentiating criteria. Where this occurs, it is commonplace, although not invariably so, for ethnicity to take precedence over class or gender in the individual's sense of identification.

Ethnicity and 'race' are distinct social phenomena and should not be conflated although they are often difficult to separate. Nor should their derivatives, ethnocentrism and racism (Werbener and Modood, 1997). 'Race', like nation, is essentially interpreted as a social construction, one, moreover, that means different things in different places. Thus: 'By demonstrating the existence of a plurality of place-specific ideologies of "race" ... rather than a monolithically, historically singular and geographically invariant racism ..., the constructedness of "race"... is starkly revealed' (Jackson and Penrose, 1993: 13).

Nevertheless, there are still racialised identities and, while there may be no 'race' in the genetic sense (hence the frequent use of inverted

commas), there is ample evidence of racism, which 'remains a wide-spread, and possibly intensifying, fact of many people's lives'. There-fore, the question is not whether 'race' exists but how 'racial logics and racial frames of reference' are constructed and used, and with what consequences (Donald and Rattansi, 1992: 1).

Recent debates and literature concerning multiculturalism have been dominated by race rather than ethnicity. Nash points to the recognition that 'whiteness' is a racial category rather than a norm against which racial differences of others can be judged, while limiting attention to 'non-whites' reflects an unreflexive whiteness. But this comes with a major caveat: 'the tension in work on whiteness as a racial category is that it may buttress rather than undermine this [black–white] binary' (Nash, 2003: 641). She argues that anti-racist arguments for 'considering human diversity in terms of anti-essentialist cultural difference' can easily be subverted 'to support ideas of national cultural purity, cultural exclusiveness and natural antago-nism between "cultures"' (Nash, 2003: 641). Hostility is thus cast as a 'natu-ral' phenomenon between cultures best kept apart. Kim (2004b) also believes that many participants in the race debate implicitly advance a white–non-white framework that falsely homogenises the experiences of non-white groups and obscures how differential racialisation processes have generated a complex structure of multiple group positions in US society. Thus, 'multiculturalism is not a unitary phenomenon and multiculturalisms differ quite dramatically from one another' (Kim, 2004a: 989). Curiously, however, she does not extend this argument to consider that exactly the same point applies to whites when 'white' is considered as a racial category.

Littler and Naidoo (2004) further explore the complexity of race in adopting Wright's (1985) idea of different heritage alignments to argue that the interconnection of race and heritage in Britain is not just concerned with exclusion–inclusion but is also 'about complex power relationships and psychologies connected to class, gender and age, among other factors' (2004: 333). They identify first an 'uncritically imperialist' alignment (334) which then mutates into a liberal multiculturalism and its tokenistic approaches to ethnic heritage. Finally, they theorise a 'white heritage, multicultural present' heritage (336) which is simultaneously a 'lament and a celebration' (338), 'the easy celebration of a multicultural present that shores up its celebration by ignoring the unequal power rela-tions of the past' (339). This recognition of the complex if potentially constrained power relationships that exist between race and pluralism can be taken further. Kim (2004a) stresses that recognising the multiplicity of multiculturalisms can include the elision of complex inter-minority

inequalities and antagonisms generated by the new diversity. In the post-Civil Rights era, a triumphalist discourse of difference pervades the debate: 'The special genius of America, according to this discourse, is the way it meets the challenge posed by difference' (Kim, 2004a: 990). But this leads to a denial that racial differences have been constructed through processes of dominance, and diversity is again naturalised as a condition of human existence rather than differences arising from asymmetries of power. Crucial to the debate on plural heritages, however, is the essence of Kim's argument: that such symmetries are more complex than is often represented and that there are two scales to racial and ethnic antagonism – majority–minority–interminority.

In this further problematising of the notion of plurality, the roles of religion, and to a lesser extent language, as ethnic markers are also important. In particular, the demonisation of Islam as *the* Other both envisages numerous variants of that religious belief as being one while also conflating religion with other issues. Thus Modood (2005) argues that in Britain, Muslims are seen as 'other' and threatening, and that there is a conflation of racial exclusion and black–white division with cultural racism, Islamophobia and what he calls the unexpected challenge to secular modernity. It is entirely possible that national core values in Europe 'can be appropriated to a Manichean division of the world into good and evil which then maps on to a divide between Christian and Muslim (West and East)' (Lewis and Neal, 2005: 434).

The othering of Islam is, however, not an easy issue because it reflects the concerns of the minority itself. In a comparative study of Britain, the Netherlands and France, Statham *et al.* (2005) found that minority group demands were normally pitched at very modest levels and were significant only for Muslims, a trait that held across the different countries. They conclude that there is no easy way of politically accommodating Islam, whose public and religious nature makes it especially resilient against political adaptation. Islam 'cannot simply be confined to privatised religious faith, but advances into the public realm of politics where the state's authority and civic citizenship obligations reign supreme'. It is better, however, to have political conflicts over being part of a national community 'than to have minorities who see themselves apart from civil society' (Statham *et al.*, 2005: 455).

There is also a geography of language that impacts on the concept of pluralising pasts. This includes both the role of language as part of the political identity of linguistic minorities, and thus a basic resource for emergent nationalism and other modes of resistance, and also the politics

of language use within established nation-states. But as Jackson (1989) also argues, language is a structure of signification reproduced in social practice, and as such does not exist outside social relations of power. Thus the politics of language intermesh with those of other axes of differentiation, most particularly in the elaboration of nationalisms. In 2005 the city government of Rotterdam promulgated a 'code of social values and public behaviour' which contained, alongside such matters as littering, the remarkable idea, endorsed by some national politicians, that only the Dutch language should be used in public spaces. Crucially, however, rather than fostering multilingual national identities, the existence of numerous and indeed multiplying linguistic minorities tends to foster resentment of their presence among majorities (Williams, 1998). Northern Ireland demonstrates yet another dimension on the potentially regressive role of language in that the 1998 Peace Agreement included the right to communicate in a language other than English, leading to Irish and Ulster-Scots being given equal status so that there were 'alternative languages for everyone' (Little, 2004: 81).

Gender and sexuality

In questioning the relationship between multiculturalism and feminism, Reitman (2005) poses several key questions: can contemporary Western society engage in politics of toleration and accommodation in respect of diversity while at the same time pursuing its commitment to reducing differentials of power between men and women? That is, is multiculturalism bad for women or is feminism bad for multiculturalism or can the two be pursued together? That these questions can still be asked is indicative of the marginalised role of gender and sexuality in the debate on plurality, culture and power (Pratt, 2004). It has been argued that modernity – and consequently its heritage – has largely been conceptualised in masculine, middle-class, urban and Eurocentric terms (Melosh, 1994). To Nash, for example, modernity was: 'dependent on the construction of the inferiority and difference of women, other races and the working classes, all defined as pre-modern, primitive and still located in the immanent world of nature' (2000: 20).

In particular, the essentially masculine gendering of modernity led to the equation of women – especially rural women – with the authentic and pre-modern. This depended on the equation of the modern with 'a male-directed logic of rationalization, objectification and developmental progress', while, according to Felski (1994: 149), feminine

qualities were equated with 'artificiality and decadence, irrationality and desire'. In contrast, romanticism 'sought to demonstrate women's greater continuity with organic processes and natural rhythms of pre-industrial society', pre-modern woman 'located within the household and intimate web of familial relations', being more 'closely linked to nature through her reproductive capacity' (Felski, 1994: 146). Nash argues that: 'this version of femininity could be denigrated as of limited value and a constraint on progress, or romantically celebrated as an antidote to the superficiality and meaninglessness of modern life' (2000: 21).

Whichever, the key point is that both viewpoints are gendered constructions which privilege masculine authority. Hitherto, it has been argued that women have been largely invisible and misrepresented in the archives of history, and that the artefacts of the past which are endowed with contemporary meanings as heritage have been largely selected from a perspective of 'heritage masculinisation' (Edensor and Kothari, 1994). This perception must, however, be set against the disproportionate role of women in the promotion of heritage and resource conservation. That said, if gender, while the focus of an enormous literature of its own, is somewhat marginalised from the debate on plural societies with its current hegemonic focus on race, then other axes of differentiation in society, such as sexuality and disability, are almost invisible. We tend to deal with these latter as compartmentalised, discrete issues rather than as part of the myriad interconnections of plurality in heritage policy.

SUMMARY

Multiculturalism, therefore, is a highly contested, ambiguous and slippery concept. Its meanings vary across space and through time, intersecting with numerous other concepts but, most particularly perhaps, with assimilation and hybridity. There is no clear political consensus on multiculturalism, either from the left or right, and there are always contested issues of the rights of individuals versus those of groups. Crucially, within the context of this book and its focus on plural heritages, multiculturalism does not in itself constitute a sufficient explanation of, or synonym for, plurality. It is to this nexus of issues that we now turn.

3 TOWARDS PLURALISING PASTS: THEORIES AND CONCEPTS OF HERITAGE

While Chapter 2 was concerned with the multiplicity of interconnections that define multiculturalism and pluralism, we focus here on the equally fluid and dynamic sense of heritage as one of the knowledges and practices through which plurality is both expressed and reflected. The chapter is concerned first to elaborate the present-centred 'paradigm' of heritage that underpins this book. We then move to explore the uses of heritage before concluding with a discussion of the multiple nature of heritages and the limits to its role as a policy instrument in plural societies.

A WORLD OF HERITAGE: HERITAGE IN THE WORLD

To reiterate, heritage is that part of the past that we select in the present for contemporary purposes, whether these be economic or cultural (including political and social factors) and choose to bequeath to a future, whatever posterity may choose to do with it. The idea that heritage is defined by meanings is rendered even more complex by the tangible and intangible binary adopted by the United Nations Economic, Social and Cultural Organization (UNESCO). This dichotomy reflects the frequent criticism that Western heritage is all too often envisaged as the built and natural environments. Thus the list of European and North American World Heritage Sites is dominated by walled cities, cathedrals, palaces, transport artefacts and national parks. In Africa and Asia,

however, heritage is often envisaged through intangible forms of traditional and popular – or folk – culture that include languages, music, dance, rituals, food and folklore. Logan, for example, points to the Ancient Quarter of the Vietnamese capital, Hanoi, where the key elements are pagodas, temples and communal buildings that have a symbolic worth linked to the intangible heritage of myths and legends, rather than a 'value based on the authenticity of their physical fabric' (2000: 261). In part, this reflects the ephemeral nature of the built environment in many societies. To reduce the tangible–intangible dichotomy in heritage to an East–West or North–South division is, however, simplistic. All societies contain both, even though the balance in that which is recognised officially as heritage may vary spatially. Moreover, as Deacon remarks of South Africa's World Heritage Site at Robben Island, no heritage value is completely tangible; even the 'tangible can only be interpreted through the intangible' (2004: 31).

In the sense of heritage, therefore, both past and future are imaginary realms that cannot be experienced in the present. As the tangible –intangible dichotomy infers, the worth attributed to these artefacts rests less in their intrinsic merit than in a complex array of contemporary values, demands and even moralities. As such, heritage can be visualised as being drawn from many resources. Clearly, it is an economic resource, one exploited everywhere as a primary component of strategies to promote tourism, economic development and rural and urban regeneration. But heritage is also a knowledge, a cultural product and a political resource that fulfils crucial socio-political functions. Thus heritage is accompanied by a complex and often discordant array of identifications and potential conflicts, not least when heritage places and objects are involved in issues of legitimation of power structures.

The contestation and dissonance of heritage

Inevitably, heritage is seen here as a diverse cultural knowledge in the sense that there are many heritages, the contents and meanings of which change through time and across space and are shaped and managed for a range of purposes defined by the needs and demands of our present societies. Heritage is simultaneously an economic commodity, a status which may overlap, conflict with or even deny its cultural role. Tunbridge and Ashworth's thesis of 'dissonant heritage' (1996) constitutes the most sustained attempt to conceptualise this inevitable contestation of heritage and its repercussions.

Dissonance is a condition that refers to the discordance or lack of agreement and consistency as to the meaning of heritage.

For two main sets of reasons, this appears to be intrinsic to the very nature of heritage and should not be regarded as an unforeseen or unfortunate by-product. First, dissonance is implicit in the market segmentation attending heritage as an economic commodity – essentially comprising tangible and intangible place products, which are multi-sold and multi-interpreted by tourist and 'domestic' consumers alike. That landscapes of tourism consumption are simultaneously other people's sacred places is one of the principal causes of heritage contestation on a global scale because the processes of sacralisation and sacralising also involve the exercise of profane forces (Kong, 2001). Second, Tunbridge and Ashworth (1996) argue that dissonance arises because of the zero-sum characteristics of heritage, all of which belongs to someone and logically, therefore, not to someone else. The creation of any heritage actively potentially disinherits or excludes those who do not subscribe to, or are not embraced within, the terms of meaning attending that heritage. Fortunately, much of this disinheritance is irrelevant or trivial: some, however, results in serious discomfort, offence, distress and anguish.

This quality of heritage is exacerbated because it is often implicated in the same zero-sum definitions of power and territoriality that attend the modernist notion of the nation-state and its allegories of exclusive membership. It is this association with ethnic and/or nationalist hegemony which implies that the idea of heritage dissonance applies best in zero-sum societies. Consequently, it could be regarded as a regressive concept, leading Littler to argue that it 'is a model that appears to suggest that heritage can only ever be imagined as a series of individualisms'. For her, the key question is how 'various inheritances interconnect and can be changed through encounters rather than the constantly individualised model of elevating "someone's heritage at the expense of someone else's"' (2005: 7).

To some extent, this chimes with Landzelius who disputes that the past should be such a constant and regressive point of reference in democratic societies, arguing instead that the imaginary lineage of heritage should be replaced with: 'a "rhizome history" of "disinheritance" [in which] the erasure of heritage ... should be mobilised as disinheritance ... in order to make the past implode into the present in ways that unsettle fundamental social imaginary significations' (2003: 215–16). Sectarian claims upon the past should be critiqued and deconstructed 'with the aim [of] subvert[ing] and deny[ing] all claims of some

kind of unbroken linkage and right to the past. The objective should be actively to disinherit each and everyone' (2003: 208).

Landzelius argues that the universal democratic solution should centre not on inheriting a 'heritage' but disinheriting a 'disinheritance', an idealistic goal that perhaps underlines the distance between the academy and the material world of ethno-nationalism and sectarianism, where egalitarian, democratic liberalism is compromised by illiberal politics couched in antagonistic discourses. Somewhat paradoxically, however, such critiques point to the role of dissonance as a condition of the construction of pluralist and multicultural societies based on inclusiveness and variable-sum conceptualisations of power. Whether through indifference, acceptance of difference or, preferably, mutuality (or parity) of esteem, the very lack of consistency embodied in dissonance can be turned round in constructive imaginings of identity (Graham *et al.*, 2000). Thus Peckham (2003: 57) asks if heritage can be redefined as a 'contact zone', 'a place where different pasts and experiences are negotiated, a site of mutual translation'.

Scale and economy

If heritage is contested along several different axes – the temporal, the spatial, the cultural–economic and the public–private, it also functions at a variety of scales in which the same objects may assume – or be attributed – different meanings (Graham *et al.*, 2000; Graham, 2002). The importance of heritage as a concept is linked directly to that of nationalism and the nation-state, and the national scale remains pre-eminent in its definition and management; World Heritage Sites, for example, are nominated by national agencies. Nevertheless, even when heritage is defined largely in the national domain, the implementation of policies and their direct management is likely to be conducted at the more local scale of the region or city. Hence heritage is part of the wider debate about the ways in which regions are being seen as the most vital sites within which to convene and capitalise on the flows of knowledge in contemporary globalisation and through which cultural diversity might be expressed. Networking, entrepreneurialism, collaboration, interdependence and a shared vision are all vital prerequisites for regional economic regeneration. Simultaneously, other institutions and agencies are also involved in strategies that 'can serve to circulate and capitalise on existing and other sources of knowledge' (MacLeod, 2000: 232), heritage among them. Indeed heritage may well be a critical factor in

that it creates representations of places that provide necessary time environments within which more essentially economic processes of wealth generation and marketing can be articulated.

It is a key feature of the post-Fordist capitalist society that knowledge is an input and an output in economic activities. Castells (1996) argues that cultural expressions in what he terms the network society are abstracted from history and geography and become predominantly mediated by electronic communication networks. These latter, which allow labour, firms, regions and nations to produce, circulate and apply knowledge, are fundamental to economic growth and competitiveness. Castells sees a world working in seconds while the 'where' questions are in long-term, 'glacial' time. Power, which is diffused in global networks, 'lies in the codes of information and in the images of representation around which societies organise their institutions, and people build better lives, and decode their behaviour. The sites of this power are people's minds' (Castells, 1997: 359).

Heritage is one fundamental element in the shaping of these power networks and in elaborating this 'identifiable but diffused' concept of power. It is a medium of communication, a means of transmission of ideas and values and a knowledge that includes the material, the intangible and the virtual. Thus for Dicks (2000), for example, heritage is a culturally defined communicative practice. It can even be argued that heritage professionals constitute, as Castells would have it, one of the global networks that produce and distribute cultural codes. Given the wide disparity of ideas concerning heritage, it is important to reiterate that as used here, heritage is a product of the present, purposefully developed in response to current needs or demands for it, and shaped by those requirements. All heritage is therefore someone's heritage and that someone determines that it exists. The converse proposition, one that is central to the subsequent discussion in this book, is that possession and inheritance create the dispossession and disinheritance.

THE USES OF HERITAGE

The resources

An initial step in understanding the relationship between the past as used in heritage and its contemporary functions is to understand the assumptions and the process by which the events, artefacts and personalities of the past

are deliberately transformed into a product intended for the satisfaction of contemporary consumption demands. As in any 'commodification' process, resources are transformed into products for both cultural and economic consumption. Clearly, heritage is an economic resource, one exploited everywhere as a primary component of strategies to promote tourism, economic development and rural and urban regeneration (Graham *et al.*, 2000, 2005). One key failure of the approach adopted to heritage in cultural theory is to ignore this fundamental economic–cultural dichotomy and valorise the latter at the cost of the absolute elision of the former. But multi-layered heritage is also a knowledge, a cultural product and a political resource, and thus possesses a crucial socio-political function. It is used to 'construct, reconstruct and negotiate a range of identities and social and cultural values and meanings in the present' (Smith, 2006: 3). The nature of such knowledges is always negotiated, set as it is within specific social and intellectual circumstances. Heritage is assembled from a wide and varied mixture of past events, personalities, folk memories, mythologies, literary associations, surviving physical relics, together with the places – whether sites, towns, or landscapes – with which they can be symbolically associated. Nevertheless, the view of heritage in any given society will inevitably reflect that of the dominant political, social, religious or ethnic groups (Graham *et al.*, 2000), leading Smith (2006) to refer to the 'authorised heritage discourse'.

As we argued in Chapter 2, heritage can be seen as a resource which provides a quarry of possible raw materials from which a deliberate selection can occur, albeit one constrained by chance survival through time (either physically or in terms of a fallible and selective human memory). Although the notion of authenticity lies at the heart of, for example, all museum activity, heritage in the sense that it is being used here is not regarded as a fixed authentic resource endowment. There is no finite quantity of a conservable past that is recognisable through objective, universal and measurable sets of intrinsic criteria (although the historic preservation and conservation movements have developed on the opposite assumption). Instead, heritage is envisaged as having moved along a continuum from the preservation of what remains, to the maintenance, replacement, enhancement and facsimile construction of what might, could or should have been.

Selected resources are converted into cultural and/or economic products through interpretation and packaging. The 'selling of the past' rarely involves transferring the ownership, or exclusive use rights, of physical resources but instead offers an experience conveyed through

thematic interpretations which are not marginal accretions but essential parts of the production process. If heritage is created for its consumers – its users (the process of 'heritagisation') – this raises questions as to who is making such decisions, managing this process and thus producing heritage. If heritage is, as is being argued here, what and where someone says it is, then it is the 'someone' in these contexts, not the object itself, that determines its authenticity and purpose. While its origins lie in the tastes and values of a nineteenth-century educated élite, the wider conceptualisation of heritage raises many of the same issues that attend the debate on the role of the past and the meaning of place. As that part of the past which we select in the present for contemporary purposes, be they economic, cultural, political or social, value rests less in the intrinsic merit of heritage artefacts than in a complex array of contemporary values, demands and even moralities. Thus heritage is accompanied by an often-bewildering array of identifications and potential conflicts, not least when heritage places and objects are involved in issues of the legitimisation of power structures.

In outlining its main uses, a simple distinction can be made between heritage as culture and heritage as an instrument for achieving other objectives. The first relies upon intrinsic, implicit values and the second on extrinsic or explicit values. Although this distinction is actually based upon a logical fallacy, as even so-called intrinsic cultural values are attached to objects, sites or places and do not exist independently of them, this does not nullify its use as an ordering device. First, the intrinsic–extrinsic binary is one widely acknowledged, especially by those responsible for the care of resources and, second, policies for heritage treated as culture tend to be quite different, and pursued by different agencies with different assumptions and goals, from those responsible for heritage as an economic entity.

Intrinsic value: the social and political uses of heritage

Heritage can be seen as having a value in and of itself, not for what it may do for society but for what it is. In regarding it as a knowledge, our concern is partly with questions such as why a particular interpretation of heritage is promoted, whose interests are advanced or retarded, and in what kind of *milieu* was it conceived and communicated? If heritage knowledge is situated in particular social and intellectual circumstances, it is time-specific, and thus its meaning(s) can be altered as texts are re-read in changing times, circumstances and constructs of place and scale. As Littler (2005) remarks, heritage is not an immutable entity but a

discursive practice shaped by specific circumstances; it is not solely concerned with practice, being as much about policy, process and, quite inevitably, contestation.

As Lowenthal (1985, 1998) has argued, this suggests that the past in general, and its interpretation as history or heritage in particular, confers social benefits as well as costs. He notes four traits of the past (which can be taken as synonymous with heritage in this respect) as helping make it beneficial to a people. First, its antiquity conveys the respect and status of antecedence, but, perhaps more important, underpins the idea of continuity and its essentially modernist ethos of progressive, evolutionary social development. Second, societies create emblematic landscapes in which certain artefacts acquire cultural status because they fulfil a need to connect the present to the past in an unbroken trajectory. Third, the past provides a sense of termination in the sense that what happened in it has ended, while, finally, it offers a sequence, allowing us to locate our lives in what we see as a continuity of events.

Although Lowenthal's analysis is couched largely in social terms and pays little attention to the past as an economic resource, it is helpful in identifying the cultural – or more specifically socio-political – functions and uses of heritage. Building on those traits which can help make the past beneficial to people, Lowenthal sees it as providing familiarity and guidance, enrichment and escape but, more potently perhaps in the context of the later discussion of plural society in this book, we can concentrate on the functions of validation (or legitimation) and identity and belonging. The past is integral both to individual and communal representations of identity and their connotations of providing human existence with meaning, purpose and value. Such is the importance of this process that a people cut off from their past through migration or even by its destruction – deliberate or accidental – in war, often recreate it, or even 'recreate' what could or should have been there but never actually was. European cities, for instance, contain numerous examples of painstakingly reconstructed buildings that replace earlier urban fabric destroyed in the Second World War.

Inevitably, therefore, the past as rendered through heritage also promotes the burdens of history, the atrocities, errors and crimes of the past which are called upon to legitimate the atrocities of the present. Lowenthal further comments that the past can be a burden in the sense that it often involves a dispiriting and negative rejection of the present. Thus the past can constrain the present, one of the persistent themes of the heritage debate being the role of the degenerative representations of nostalgic pastiche, and their intimations of a bucolic and somehow better

past that so often characterise the commercial heritage industry. More important, however, two problems stem from the idea of plural versions of the past (Graham, 2002). First, as Atkinson (2005) argues, powerful groups often promote 'sectarian claims upon the past' for their own ends (Landzelius, 2003: 208); second, these partial narratives also find material forms as heritage sites and spaces. Thus 'the problem is that fixed essentialist representations of heritage at delimited heritage sites look set to endure' (Atkinson, 2005: 147), in part because of the commodification and consumption of place and the enduring boundedness and territorialisation of Western society.

Extrinsic value: the economic uses of heritage

As Sack (1992) states, heritage places are places of consumption and are arranged and managed to encourage consumption; such consumption can create places but is also place altering. 'Landscapes of consumption ... tend to consume their own contexts,' not least because of the 'homogenising effect on places and cultures' of tourism (Sack, 1992: 158–9). Moreover, preservation and restoration freeze artefacts in time whereas previously they had been constantly changing. Heritage – variously defined – is the most important single resource for international tourism. That market is highly segmented but although different types of tourist will consume heritage at different levels, consumption is generally superficial for culture is rapidly consumed. Tourism is an industry with substantial externalities, in that its costs are visited upon those who are not involved in tourism consumption. The same also applies to the transport industries upon which tourism depends. Thus tourism is parasitic upon culture, to which it may contribute nothing. If taken to the extreme, the economic commodification of the past will so trivialise or distort it that arguably this can result in the destruction of the heritage resource, which is its *raison d'être*.

One difficulty with arguments concerning the extrinsic value of heritage is that there is little empirical confirmation of the universal validity of the past reconstituted as heritage to individual and group welfare. Ennen's (1999) study of the two Dutch cities of Leeuwarden and Alkmaar, both of which have substantial historic environments that are carefully integrated into other urban planning and management schemes, concluded that less than 20 per cent of the respective urban populations actively consume and support heritage – the 'connoisseurs' – even though most urban dwellers have positive responses to heritage

and the historicity of living in monuments. For example, English Heritage's study, *The Place of Heritage* (2000a), found that 98 per cent of respondents believed the historical environment to be a vital educational asset, while 87 per cent thought that its preservation should include public funding. However, Ennen's conclusion that the largest group of urban dwellers had a 'take-it-or-leave-it' attitude to heritage suggests that – beyond such broad aspirational attitudes – an actual engagement with the historic environment is very much the preserve of a minority. There are thus equity considerations, as shown in another Dutch study by Kuipers (2005) who found that while the national government designates urban conservation areas, the costs of living there fall upon residents who may place little or no value on the historicity of the areas as ascribed by outsiders. Ennen (1999) concludes that there are fragments of meaning and fragments of consumption, and that urban heritage as an instrument of urban policy is useful only when there is adequate research into the meaning that that heritage has for its users.

The duality of heritage

To summarise, therefore, heritage can be conceptualised as a duality: a resource of economic and cultural capital that is simultaneously multi-sold in many segmented marketplaces. The duality of heritage is less a dialectic than a continuous tension, these broad domains generally being in conflict with each other. New Zealand provides one salient example. Here, the Maoris, who offered an instant tradition, were positioned as 'honorary whites' with a rich mythology, an epic story and a tradition of being great warriors (Phillips, 2005). This is not to deny that race was an important element of New Zealand's evolving national identity in the late nineteenth and early twentieth centuries but only to assert that it was very difficult to exclude the Maoris from a definition of New Zealand identity in which New Zealanders were 'the empire's finest sons, who could compensate for the decadence ... [of] Britain's cities' (Phillips, 2005: 166).

The ensuing policy of biculturalism – Maori and Pakeha (New Zealanders of white colonial descent) – embodied in the Te Papa museum in Wellington does, however, illustrate something of the tensions induced by even this progressive illustration of race and heritage. Williams (2005: 94) believes that there is a rigid segmentation of the two ethnicities that disallows the notion of making the encounter

'work'. Maori and Pakeha are treated as 'non-intersecting cultural total-ities' that represent an artificial biculturalism. But, simultaneously, Dyson observes the pressure on museums such as Te Papa to be commercially viable and populist in presenting a version of the nation that is commensurate for consumption as a globalised consumer product. He writes: 'Kiwiness is partnered with a homogenised, neo-primitive "Maoriness" to produce a back-projection of the nation's history, which skips the colonial phase in order to produce a version of the nation fit for the neo-liberal global economy' (Dyson, 2005: 128–9).

So Te Papa both represents the collective imaginary of the legitimating myth of New Zealand biculturalism, and is also a national institution geared to consumerist culture. The two heritage domains are linked by their shared dependence on the conservation of past artefacts and the meanings with which these are endowed; it is the latter which generally constitute the broad arena of contestation. The cultural commodification of heritage embraces state-sponsored allegories of identity expressed through an iconography that is congruent with processes of legitimation of structures of power. It also invokes, however, more localised renditions of identity which, in their appeal to the popular and resistance to the centre, may be subversive of state hege-mony. Thus, whatever their form, tension and conflict are inherent qualities of heritage.

MULTIPLE NATURE OF HERITAGE

The pluralities

It follows, therefore, that pasts, heritages and identities should be considered as plurals. Not only does heritage have multiple (and simul-taneous) uses but also the growing cultural and social diversity and frag-mentation of societies raise issues as to how this heterogeneity should be reflected in heritage selection, interpretation and management. Thus many pasts become transformed through many heritages into many iden-tities, only some of which are associated with place, which may support, coexist with or conflict with each other. Historians may point out that this social diversity is by no means unique to our age but is a permanent condition of humanity, albeit one suppressed in ethno-nationalist constructs of belonging. This may well be so, in which case the contem-porary novelty lies in the awareness of a previously unappreciated condi-tion and the political desire to act upon it. It is an inescapable condition

that heritage as a practice and knowledge in an age of diaspora and transnational networks is concerned with both the boundedness and continuity and also the hybrid fluidity of cultures.

Given that point, the dearth of discussion on the linkages between heritage, pluralism and multiculturalism is in itself indicative of the point that heritage as an identity resource has largely been conceptualised in national terms as traditionally conceived. Graham *et al.* (2000: 183–4) stress that heritage functions as a cultural and economic resource at a series of levels – local, national, supranational (as in Europeanness) and global – but that 'the dominance of the national [remains] so pervasive that it is difficult to imagine heritage without ...the symbiotic relationship between national heritage and nation-states.' Pendlebury *et al.* (2004) do observe that heritage is supposed to have values that transcend the nation, and Deacon, for example, discusses how Robben Island became a World Heritage Site because it is a symbol of the 'the triumph of the human spirit over adversity' (2004: 309). She observes, nevertheless, that such universal/global inscription on the 'basis of symbolic association alone has been limited' (310), one other obvious example being Auschwitz-Birkenau, inscribed as a World Heritage Site in 1979 on the grounds of its symbolic importance as a place of outstanding universal significance

Generally, however, the debate on the enduring importance of representing the nation is foregrounded in the museum literature (Boswell and Evans, 1999). There are definite signs of academic 'parallel tracks' and a lack of empathy with cognate disciplines in McLean's rather bizarre claim that there is little discussion of 'identity negotiation and construction in heritage', especially given that heritage has 'an identity conferring status' (McLean, 2006: 3). Elsewhere, however, she makes the point that 'museums authenticate and present identities through the presentation of heritage' and that in the twenty-first century – as encapsulated in the example of New Zealand's Te Papa – narrating the nation becomes a case of narrating its complexity and the politics of recognition in a multicultural age in which 'the identity of the nation becomes increasingly fluid and contingent' (McLean, 2005: 1). Traditionally, museums were capable of articulating two temporal narratives: one, a distinct national trajectory, the other the nation as final triumphant stage of successive progression (Macdonald, 2003). Crooke, for example, demonstrates how the National Museum of Ireland incorporated, in its evaluation and care (curatorship) of Irish archaeology, a certain vision of the Irish nation that foreshortened the distance between a past 'ancient nation' and the present: 'the Early

Christian Period (early medieval) became inspiration for the new Ireland' (Crooke, 2000: 151).

Thus museum management and other public authorities and agencies are ascribing instrumental roles to heritage planning and management which are being expressed through official policies. These include: global profiling and marketing, assertion and enhancement of distinctive local identities, the propagation and implementation of notions of multiculturalism, and the furtherance of social cohesion and inclusiveness. Heritage is thus burdened with many and increasing public roles and expectations. A major difficulty in satisfying any of these multiple expectations is that heritage producers themselves are markedly diverse and may be indifferent to, or just unaware of, these wider expectations. Unlike many commercial commodities, the assembly of the heritage product is not managed by a single organisation nor even controlled by a consistent purpose. On the contrary, each stage of the production process is usually managed by quite different organisations for quite different motives. The identification, preservation and maintenance of the resources; the assembling, packaging, interpreting and promoting of the product; and the managing of its consumption, are all generally conducted by separate bodies with their own working methods, expertise, ethos and objectives. The individual's experiences of heritage are also plural. It is consumed for diverse purposes (often in combination) and may be intended to bestow feelings of enjoyment, distraction, enlightenment, identification, security, solidarity and many more emotions. Heritage can also be consumed, as mentioned above, to achieve collective or individual goals which may or may not have been the goal of the heritage producers. Also individuals have always been capable of identifying with different spatial jurisdictional or imaginable scales. Finally in this list of plurals, there is the communication of heritage which occurs through a multiplicity of channels of communication.

The limits of heritage

If heritage is a principal instrument for the pursuit of public policy in culturally pluralist societies, it is necessary to add some cautionary caveats. First, the influence of public heritage policy is reduced by the very multiplicity of official agencies operating in this field and the absence of coherence or consistency in the messages they attempt to project. Second, many public heritage producers and promoters underestimate or simply fail to consider (let alone understand) the reactions of their targeted consumers. Most public heritage is not noticed except in

the sense that it is consciously or even subliminally ignored. Even if it is experienced, it is highly unlikely that such heritage will be understood in the ways its producers intended. Most European cities, for instance, 'were plurally encoded by socially pluralist societies and are now also decoded pluralistically' (Ashworth, 1998: 269). Much of the iconography is not decoded at all, less because it is unintelligible than because of its irrelevance to contemporary plural societies. Such data as does exist suggests that consumers have conscious or unconscious strategies of resistance to the messages intentionally conveyed by public heritage. The evidence for officially created diverse and hybrid representations of heritage is less than convincing, one reason why official narratives are often subverted by unofficial spectacles, parades and the like that promote the heritage stories of marginalised groups. Thus consumers change and adapt public heritage to conform to their much more significant private heritages, even to the extent of creating a counter-culture supported by a counter-heritage.

In pursuing this idea that there are inherent limits to heritage in plural societies, Newman and McLean (2004) make the rather insular claim that much of the rhetoric on heritage and social inclusion focuses on the United Kingdom. It does, however, provide an apposite example. Hence, Pendlebury *et al.* argue that English Heritage's policy document, *The Power of Place* (2000a), relates an interpretation of multiculturalism to a British paradigm of pluralism in which cultural diversity is concerned with 'equality and valuing different cultural experiences, whether they are due to ethnic identities, social or economic situations' (Pendlebury *et al.*, 2004: 15). Littler sees the key question for Britain as being: 'what are the possibilities for radical heritage agendas that can imagine decentred, hybrid and culturally diverse narratives of British history and identity?' (Littler, 2005: 1). While she inherently limits the scope of this query by couching the question largely in terms of race, racialisation and masculinity, by assuming that 'radical' has a self-evident meaning, and also by conflating England with Britain, Littler still makes several points regarding policies for plural heritages. As she argues, and we develop in depth later, such policies can be articulated in a number of ways. One possibility is for an entrenched state to see its past and present as multicultural but simultaneously seal off many of the routes for continued immigration and asylum. Again, pluralist, inclusive heritage policies can have a range of ends, not all of them progressive, especially as such policies can be used to essentialise cultural difference by exoticising

'other' cultures or homogenising and sentimentalising 'local' cultures. The language of inclusion can easily imply assimilation to a pre-existing set of national norms rather than the acceptance of a genuine diversity (as we exemplify at length later). Littler and Naidoo (2004) note that while the British present is envisaged as being multicultural, the British past and heritage is still imagined as being 'white'. Hence, the language of inclusion can imply assimilation to a pre-existing set of national norms rather than a genuine diversity.

Hall (2005) takes this further, although his arguments are certainly less than precise as to the definition of heritage. He identifies at least two challenges to which British national heritage – 'The Heritage' – has to respond. The first is a democratisation process that has stopped short at what he terms the frontier defined by the great unspoken British value of whiteness. The second is concerned, more broadly, with the rising cultural relativism which is part of the de-centring of Western and Western-oriented or Eurocentric grand narratives. Crucially, he then links the British focus to five wider changes in global intellectual culture which have powerful resonances through the remainder of this book. These are:

- a radical awareness by the marginalised of the symbolic power involved in the act of representation; as Naidoo (2005) contends, to acknowledge that traditions are invented does not make them necessarily null and void
- the growing sense of the centrality in politics and society of culture and its relation to identity
- the rise of a politics of recognition or consciousness among the excluded to set beside the older politics of equality
- a growing reflexivity about the constructed and therefore contestable nature of the authority of those who 'write the culture'
- finally, a decline in the acceptance of traditional authorities and the concomitant demand to write one's own story which translates into the decolonisation of the mind.

In sum, Hall (2005: 31) envisages these five sets of changes as constituting a general relativisation of 'truth' as 'truth-as-interpretation' in 'the palimpsest of the postcolonial world'. He identifies four themes to any agenda that might deal with this, although all these points assume the compliance of the relevant minority communities which might very well not be the case:

- Mainstream versions of 'The Heritage' could revise their own self-conceptions and rewrite the margins into the centre, the outside into the inside.
- There could be an escalating profile of creative activity from minority communities in all the arts.
- The record of migrant experiences themselves could be called upon.
- There could be a rewriting of the 'traditions of origin' which are often deployed to represent minority communities as immured in their ethnicity or 'racialised difference' (exoticism) (Hall, 2005: 33).

Hall's argument encapsulates something of the burden carried by the fragile, divided and inchoate concept of heritage. Certainly, plural and multicultural heritage by definition has to go beyond the national. But it must also incorporate that scale as well as the local and the supranational. In redressing the imbalances of the mainstream heritage vis-à-vis the exclusion of minority communities from it, there is an implicit privileging of the racial axis of differentiation at the expense of all others. This resonates with Kathryne Mitchell's comment (2004: 648) that we rarely address the question as to what immigrants are 'being assimilated *into*'. Hall's five changes in global intellectual culture and his four themes could be read in other ways. For example, they might apply in precisely the same terms to reactionary representations of identity and the multiplicity of marginalised and often racist groups excluded from the mainstream. The value of this agenda lies, however, in its recognition that pluralism and multiculturalism within the heritage domain is, paraphrasing Mitchell (2004), about the active achievement as well as recognition of diversity. Our concerns in Part III of the book are with the heritage policies and management strategies that might translate these issues into the everyday realities of the material world.

TOWARDS PLURALISING PASTS?

On 9 January 2006, 'Culture on line', a part of the UK government's Department of Culture, Media and Sport (DCMS) launched the ICONS programme, announcing the 'first twelve official icons of England'. Subsequently, this has been supplemented by a website (www.icons.org.uk). This relatively unremarked event in a single country illustrates aptly the contemporary social and political contexts within which heritages are being created and promoted in

the modern world. It raises and exemplifies many of our concerns, as expressed above, about the variety of officially endorsed roles that heritage is expected to play, the numerous social, spatial and even economic dimensions determining the selection of the content of such heritage, and the nature and intent of the agencies assuming the responsibility for these tasks.

One reaction to the announcement must be surprise that the enterprise had even been attempted. Although of course countries and their ruling dynasties and elites have always had their emblematic trappings of flags and anthems and symbolic legitimating rites, the notion of a national government ministry concerning itself with surveying the entire past cultural output and behavioural traits and preferences of a country would have been greeted with disbelief, if not ridicule, not long ago. Indeed even the existence of government ministry with such responsibilities and preoccupations, now commonplace in most countries, is a recent innovation.

The question, 'Why official icons?' touches again on the discussion, raised above, as to whether or not an identification of people with their pasts is an individual or a collective process: whether the collective identity is merely the aggregate of the individual, or is an additional dimension imposed from above for some collective purpose. Here there is clearly a 'nationalisation of the past', with a government ministry taking the lead about the symbols with which people do, or should, identify. In fairness to the initiating body, and perhaps as a reflection of the increasing awareness of the pluralisation and even individualisation of society, it has been made clear that this is only the beginning of a consultation exercise, with individuals and representative organisations being invited to submit more, or possibly even alternative, suggestions.

The level in the spatial scale hierarchy of jurisdictions can also be questioned. The choice of England rather than Britain or the United Kingdom is presumably related to devolution in the UK, which in this respect is viewed as a multinational state in which Wales, Scotland and Northern Ireland will have their own icons. The stress on the national scale, however, rather than the local, regional, European or global, is assumed to be self-evident in that, 'our response to icons has shaped our understanding of personal and national identity' (DCMS, 2006: no page reference). The national scale is assumed to encompass the regional or local scales upon which it is superimposed.

The twelve items originally selected for iconisation (since added to) illustrate the compromises along the many dimensions of heritage described above that are needed to answer the question: 'What constitutes heritage?' There are historic buildings and personalities but also

modern objects and structures: there are tangible items but also intangible ones. The accepted artistic cultural canon is represented alongside popular folk custom and tradition. Variety and something for everyone seems a dominant criterion. As a government minister put it: 'No-one can fail to respond to some of the icons that feature in the project.' The more conventional idea of public heritage and publicly endorsed culture is represented by: a megalithic monument (Stonehenge); two books (*Alice in Wonderland* and *The King James Bible*); a painting (Holbein's portrait of Henry VIII); and a song (Blake/Parry's 'Jerusalem'). Popular culture is expressed through: a modern statue ('The Angel of the North' at Gateshead); a sports trophy (the FA cup); a traditional entertainment for children ('Punch and Judy'); and a cup of tea. There are three design items: the 'Routemaster' double-decker bus; the Spitfire fighter plane; and the passenger ship, SS *Empire Windrush*.

In terms of our concern with pluralism, the regional dimension is to an extent represented by the 'Angel', which visually marks the gateway to 'the north', and the Routemaster bus, until recently a defining symbol of the London streetscape. The ethnic minorities are represented by the *Empire Windrush*, the ship that brought the first large-scale immigration from the West Indies in 1948. However, the focus remains firmly national and essentially uni-cultural in the sense that it is expected that everyone can identify with something if not everything.

Finally the exercise implicitly and explicitly suggests answers to the fundamental question: 'What is the purpose of heritage and, specifically, why do governments attempt to create it?' A number of unconvincing justifications for the programme are vaguely suggested but not pursued. These include a, no doubt commendable, educational goal to create 'an on-line collection' as an 'educational resource', and a more doubtful aspiration that as the 'icons are powerful and really switch people on', they will 'draw new audiences to sporting events, museums and galleries'. These justifications, however, are only secondary to the simple idea that, 'icons will identify what makes England what it is'. This may be more than just the reinforcing of nationalism with a popular national identification, an idea that is prevalent throughout subsequent chapters. There is also the idea that, 'icons are important to us because they evoke thoughts and emotions about how we feel about ourselves and our place in society' (DCMS, 2006: no page reference). Transformed into policy it may be that governments have a vested interest in promoting a heritage that reassures and reconciles rather than disturbs and divides. Heritage is being used here to sooth away our individual and collective stresses, leaving only

contented well-balanced people in an all-inclusive harmonious society, at ease with its promoted past and predicted future.

Behind these and other such bland and seemingly quite innocent uses of heritage for cultural inclusion and social stability may lie a number of quite misleading and possibly even pernicious assumptions. As we have suggested above, the past, and the heritage we have made of it, is not inevitably so all-inclusive or so harmonious. Icons can make us, or others, feel uncomfortable. The religious meaning of the icon is a window on the divine, drawing the individual soul to a god, through a highly stylised representation of an unchanging spiritual truth communicated by a formalised art work. Using icons as pedagogic instruments of transitory public policy in this way seems a contradiction of their essentially individual and timeless purpose.

The use of the word may, however, merely be a misnomer, and public heritage now exists in an age of celebrity. Society needs such symbols for a variety of purposes as witness the competitive-listing television programmes to nominate the 'most famous Briton/novel/painting/poem etc of all time' (a formula initiated by the BBC but now imitated in a number of other countries). It is in such curious contexts that our investigation into the roles of heritage in plural societies is embedded.

4 PLACE, IDENTITY AND HERITAGE

There is an underlying assumption that 'imagined communities', as Anderson (1991) famously described the nation, need 'imagined places' in which to be located. Specific place identities are therefore created in order to legitimate the claim by a group upon defined physical spaces, whether, it should be added, they currently physically occupy such spaces or not. The relationship between these two products of human imagination, communities and places, is reciprocal. The group is seen as being formed by the place ('we are what we are because we come from here') while the place becomes special through its association with the group ('here is where we were formed and thus belong'). Space is transformed into place through traditions, memories, myths and narratives and its uniqueness confirmed and legitimated in terms of their relationship to particular representations of the past. Landscapes and cityscapes, which in turn may become ethnoscapes and stage-sets for spectacle, parade and performance, embody an official public memory marked by morphology, monuments, statuary and nomenclature (Ashworth and Graham, 2005).

This chapter explores the enduring importance of place identity as it relates to the interconnection of heritage and plurality, our assumption being that the relationships between heritage, identity and place are mediated through a complex series of overlapping imaginings (and non-imaginings) of place that, quite inevitably, create conflicts of allegiance. Places, like heritage, are socially constructed; as Cresswell (1996: 60) remarks: 'the meaning of a place is the subject of particular discourses of power.' At root, the creation of national heritage in support of the concept of the nation-state led to a nationalisation of the past and to an official national culture and heritage. Place identity can thus become a means of resistance, most obviously in the oppositions of regionalism to nationalism and of minority groups to hegemonic representations of ethnonationalism. Moreover, the national is also being challenged from above by globalisation,

and heritage is implicated in the ideas of overarching representations of belonging and consensus, universal values expressed through concepts such as Europeanness and world heritage.

In pursuing the relationships between place identity and heritage, we first explore the debate on the boundedness or otherwise of identity and its expression as nationalism. It is then argued that place identity does matter, not least because of the enduring importance of territoriality and identity politics, but also through the ways in which representations of landscape are critical elements in the cultural and economic commodification of heritage and, as will be seen, a potent source of dissonance in plural societies. Third, in considering the functions of heritage in such societies, it is important to understand something of the creation and management of place identities. We summarise the interconnectedness of place identity and heritage through a brief consideration of one particular national policy, the Dutch 'Belvedere' programme.

THE BOUNDEDNESS OF IDENTITY

We can begin with the now well-worn (and critiqued) arguments of writers such as Giddens (1990, 1991) and Bhabha (1994) who argue that identities are becoming 'disembedded' from bounded localities and the traditional frameworks of nation, ethnicity, class and kinship. At the core of such ideas lies the key assertion that the global networks have diminished the importance of place and traditions, ruptured boundaries and created hybrid, in-between spaces. This all now seems something of an exaggeration and can perhaps even be construed as an apology for globalised capitalism. As Duncan and Duncan (2004: 638) remark, the question of continuity over space and how it is achieved 'despite the inherent unboundedness and historical dynamism of cultures' is a key issue in understanding the coherence of those cultures. For Mitchell (1993), hybridity may counter and complicate nationalist ideologies but it also gives sustenance to capitalist ideologies while hybridity can also be criticised as a 'catch-all category which ... ignores the specificity and irreducibility of different experiences of marginalisation' (Papoulias, 2004: 56). Again, Gilroy's conceptualisation of diasporic consciousness as a sub-national and transnational non-territorial identity can be critiqued for unquestioningly regarding geographies of fluidity as being progressive and claims of rootedness as regressive (Nash, 2004).

It is, to an extent, a question of balance. As Atkinson (2007) argues, the influence of Halbwachs (1992) and Nora (1996–98) means that accounts of memory, for example, do tend to focus on fixed, bounded places and sites of memory (as recognised in Nora's self-evident and now hackneyed term, *lieux de mémoire*). Such locations have memories ascribed to them, and consequently space, place and landscape are implicated in the business of memorialisation and commemoration. But, Atkinson argues, an excessive focus on bounded sites of memory risks fetishising place and space too much and obscures the wider production of social memory throughout society. Dynamic, shifting memory is continuously productive rather then merely confined within demarcated sites. The city, for example, is a typography of memories with, as Landzelius (2003) observes, multiple pasts and a continual remaking of memorial sites.

We argue that place identity remains important but in this latter more dynamic and complex sense that meshes macro-changes in a globalising world with the national and the local. Thus Anderson (1995) and Bauman (2004) point to the deterritorialisation of economic activity and the seemingly paradoxical reterritorialisation of the nation-state, which represents not the homogenisation but a polarisation of the human condition. Globalisation is best thought of as 'glocalisation', the reassertion of place in the midst of time-space compression. Castells (1998: 357) admits to the re-emergence of local and regional government as being better placed to 'adapt to the endless variation of global flows', but this also points to heritage as being a knowledge that is rooted in place and region. Its narratives may communicate the local to the global network, for example through the representations of international tourism and marketing imagery, but critically, they are often far more intensely consumed as internalised, localised mnemonic structures. Bauman (2004) warns, however, that being merely local in a globalised world is inevitably a secondary existence because the means for giving meaning to existence have been placed out of reach (Clarke and Doel, 2004). In sum, therefore, the rise of the network society does not necessarily lead to the demise of place as a-spatial communities long predated it; rather it points to the idea of multiple layerings of identity and place with potentially conflicting supranational, national, regional and local expressions, in turn fractured by other manifestations of sameness – religion, language, high culture – that are not necessarily defined in terms of those same spatial divisions.

There is, however, another dimension to this, which is that the enduring importance of place and identity arguably continues to privilege the national at the expense of other scales. Amin (2004) may argue for an

equal and empowered multiple public with no myth of origin or destination but identified only by its commitment to a plural demos, but 'it is the nation which ultimately and inevitably returns as the backdrop to the liberal fantasy' (Mitchell, 2004: 648) and 'remains a potent rallying cry in Europe' (Peckham, 2003: 2) and worldwide. Indeed, for Canada, the plural demos has become nothing less than the foundation of contemporary national identity. In what is still the only developed consideration of the relationship between heritage and scale, it is argued that:

> the meso-level [scale] of the nation has long been dominant in the history of the creation of heritage awareness and of its political uses. Indeed nationalism and national heritage developed synchronously in nineteenth-century Europe. The nation-state required national heritage to consolidate national identification, absorb or neutralize potentially competing heritages of social-cultural groups or regions, combat the claims of other nations upon its territory or people, while furthering claims upon nationals in territories elsewhere. Small wonder then that the fostering of national heritage has long been a major responsibility of governments, while the provision of many aspects of heritage has become a near-monopoly of national governments in most countries. The dominance of the national is now so all-pervasive that it is difficult to imagine heritage without national museums, archives and theatres; without national monuments, historical narratives, heroes and villains; without national ministries, agencies, laws, policies and financial subsidies.
>
> (Graham *et al.*, 2000: 183)

This supremacy of the national compromises and constrains the effectiveness of all other forms of representing heritage, place and identity. The movement towards European economic and political integration and then the creation of the European Community/Union, requires, as the use of the word 'community' suggests, the legitimation of a specifically European heritage (Ashworth and Larkham, 1994; Ashworth and Graham, 1997). Risse (2003), for example, sees three different ways of doing this:

- In a zero-sum model, Europeanness replaces national and other territorially defined identities. This, however, runs counter to the powerful imagined community of the nation-state and its correlation with sovereignty and statehood.

- In a 'layer-cake model' of multiple identities, the social context of an exchange or interaction determines the particular identity invoked.
- In a 'marble-cake model', people hold multiple identities which are invoked in a context-dependent way but are 'enmeshed and flow into each other in complex, reciprocal ways' (Risse, 2003: 77).

The underlying difficulty, however, as Risse admits, is that Europeanness is differently configured and differently interpreted in different national contexts and that, while the 'marble-cake model' may be held to reflect a progressive multiculturalism, there is ample evidence of European governments and electorates opting for an often conflictual 'layer-cake' approach.

An acknowledgement of the enduring importance of the national is less a fetishising of place than a recognition of the long-standing conservative opposition to state-sponsored multiculturalism and its support for 'nationalist enframing' (Mitchell, 2004: 647), together with its resonances of the *pays* but more particularly of *heimat and* even *lebensraum*. There is also one further contradiction to this question of the boundedness of identity. As seen in Chapter 2, where we discussed Kymlicka's (2003: 160) point that 'the preference for global over local forms' of what he terms interculturalism 'is quite explicit in many countries', the contestation of heritage in plural and multicultural societies is much more likely to be focused at the national and local scale than at the global and supranational scales where a tokenistic observation and approval of multiculturalism is divorced from institutional structures of governance that remain fixed in territorially bounded place. Identity may be socially and geographically diverse rather than neatly bundled, but the interplay of jurisdiction remains focused at the national level, as does the recognition that there are legal limits to the acknowledgement of plurality and redress for the inequalities which it creates. Nationalism still functions to structure heterogeneity into simplifying representations of sameness and meshes with two other powerful indicators of the enduring importance of place identity, namely territoriality and landscape.

TERRITORIALITY AND LANDSCAPE: DOES PLACE IDENTITY MATTER?

Territoriality

Duncan and Duncan (2004) cite Eagleton's (2000) use of the term, 'cultural wars' to define those conflicts that depend on culturalist

explanations and justifications and are marked by 'ethnic cleansing' in which 'ethnic groups claim essentialised or allegedly primordial cultures that are linked to territory' (Duncan and Duncan, 2004: 392). The obvious examples include the former Yugoslavia and its disintegration into a series of national and ethnic states (Glenny, 1999), Israel and Palestine, and Northern Ireland. Taking the latter as a typical case, Graham and Nash (2006) argue that while the 1998 Peace Agreement addresses the political geography of Northern Ireland in terms of state jurisdiction, it fails to take account of the territoriality embedded in Northern Ireland politics and society, or the ways in which identities remain firmly vested in what are very often local places defined by class and ethnicity.

This social construction of scale by the actions of groups and individuals has been explored by Flint (2004) through the terminology of 'spaces of hate'. Drawing upon Sack (1986), he observes the continuing importance of territoriality for 'hate groups', which delimit and assert control over geographical areas and support ideas of enclosed or sealed places. Thus border construction and maintenance is important to this pursuit of territorially defined politics, remaining 'a feature of politics within places rather than the preserve of international affairs' (Flint, 2004: 8). Gallaher's comment (2004) regarding the US Militia Movement that the 'last line of defence' is at the local scale has also distinct resonances with territoriality in Northern Ireland which is concerned as much with internal control of ethnic territories as with their bounded delineation. As Paasi (2003) observes, identities and differences are actualised in many ways on several spatial scales. Thus, localised identities, especially when configured through ideas of race, gender, religious or class difference, 'are among the most dynamic bases for both progressive political mobilisation and reactionary, exclusive politics' (Paasi, 2003: 476). Northern Ireland does indeed provide an apposite illustration of this argument. Here, the classical tensions between ideals of equality and claims to difference, and between individual liberty and collective rights are inflected by conflicting ethno-national perspectives on the meaning of the good, the just and the right (Graham and Nash, 2006). Identity remains vested in traditional principles of ethno-nationalism that locate cultural belonging and citizenship in a 'living space' defined by clearly demarcated boundaries and zero-sum models of space and place. Senses of belonging correspond to a geography of territoriality that is both the basis of the most essentialised group identities and the potent focus of national mobilisation (Yiftachel, 2002).

In general terms, territoriality is put into practice through four mechanisms that combine a mixture of consent and coercion (Graham, 1998; Agnew, 2002):

- a popular acceptance of zero-sum classifications of space that support hegemonic control over space
- the integration of past and present into narratives that create a sense of place and identity and underpin the legitimacy of political ideologies
- territorial markers and boundaries which act both as symbols of internal cohesion and external warning
- an enforcement of control over space by surveillance and policing which, in the context of Northern Ireland, includes the activities of paramilitary organisations.

Territoriality works at a variety of scales and policies from the workplace and home to the world as a whole (Sack, 1986). Nationalist/ republican and unionist/loyalist relationships to place in Northern Ireland are often read simply in terms of respective narratives of native dispossession and settler mission to civilise and stay in the face of resistance. While these narratives may shape attitudes to the meaning of place, the micro-geographies of segregation and struggles for territorial control are between communities that are themselves differentiated by class, lifestyle and gender, and by the internal fragmentation of their respective ideologies. This demonstration of the enduring power of place-centred identities – and the ways in which people continue to locate themselves in clearly demarcated territories – is marked by an iconography that portrays a resistance to hybridisation. Socially excluded groups self-define their material worlds through micro-scale versions of the zero-sum trap of the ethnic nation-state and the further snare, in Glover's (1999) terms, of the vendetta from which the only escape is an awareness of how the stories on both sides were constructed in the first instance.

Landscape

Landscapes have long been regarded less as places shaped by lived experience than as largely symbolic entities. Not only are they shaped by cultural practices but they are also symbolic of cultural and social beliefs (Crang, 2001). Thus landscapes can be interpreted as texts that interact with social, economic and political institutions and can be regarded as signifying practices 'that are read, not passively, but, as it were, rewritten as they are read'

(Barnes and Duncan, 1992: 5). Similarly, the heritage complex of the European city has been likened to a text that can be read in different ways, even though it may be difficult to determine which identities are being shaped by which communications (Ashworth, 1998). Nevertheless:

> A symbolic or iconographic approach to landscape recognises explicitly that there is a politics to representation. Landscape representations are situated: the view comes from somewhere, and both the organisation of landscapes on the ground, and in their representations, are and have been often tied to particular relationships of power between people.
>
> (Seymour, 2000: 194)

To Duncan (1990: 17), landscape is 'as an ordered assemblage of objects, a text [which] acts as a signifying system through which a social system is communicated, reproduced, experienced and explored'. Perhaps the most developed exemplar of this approach is Cosgrove's study (1993) of the fifteenth and sixteenth-century Venetian Republic and the construction of its Palladian landscape by a dominant urban merchant class. He argues that the visual scene and its various representations are regarded as key elements in the complex individual and social processes whereby people continuously transform the natural world into cultural realms of meaning and lived experience. These realms are historically, socially and geographically specific, as is our reading of them, separated by time, space and language from their origins. Cultural landscapes, therefore, are 'signifiers of the culture of those who have made them' (Cosgrove, 1993: 8) and, in urban cultures, powerful groups will attempt to determine the limits of meaning for everyone else by universalising their own cultural truths through traditions, texts, monuments, pictures and landscapes.

Other commentators see landscape somewhat differently as a polyvocal text, rewritten as it is read or viewed. But whichever the perspective, it is more than a straightforward hegemonic relationship of some form. For Daniels (1993), landscape is a highly complex discourse in which a whole range of economic, political, social and cultural issues is encoded and negotiated. This works along two separate dimensions. First, we have a complexity of images and a polyvisuality of interpretation that reflects an array of social differences, landscape interconnecting with the constantly mutating markers of identity. Second, a single landscape can be viewed simultaneously in a variety of ways, emphasising how hegemonic interpretations are always open to subversion. Thus Cosgrove's analysis of

landscape as power has been criticised as unduly narrow, not least because it fails to address issues such as gender, sexuality and 'race' (Rose, 1993; Seymour, 2000).

In the specific sense of plural heritages, we have found it useful to follow Don Mitchell's argument (2003) that landscape is:

> a concretization and marker of memory ... more than a way of seeing, more than a representation, more than ideology – though it is very deeply all of these. It [is] a substantive, material reality, a place lived, a world produced and transformed, a commingling of nature and society that is struggled over and in.
>
> (Mitchell, 2003: 790)

As in the US 'Deep South' where commemoration meshes public memory of the Civil War, Civil Rights and unequal power (for example, Alderman, 2000; Dwyer, 2000), practices and sites of commemoration are embedded in cultural landscapes, which thus become arenas of contested meanings. In her anatomy of memory, politics and place in the new Berlin, Till (2005: 9) writes of 'ghosts', of places of memory being 'created ... to give a shape to felt absences, fears and desires that haunt contemporary society' and through which 'contemporary dreams of national futures are imagined' (193). Till also points to the dichotomy that characterises all memorialisation, that between the 'evoked ghosts' and the ways in which places of memory 'are made today to forget' (2005: 9). This fails, however, to capture the sense of the past being a hard-edged political resource, its contestation reflecting the unequal capacities of political groupings to exploit it to their own advantage and to the discomfiting of opponents. Kong (1993: 24) argues that landscapes of memory are important identity resources for political ideologies 'in that they can be used to legitimise and/or challenge social and political control'. As such, landscapes function as significant sources for unravelling present geographies of contested political and cultural identities (Whelan, 2003).

Does place identity matter in pluralising societies?

In this lived and contested world, the existence of a strong place identity is often assumed to be in the interests of both the individual and the group. Such identities are created and managed, either as official

expressions of social cohesion while recognising diversity, or as unofficial acts of resistance towards a hegemonic core.

While 'liberal multiculturalism acknowledges that neither a neutral nor a monocultural public space is the aim of policy' (Loobuyck, 2005: 112), the idea that space and place can be neutral is in itself a fallacy. All constructs of space and place, even those that pretend to 'neutrality', carry an ideological intent. Above all, notions of plurality and multiculturalism implicitly inherit a tradition of 'us' and 'them', of the 'nation' and foreign-ness. Plurality can subvert what is seen as the national, therefore raising the issue of defining limits to multiculturalism 'by arresting the ever proliferating flow of differences that cultural plurality potentially produces' (Lewis and Neal, 2005: 431). The enduring importance of a national identity constructed around core values that are deemed to be emblematic of a society and its peoples means that place identity still matters. Again, the resistances to national identities are themselves locked into constructs of territoriality as well as identity definition through repre-sentations of landscape and place. Identities may still transcend place but politics remain intensely territorial, as does citizenship.

THE CREATION AND MANAGEMENT OF PLACE IDENTITY: THE BELVEDERE PROGRAMME

If an interest in 'sense of place' is as old as the study of geography itself, what is nonetheless new is the increasing interest of official government agencies at various levels in this very idea. Quite inevitably, this further increases the potential for contestation between such official representa-tions and unofficial narratives of place, often shaped as a conscious act of resistance against the state. Moreover, the institutionalisation of 'sense of place' through heritage policies may also enhance the degree of dissonance that can exist between communal and individual perspec-tives on place and time. One such example concerns the national inter-ministry, long-term Dutch government policy programme known as 'Belvedere', which was initiated in 1999. This political strategy to link cultural history and spatial planning is more comprehensive and better financed than most other national heritage programmes, and thus poses much more widely applicable questions that stem directly from this book's concern with heritage, place and identity in plural societies (Kuipers and Ashworth, 2001).

The objectives of the Belvedere programme (2000) are to locate, label and map all those landscape regions and cities in the Netherlands which are perceived as having a clear, distinctive character and which, therefore, can contribute to the creation or enhancement of a local identity. This raises the immediate practical question of recognition. What is this local identity that is being sought and how can it be recognised? It should be stressed that there is no explicit mention in the policy documentation of any national stereotype of landscape or cityscape whose local manifestation is to be sought. It is assumed that the country is a palimpsest of localities which are defined by some common collective identity as a concept similar to that of collective memory. But collective identity poses the same question as does collective memory: is this an aggregate summation of a myriad of individual identities or something quite separate and plausibly different? In addition, in the Netherlands, the underlying assumption of the Belvedere programme is that a coherent national identity is shaped from the myriad local ones. This contrasts with unagreed societies where, as for example in Northern Ireland, the same palimpsest has no sense of commonality. Thus the Netherlands seems to suggest a 'Russian doll model' of comfortably nesting identities, ranging in size from the single individual to the largest collectivity applicable, whereas Northern Ireland suggests that models of conflict are more relevant.

In practical terms, the Belvedere programme depends very largely on local government agencies responding locally to the stimulation and opportunities offered by the national bodies. While heritage conservation is generally concerned with place as a collection of physical elements that can be physically or legally protected, it is much less clear how to safeguard a local community or, as in this case, a local identity created by such a community. Both communities and identities are in a process of constant change and are not static entities capable of being frozen at a particular moment in time. This points to several questions about the links between heritage and place. In many ways, the discussion of identity echoes the parallel discussion on heritage as the contemporary uses of the past. Heritage draws upon elements of history, memory and selective relict artefacts as resources to effect a self-conscious anchoring of the present in a selected time context. This dominance of the past, however, raises the twin dangers of creating an identity based upon social and cultural elements that are already obsolete and largely irrelevant to the daily way of life of most locals, while also possibly fossilising past or present patterns in a way that will inhibit future change.

In the context of the Belvedere programme, the motivation for what is a heavily subsidised government initiative is quite explicit, namely, the strengthening of local identities as a counterpoise to increasing economic and cultural globalisation which is seen as threatening to produce a homogenous universal 'placelessness' that is assumed to be undesirable. This places the programme squarely in the much wider debate about the impacts of globalisation–localisation. There is a search for a 'balance', here assumed to be the realisation of the economic gains of globalisation while compensating in the cultural sphere by a support for localisation or at least a mitigation of the losses anticipated locally. However, both sides of the balance can be questioned. Globalisation may instigate or accelerate change in senses of place, leading even to the much-feared death of locality but, equally, it may be only the substitution of one place identity for another at a different scale. The 'global village' remains local in one sense if not another. Similarly the attempt of national governments to support a sense of local identity may of course lead to a standardisation of what is conceived and planned to be local that is itself homogeneous. The local becomes global in its reproduction of the same 'local' features, while, conversely (as is often the case with urban conservation planning), the global may itself be a universalisation of what was originally local.

As with many areas of policy, including particularly those relating to the conservation of the natural and built environments, and perhaps also cultural policy more generally, the question of who is making decisions becomes intertwined with the decisions themselves. In this case, it may be as important to determine the identifier as that which is being identified, especially in the context of plural and multicultural societies with their inevitable resonances of 'insiders and outsiders'. In Belvedere, national policy is implemented locally and local initiatives and ideas are validated nationally. Potentially, however, this creates the absurd situation in which outsiders define the sense of place of insiders, who are informed what their recognisably distinct local identity might be. This circumstance would seem to defeat the initial purpose of the exercise. More subtly, however, there is the distinct possibility of an interaction between the two place identities, one projected for external consumption, the other intended for local internal use. Outsiders may seek out aspects of the local identity for various reasons, while insiders similarly adopt the externally projected images of themselves at the local scale. Place-product commodification and branding cannot be separated for a perfectly segmented market. In reality local insiders and non-local outsiders, official policies and local

reactions, diverge and converge in a continuous dialectic of the individual and the collective.

To date, about a third of the national land area and about two-thirds of all urban settlements in the Netherlands have been designated under Belvedere as suitable for long-term protection and enhancement for their value to local place identity. This raises the question of the identity of the remaining two-thirds of the country and one-third of towns. Have these by default been declared 'identity-poor' or even 'identity-less'? Do the inhabitants feel no sense of place or only that their place has an identity that is less easily recognisable or less valuable than somewhere else? The idea of the existence of an 'identity value surface', which, at least in theory if not in practice, could be mapped, points to some intriguing possibilities with applications in the geography of decision making. Such questions return the discussion to the differences between the official reliance upon the more universally recognised physical attributes of a region, and the intangibles that contribute most strongly to an individual's unofficial collectively unendorsed sense of place.

It cannot also be assumed that there is one single identifiable collective place identity. If any particular idea links all the subsequent case studies in this book, it is that society is diverse and these many diversities will result in equally diverse place identities. Like the sense of time transformed into heritage, the user creates place identity. Thus it can be argued that programmes such as Belvedere are quite fundamentally flawed. The identity being sought is a chimera and the process of the search is a serious denial of the social, ethnic and racial diversity of contemporary Dutch society. If there is one single lesson that this book can teach, it is that words such as 'identity', alongside 'heritage', must almost always be pluralised when used in public policy.

SYNTHESIS

There remains a key issue that is rarely posed explicitly in policy statements such as Belvedere, largely because the answer is assumed to be either self-evident or devoid of any useful meaning. Do people need to identify with places? Belvedere and similar policies are driven by the assumption that a distinctive, clear place identity is, if not a necessity, at least beneficial. Specifically, certain benefits, whether economic or psychic, emanate from the officially endorsed 'identity-rich' regions and are conferred upon their inhabitants and other users of such places.

Conversely 'identity-poor' areas have no such advantages, either in their economic or their cultural commodification.

This prompts two conclusions. First, it can be argued that these assumed benefits accrue to collectivities and contribute to collective attributes such as social cohesion or political allegiance, whereas the individual does not automatically receive any benefit. Second, it is dangerous to conflate identity with place identity. Far from being a universal basic human need, it can be argued that much social and even political identification may have no need of place. But, as demonstrated by the examples cited in Part III of this book, the creation of place identities from heritages remains simultaneously a fundamental psychic and economic necessity. That these processes and practices are sited within plural and multicultural societies means that the contestation of heritage is also an inescapable human condition.

PART II
A TYPOLOGY OF
PLURAL SOCIETIES

5 NATURE AND TYPES OF PLURAL SOCIETY

Moving on from the meanings and dimensions of heritage and of place identity discussed in Chapters 2 and 3, we return here to the issues arising from cultural pluralism (see Chapter 2) and, specifically, its relationship to official policies. Although it is difficult to encapsulate the variety of peoples and places in any set of simplified models, it is nevertheless necessary in applying these concerns to a range of global case studies to create a typology of policy reactions to social pluralism. This chapter sets out to construct a classification of contemporary practice in heritage in the context of the pluralisation of places and the societies that shape them.

As a prelude to the more detailed discussion of the typology in Part III, the central concern here lies in the assumed instrumental role of public heritage in pursuit of different policies within plural societies. We seek only to clarify what distinctly different options are currently evident for the management of plural societies and what roles heritage has, can or should play within such situations. It is self-evident that society is composed of individuals, that individuals are different, and thus that society must be plural. Heritage, however, is about common values, common purpose and common interests. Societies may be pluralising in the ways discussed in Part I but official heritage often remains stubbornly in the singular. The link between people and places adds a further dimension in that heritage is an important, perhaps the most important, instrument by which societies shape place identities. Thus plural societies should create and be reflected in, pluralised place identities: heterotopias in which social diversity, eclecticism, variety, ephemeralism and libertarianism are manifested and valued.

As was clear from the definitions of heritage in Chapter 3, the first question to be posed of all heritage creation and management is not: 'What have we got?' but: 'What do we want to do?' Goals determine content rather than vice versa. Heritage is not a fixed endowment imposing responsibilities or constraints on society. Society through its political institutions sets objectives,

desirable for whatever reason, to be attained through policies for heritage. Place and society interact, with distinctive places being simultaneously a goal to be attained, an instrument for the attainment of social goals, and a measure of progress towards these. The sequence: social goal – heritage policy – heritage place will now be followed in an investigation of a range of models of plural society as expressed in public policies. This list is not complete, exclusive or comprehensive, and the application in particular places is rarely clear-cut or static through time. Variants of more than one model can co-exist at the same time and place. The objective is not only to demonstrate that there are many quite different policy reactions to the pluralisation of society encapsulated in particular social models, but also to illustrate that heritage plays a critical but different role in each. Each policy model will be defined and described and an indication given of the ways in which heritage is, or could be, used as an instrument of its application. We identify five such sets of models (Figure 5.1):

- assimilatory, integrationist or single-core
- melting pot
- core+
- pillar
- salad bowl–rainbow–mosaic.

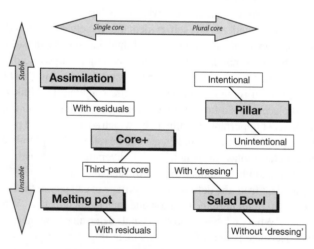

Figure 5.1 The models of policy in plural societies

ASSIMILATORY, INTEGRATIONIST OR SINGLE-CORE MODELS

In these models, society accepts the valid existence of only one set of common values, social norms and practices, and ethnic cultural characteristics as legitimately determining the place identity. Although, in modern Europe especially, racial characteristics could be quickly added to this list, it has not always been essential to the model. (French colonial policy would accept black *assimilés* or Portuguese policy *assimilados* as long as they were culturally French or Portuguese respectively.) Place identity is expressly strongly linked to social identity: the people belong to the place and the place to the people. Geographically and historically this has been probably the most widespread model. The principle of *cuius regio, eius religio* has been a deep-seated touchstone of attachment to the idea of insiders–outsiders, greatly exacerbated by the rise of nineteenth-century romantic nationalism with its concepts of the unity and integrity of a definable nation.

The extreme manifestation of this would be the absolute denial of the potential legal recognition of any pluralisation. Historically this has often been the case worldwide, the best hope of minority coexistence being 'quarters of tolerance', as in cities across Europe before and during the Middle Ages (Vance, 1977). It may remain the case in ethnically exclusivist societies such as Japan or Korea and, at worst, may result in the pogrom/*Endlösung*/ethnic cleansing scenarios of recent history, of which the heritage reflection is not pluralisation but denial and exclusion (Tunbridge and Ashworth, 1996). Such extremes, however, do remain exceptional cases.

Variants from the single core may be accepted as temporary phenomena in the process of assimilation. Some more permanent variations may be permitted only in so far as they are seen as sub-sets of such a core, contributing to rather than challenging it. Policy with regard to new additions is simply assimilatory or integrationist. Deviant cultures are seen as impermanent phenomena in transition to assimilation through policies for integration. This process does not, and must not, change the essential characteristics of the single core, which assimilates without itself being affected by such incorporation.

Few words figure so prominently in the current political debate in Europe over cultural differences as 'integration', which is generally seen as a self-evidently desirable attainment for both 'host' majority and 'guest' minority. (This metaphor is also widely used and expresses the

temporary character of the situation and the way the two parties are perceived.) Integration is often a goal of both the political right and left, although with significantly different meaning. It can be regarded as a 'default' term (Phalet and Swyngedouw, 2003: 7) used to avoid words with a high political charge such as 'assimilation' or 'diversity'. In the political debate, integration is used with two quite different meanings. The first is acculturation: that is, adapting culturally to the majority society until indistinguishable from it. Second, functional integration refers to the capacity of a minority group, most usually comprised of relatively recent immigrants, to function effectively within the dominant society. This may require not only an acquisition of some essential survival skills, especially language, but also an understanding of a myriad of detailed and relatively trivial operations necessary for daily life. Functional integration is, however, more widely associated with the structural aspects of the host society such as position in the labour market, housing market, education system and civil society. Functional integration can be measured more effectively than acculturation, although this may be in a negative sense as when it is demonstrably lacking in culturally segregated residential or educational ghettoes. Functional integration is also more prominent in government policies and expenditures, such as that on social services, social housing, special education and policing.

The 'assimilation thesis' assumes the existence of a positive relationship between acculturation and functional integration. Acculturation is seen as both a resultant of successful functional integration and also as a major cause, or at the very least, a necessary precondition of it (Phalet and Swyngedouw, 2003). This assumed relationship is at the core of expressed government policies in many European countries. It also allows policies of assimilation motivated by fear or dislike of the culturally different to be pursued under a cloak of charitable concern for the socio-economic well-being of such groups. They must be assimilated for their own economic and social benefit as well as that of society as a whole. Government policies therefore often fail to distinguish between acculturation and functional economic integration, regarding the pursuit of one goal as contributing to the other. This assumption or deliberate adoption of a link between acculturation and functional integration is, at best, unproved and, at worst, demonstrably incorrect in many instances. Some non-acculturated groups are typically economically successful, contrasting sharply with other economically dysfunctional but acculturated groups.

Heritage in assimilation models

The function of heritage in this model is to act as an instrument of assimilation of 'outsiders' into the core while constantly reaffirming and strengthening it among 'insiders'. Heritage exercises an educational and socialisation role as excluder and includer. The major practical problem with the model is the management of non-conforming, non-assimilating groups and ideas. There are three heritage policy options for managing these.

The first is incorporation into the core through transitional measures effecting social change among deviant groups. Both the teaching of geography, through 'homeland studies' (known in German as *Heimatkunde*) and history, through the creation and promotion of 'national history' are long familiar instruments for this. Both present a clear, unambiguous account of the undivided 'nation' as a unique people, its characteristics, claims and boundaries, admitting of no deviation, variety or alternative narratives. A not uncommon variant of this should be noted, namely the two-directional model where two different public heritages are presented in parallel, the one for external and the other for internal consumption. There is no conflict or tension in this bipolarity, which is not an expression of two societies but only of a single society narrated in different ways to different markets. This is especially evident in postcolonial countries engaged simultaneously in local nation-building and attempts to position themselves within global economic and social systems. The second option is the marginalisation of deviance through museumification or vernacularisation. Deviant groups may be tolerated if regarded as non-threatening and capable of being marginalised as quaint heritage survivals. They are rendered politically irrelevant and thus a harmless deviance.

A third heritage policy option is simply denial. There is no variation or social deviation. Nomenclature alone can be effective. The naming of places is a claim upon them while a social group that has no name has been denied at least official existence. Denial may take the form of the alteration, concealment or destruction of non-conforming heritage. History, archaeology and the assembling of archives are inevitably selective, as all aspects of human pasts tend to infinity. If a non-conforming group is ignored, deleted from maps or, in extreme cases, has its physical heritage removed, the existence of such a group is undermined while any possible future claim it may make to a separate existence or territorial possession is (terminally) compromised.

MELTING POT MODELS

The basic idea of the melting pot is straightforward. The analogy from the steel industry was coined and developed as a conscious policy in settler societies in which ethnically diverse immigrant streams were 'smelted' into a new homogeneous identity. The diverse ingredients produced not a composite or an amalgam but an original and unique product. The crucial similarity between assimilation and melting pot models is that the desired end product of each is a society composed of a single core, a culture of shared values, norms and identity. The equally crucial difference is that such a core already exists in the assimilation model and new ingredients are absorbed without materially changing it. Conversely, in the melting pot, the various ingredients fuse into a new core that is not the same as any of the ingredients of which it is composed. Thus both are single core models but produced by, at least in theory, a quite different process of integration: this difference, however, often becomes blurred in practice.

The model has been applied in some form or other in three main types of society. First, and archetypically, there are the settler societies where long-term immigration from ethnically diverse sources was absorbed and a new national identity, distinctly different from any constituent immigrant group, was forged. The term itself was coined in the United States but the idea, if often less explicitly stated, was also adopted in the 'White Dominions' of the British Empire (especially Canada, Australia and New Zealand). Such settler societies of Europeans overseas have always been an uneasy balance between melting pot and salad bowl models. As long as the immigrant streams were not too racially or culturally heterogeneous then the melting pot model seemed to operate smoothly. Until the 1930s, the United States aided this process by its ethnic and racial quota system, which was intended to guarantee that the ingredients in the pot would be not so varied as to threaten its capacity to assimilate them into the new product. Canada also classified British and other Dominion migrants as 'settlers' leaving the term and status of 'immigrant' to other groups to whom quotas applied.

Second, there are societies confronted with the more or less immediate necessity to create a new and unique identity from existing ethnically diverse populations. The most common instance of this in the past half century has been the ending of a colonial regime, which usually had little interest in nation-building, and its replacement by a newly independent state. Often occupying an area within boundaries that were also new, such polities had to engage in the creation of a nation that had not previously

existed. The new postcolonial Indonesia or the Philippines are archetypi-
cal cases, while Israel after 1948 faced the unique situation of the need to
melt the recalled Jewish diaspora into a new or re-created nation.

Third, there are some instances where governments have attempted to
forge new social and political identities for parts of their populations. This
is a form of social engineering usually undertaken for ideological reasons,
with the objective of changing society from within. The concept of 'year
zero' was strong in the Russian Revolution, as in many previous ones.
However, this denial of heritage and deliberate rejection of the baggage of
an equally rejected past always coexisted uneasily with cultural national-
ism inherited from centuries of Russian colonial settlement. The new
'Soviet man' was supposedly, if contentiously, to be nurtured in the social-
ist new towns of which Poland's Nowa Huta is perhaps the most impres-
sive in its magnificent, monumental, architectural determinism. The
philosophies behind the post-war new towns of Britain, and later Europe,
as well as the new IJsselmeer polders of the Netherlands, contained at least
weak echoes of this idea of the creation of the 'New Jerusalem' where a
new and better society, freed from the divisions of the past, would be
fostered and flourish.

Heritage in melting pot models

The roles of heritage in this process of creating new nations or new soci-
eties are clear. In settler societies, the immigrant abandons, willingly or
with official encouragement, the heritage baggage that may have accom-
panied the migration and identifies with the new place, its heritage and
its values. The new migrant learns, often through official classes, that
historical events, personalities and associations that predate the migra-
tion by many centuries, are his or her heritage. Equally in postcolonial
nation-building the new citizen adopts a new heritage, often identifying
with the pre-colonial roots or with proto-national survival during colo-
nial rule. It is not surprising, therefore, that such societies stress the trap-
pings of national identity, its flags, anthems, oaths of allegiance and the
like. At an organisational level, countries such as the United States,
Canada or Australia have heritage institutions and practices that often
predate those of the old world, and in many instances devote more
national resources to heritage activities than countries with a longer
history. Similarly, postcolonial governments are generally quick to
establish an official interest in heritage sites, associations and their inter-
pretation. They simply have a more obvious and pressing need for the

propagation of strong core values and beliefs, which longer-established nation-states can take more or less for granted.

The working of the melting pot, however, is nearly always somewhat more complex in reality than in theory. Almost all the cases considered in Chapter 7 share the essential difficulty of residuals, namely those cultural groups that for one reason or another fail wholly or partly to be absorbed. This could be because few settler societies created their identities on a *tabula rasa*. Indigenous populations existed and these were often viewed, at least initially, as either an undesirable ingredient to be kept outside the melting pot or just incapable of being absorbed. Second, some immigrant groups in settler societies, or ethnic minorities in new postcolonial states, may not melt, either because they are unwilling to abandon their existing cultural traits and adopt the new identity, or because the majority society is unwilling to accept their full participation.

The treatment of these 'residues' has always posed difficulties and is a matter of continuing controversy in both settler and postcolonial societies. There are three main policy reactions: namely to ignore, to marginalise or to engage in cultural hyphenation. Most aboriginal populations were variously subject to the first two policies: they were often overlooked and, even when noticed, excluded deliberately from the melting pot. Their heritage when not ignored was often treated as an exotic, if essentially meaningless, 'native' embellishment. An alternative is hyphenation, which recognises that the smelting process has been only partially successful. The rise of hyphen-specific heritage in the form of educational programmes, heritage trails, museums, exhibitions and statuary raises similar ambiguities about whether the intention is internal group cohesion and separation from the mainstream, or a wider inclusion of such groups in a more nuanced core product. The melting pot model thus begins to take on many of the characteristics of the core+ model discussed below.

In theory the melting pot model produces an end product that will vary according to the nature of the ingredients added. If the mix of ingredients varies over time, because for example the origins of the immigration flows change, then so will the new identity that is being forged. Once initially established however, the new society may prove reluctant to allow further change. The original idea of melting existing diversity changes into a process whereby the end product is predetermined and the ingredients are then selected to produce such a product. Once the new nation, whether postcolonial or settler, has been created by the melting pot then, in practice, the model may be abandoned and effectively transformed into an

assimilation model in which additions to the accepted core are allowed only if they do not alter that core.

CORE+ MODELS

This is a very diverse family of models, often with quite different origins. It is found in developed Western democratic societies that have longstanding agreed national unities but now accommodate substantial culturally divergent migrant groups. It is also prevalent in emergent postcolonial societies engaged in the process of nation-building within ethnic diversity, where other ethnic cultural groups supplement a majority culture. Central to the model is the existence of a consensual core identity, the *leitkultur or* leading culture to which are added a number of distinctive minority cultural groups. The relationship of the core to these add-on attachments is critical. The core culture and its values are both normally that of a substantial cultural majority, but are also accepted by the minorities as having an undisputed primacy due to the numerical, historical or political dominance of the core. In turn, the add-ons do not compete with the core for dominance and do not dilute or fundamentally amend it. They may even be viewed as enhancing the core by contributing useful additions to its variety. This is significantly different from the salad bowl notions of multiculturalism discussed below, as the core+ model includes a clear rejection of any cultural relativism or parity of esteem and power between core and peripheral add-ons. Equally, however, it differs sharply from both the assimilation and melting pot models in that the objective is not the ultimate incorporation of the minorities into either the existing core or into a new composite national identity. The add-ons are accepted as having a valid and continuing existence and may be regarded by the core society in one of two ways. They may be viewed as something apart, of no especial relevance to the core, but equally as unthreatening to it, as there is no perceived necessity for the majority to adapt, participate or even particularly notice minority cultures. Alternatively, the peripheral add-ons can be viewed as in some way contributing to or enhancing the core: as sub-categories of it; as contributory, often regional, variants; or as more or less exotic embellishments which can be selectively added as and when desired.

An important distinction needs to be drawn between what can be called 'inclusive' and, conversely, 'exclusive' add-ons to the core culture. The former not only augment the core but open it in the sense

that a minority culture becomes a part of everyone's culture. All may, if they wish, participate (at least selectively) in aspects of the minority cultural expression and to an extent regard it as also theirs. Exclusive add-ons however, are regarded as relating only to the group concerned and are commonly only accessible to that group. They provide community cohesion within the minority but have little significance to the wider society, which may not even be aware of their existence. Exclusive add-on cultures typically do not promote themselves, let alone proselytise, in the wider society.

Minority add-ons are of various type and origin. They may be part of a spatial, cultural and frequently jurisdictional hierarchy. This occurs in many European states where distinctive and recognised 'home nations' (the nomenclature itself recognises both a certain separateness of nation as well as being part of the same homeland) whether Scots, Fries, Bretons, or Bavarians relate to British, Dutch, French, or German core cultures as integral, if hierarchically subordinate, parts of a wider whole. Many European societies have adopted, whether consciously or incrementally, such core+ models as reaction to the existence of relict or incomplete 'semi-nations' (such as the Basques, Welsh, Corsicans, Catalans and the like). These are non-inclusive in the sense that they concern only a part of society and participation by all is not expected or usual.

Add-ons may be ethnic rather than spatial, involving a racial, religious, linguistic or other ethnic variation from the core; it may or may not be spatially concentrated, but is often added as an adjective to the core noun. Such hyphenation is not seen as a weakening or qualification of identification with, and participation in, the core culture. It is a hyphenation but without the ambiguity as to which element takes precedence, to the extent that the concern with the maintenance of core cohesion is relaxed. In many other cases, the minority add-ons may be the result of an intrinsic cultural diversity, either in a postcolonial state or as a consequence of more recent immigration of groups with sharply different racial or ethnic characteristics. The degree and form of acceptance of the minority varies, both within and beyond the limits of core+ models.

There is one final variant of the core+ model, which occurs when a plural society with deep social diversity adopts a leading culture which is not the culture of the majority or indeed even of any of the diverse cultural groups involved. This 'third-party' culture provides an overarching, neutral and thus acceptable integrating element. It could be argued that the so-called imported core, rather than being a leading culture in the sense argued above, is no more than a set of postcolonial survivals, such as a lingua franca or

familiarity with governmental agencies and practices that facilitate the efficient functioning and cohesion of society. It is thus not so much a core in the *leitkultur* sense as a convenient binding mechanism. This may be recognised as only a short-term transitory situation pending nation-building around an indigenous or created core culture.

Heritage in core+ models

Unlike some of the other cultural models discussed in this book, core+ models have generally not been created, at least initially, by conscious official policy. They have more usually emerged as a consequence of ad hoc reactions and adjustments of governments and individuals although, once in existence, they may shape official policy. However, unlike many of the models discussed here, core+ models have received little formal attention from theorists, policy makers or polemicists. They may even be seen as default models, emerging and being, however reluctantly, accepted as alternatives to successful assimilation or absorption, or in lieu of the adaptations needed for a multicultural salad bowl.

Often by circumstance rather than design, heritage has multiple roles in such societies. It may be used as the instrument for creating and sustaining the leading culture. It can adopt a defensive position whose task is to preserve the integrity of the core, preventing its perceived essential character from being diluted and subsumed by the periphery. Simultaneously, it can be used to promote the values and norms of the core among the peripheral add-ons thus preventing society fragmenting into non-communicating cells. This is the social inclusion role of heritage much in evidence in many recent official cultural policies. Conversely, it can also be adapted to a core enhancement role by promoting the heritage of the peripheral minorities to the core populations. This uses diversity as both strength and embellishment, as all are invited to appreciate and even participate in the minority cultures. The ethnic add-on urban district has become something of a cliché in heritage planning and in tourism product-line development. Cynically it could be said that if a place product is in need of economic, cultural and social reinvigoration, then create a 'Chinatown' or a 'Little Italy, Portugal, Russia or Somalia'. This policy reaction was once largely confined to the major settler societies of North America and Australasia but it is now almost as evident in many European cities. A more exclusivist use of heritage occurs when ethnic minority groups are officially seen as non-threatening and tolerated as more or less closed entities. However, they are not promoted to the

core and are generally unsupported by public heritage actions while left free to encourage and develop their own heritage within their own societies.

Core+ models tend to be unstable if only because change is an intrinsic part of the essentially dynamic process described above. Such change can be of various kinds. The selection of cultural add-ons can be continuously altered as new groups become acknowledged as suitable for such selection or as old ones cease to be sufficiently distinctive and merge into the dominant culture. Similarly the relationship between core and add-ons is likely to evolve. The culturally autonomous groups may lose their internal coherence, in practice passing through a transitory phase in a process of acculturation and functional integration into the core. At this point the model clearly evolves towards assimilation. The difference between inclusive and exclusive add-ons, described above, may be significant here. Certainly the process by which the peripheral add-ons are made accessible to a wider society could be viewed as potentially destabilising the model in so far as its partial adoption by the core is unlikely to leave either core or periphery unchanged. The peripheral groups may have their integrity undermined by the selectivity and distortions of the process of inclusion.

A defining characteristic of these models is that their core remains substantially unchanged by additions to it, retaining its hegemonic cultural position, yet may be embellished by such additions. The point where embellishment becomes substantive change may be difficult to detect but clearly could occur. Three outcomes then become possible. The core+ model remains, with an evolving leading culture that still forms the common component between the different elements. Alternatively, the core loses such potency and the society shades into the salad bowl cultural models considered below. Finally, the core could be weakened to the extent that the minority add-ons become sharply demarcated and mutually exclusive. Such an evolution could result in the 'pillarisation' of society considered next.

PILLAR MODELS

Pillar models have often been a defensive reaction in deeply divided societies, maintaining an overall unity while satisfying the fissiparous tendencies of the constituent groups. In this model, society is conceived as being a set of 'pillars', each self-contained and having little connection with each other. Collectively, however, all the pillars support the superstructure of

the unified state which imposes a minimal uniformity, allowing each group to manage its own cultural, social, educational, political and even economic institutions. It depends upon the idea of maintaining separation, and minimal contact between the groups without privileging any particular group.

There are relatively few cases of the application of this model and even in those cases where it has been self-consciously implemented, it is often in many ways less complete in reality than the theory suggests. The idea originated in the Netherlands as a pragmatic solution to the problem of the post-reformation religious divisions that plunged much of the rest of Europe into civil war. The simple two-fold division of Protestant and Catholic pillars (*zuilen*) was later supplemented by others, based on socio-economic divisions and even a non-sectarian pillar for those rejecting all the others (Lijphart, 1968). The survival of the model has been threatened by a secularisation and individualisation of society, which has weakened the solidarity of the pillar groups, but also by the rise of Islam, which, reasonably enough, increasingly demands its own pillar with appropriate institutional recognition and sovereignty. This dismays many who doubt the commitment of such a potential pillar to the shared values of the overarching state

There is a tempting, and not wholly unrealistic, parallel to be traced between the Dutch separate-but-equal pillarisation and the ideology of apartheid developed by Afrikaner, Dutch and German ideologues in the 1930s. Physical separation based exclusively on race rather than culture was incomplete, however, due to the economic dependence of the white pillar on non-white labour. Apartheid also contained an inequality of provision and esteem within the state as a whole.

A distinction can be drawn between intentional pillar models and unintentional or accidental pillar models. Apartheid South Africa is the clearest case of the intentional application of a carefully thought-out set of theoretical ideas. The Dutch case may have originated through pragmatic compromises and solutions but, once established, the model was self-consciously and deliberately applied and elaborated into many aspects of Dutch society over a long period. Neighbouring Belgium, on the other hand, has evolved incrementally into a de facto and somewhat reluctant pillar society as a compromise resolution to the conflict between the aspirations of its three language groups.

Heritage in pillar models

The roles of heritage in such models are usually quite self-evident. Each group creates, manages and consumes its own heritage for its own exclusive

consumption. The role of the overarching state would be restricted to maintaining an equality of provision. It would not, as in core+ models, use heritage in pursuit of social cohesion through encouraging mutual knowledge or participation between the pillars. It is, at least in theory, in effect a multiple-core model with the only collective commitment of the state, operating through consensual agreement of its constituent parts, being to guarantee equity and supervise the functioning of the system.

All the models of plural societies considered so far are subject to evolution, but it may be that pillar models are intrinsically transient and susceptible to metamorphosis. There is an inherent tension between the separation of society into mutually exclusive parts and the maintenance of an overall parity of esteem. Most such models emerged or were created in response to a particular circumstance. They are therefore a time-bound compromise. Changes in the demographic, economic or political environment may destabilise the carefully balanced compromise to the advantage of one of the pillars, introduce new groups not represented in the pillar system, or render the whole structure increasingly irrelevant to a different society. However, the model has demonstrated remarkable robustness in the Dutch case in particular, where the imminent demise of the pillarised society in the face of social change has been regularly predicted for a century or more. The model has proved capable of accommodating pillars of different size, importance and determining criteria, as well as being able to create new pillars as society changes. It has proved attractive to states constructed as loose federations of largely autonomous parts, especially when the political divisions are coterminous with cultural differences. Furthermore, although the pillar model may be unstable in the long run, it may permit the resolution of otherwise intractable inter-community socio-political problems in particular places and times.

SALAD BOWL/RAINBOW/MOSAIC MODELS

These variously named group of policy models are what is generally meant when multiculturalism is discussed as a utopian aspiration or an apocalyptic concern (see Chapter 2). They share in the basic idea is that the diverse ingredients are brought together and collectively create a whole without losing their distinctive characteristics, unlike either the assimilation or melting pot models with which this model is most commonly contrasted. The result has been described using a number of metaphors. The 'salad bowl' pictures diverse ingredients brought

together to create a collective dish without sacrificing the distinctive recognisable tastes of the components. The cultural 'mosaic' envisages individual fragments together creating a recognisable pattern while each *tessera* remains unchanged and individually identifiable. More recently, the 'rainbow' society imagines different colours producing a regular pattern, by remaining distinct while merging at their edges seamlessly into each other.

As observed in Chapter 2, such policies can be either descriptive or prescriptive. The descriptive model is simply a recognition that society is a cultural mosaic and that policy operates in that context. Prescriptive models move from recognition of the existence of social diversity to policies designed to foster, strengthen or capitalise on such diversity. These models can be pluralist or separatist in their objectives. The former treats cultural diversity as an asset, which should enrich society as a whole and be, as far as possible, universally accessible. The latter, in contrast, seeks to discover and foster cohesion within the different groups through an accentuation of their differences.

There are three main difficulties with the policy application of these models, which will be evident in the cases described in Chapter 10. First, there is the question of spatial scale. At what scale is the cultural variety apparent? Salad bowl policies may reflect a vision obvious at the national scale but less apparent, and even possibly irrelevant, at the uni-cultural local scale. Second, at what point on the spectrum between the individual and society as a whole is the group to be defined, and who makes such a definition? Third, there is the question of the necessity for some binding element: a dressing on the salad; regular structure to the rainbow; or pattern in the mosaic. Conversely, is it possible to sustain a coreless diversity without any universally accepted values or norms, beyond presumably those of acceptance of the existence of the salad bowl itself?

Heritage in salad bowl models

There are two main sets of policy instruments, which can be labelled inclusivist and exclusivist. The former endeavour to include every possible social group and invite all to be part of such heritages. The focus is on openness, making all heritage widely known and widely accessible. Such policies have two main problems. First, there is an absence of weighting within the selection: all make a contribution presumably equally without any consideration of the size, historical significance or intrinsic value of the contribution of any particular group. Second, inclusivist policies may

be resisted as tending to dilute and distort group heritages, an objection that may come from new minorities perceiving the trivialisation of their identity as much as from old majorities fearing the diminution of theirs.

Conversely, and sometimes in reaction, exclusivist heritage policies recognise but also empower each distinctive group with the selection and management of its own heritage. The assumption often made that 'social inclusion' through heritage is a self-evident social benefit is challenged by exclusivist heritages that are non-threatening to the rest. Similarly, the rise of the idea of cultural empowerment whereby groups are encouraged to re-establish ownership and control of their own heritage can be highly exclusivist. Not only may outsiders be afforded a lower priority for experiencing such heritage, but in extreme cases that have occurred it can become not just 'ours to preserve' but also 'ours to exclude, deny and even destroy'.

While the differences in approach and objective between salad bowl and both assimilation and melting pot models are clear and evident in official heritage policies, it is often less easy to distinguish them from core+ models. Certainly there are cases, discussed in Chapters 9 and 10, of policies which are labelled as being multicultural salad bowl models but which in practice include caveats that reserve a special role for one, or more, of the groups. Exclusivist salad bowl models, which accent the sovereignty and cohesion of the separated groups, are difficult to distinguish from pillar models and the one may evolve into the other.

LIMITS AND USES OF A TYPOLOGY OF MODELS

The typology of models used here is, of course, only an aid to understanding the complexity of the reality of plural societies. Inevitably, they are somewhat arbitrary in taxonomy, incomplete in that other variants could be discovered and added to the classification, and may convey a spurious and misleading uniformity. There is considerable overlap between the models, while, as discussed in Chapter 2, they are subject to a process of almost continuous change tending to evolve from one form to another. Any resulting lack of precision in reconciling a policy with a model is often compounded by a less than meticulous use of terminology by those responsible for implementing such policies.

It would simplify our task considerably if it were possible to assign individual countries to specific models on the basis of their policies. Unfortunately, this is only rarely possible. Different models may be adopted at

different times in the same country in response to changes in the composition of society and variations in governmental policies. It is also not uncommon for different models to be applied at the same time in the same country. Different official agencies with diverging objectives and interests, or operating at different spatial scales in the jurisdictional hierarchy, are very likely to react differently to cultural plurality.

However, the existence of a variety of visions of plural societies and of official approaches to them at least refutes any simplistic notion that there is a dichotomy between uni-cultural and multicultural visions of society and that a definitive binary choice in policy is required. There are models predicated upon the production of a clear single outcome, through assimilation or melting pots, and those whose objective is some form of cultural pluralism, whether expressed in the separate multiple cores of the pillar society, the more nuanced relationships of core and add-ons in core+ models, or the equality in diversity of the salad bowl. It is also clear that while some policies envisage an ultimate steady-state outcome, others are content to manage a more shifting series of continuous transitional phases.

Our initial assertion that heritage is a major instrument for attaining these objectives remains intact. Each of the very different models makes an active use of heritage, although quite clearly different models, pursuing different social objectives, use a different heritage in a different way. The extent of success in this task depends largely upon the operation of the caveats surrounding heritage management by official agencies stressed in Chapter 3, which help dispel any pseudo-Orwellian idea of a monopolistic manipulation of pasts in the service of visions of futures. The robustness of the models and their usefulness in structuring social complexity and understanding geographical reality must now be tested in real world applications. In Part III, the five chapters (6–10) address each of the major categories of models in the typology through a series of intensive case studies.

PART III
HERITAGE IN
PLURAL SOCIETIES

PART II

HERITAGE IN

PLURAL SOCIETIES

6 HERITAGE IN ASSIMILATION MODELS

As discussed in Chapter 5, the essence of assimilation is that only one legitimate set of collective core values exists in a society. Variations from this may be permitted only in so far as they are seen as sub-sets of such a core and contributing to it. Policy with regard to new additions is simply assimilatory or integrationist. Deviant cultures are regarded as temporary phenomena in a process of transition to assimilation through policies for integration. This process does not and must not change the essential characteristics of the single core, which assimilates without itself being affected by such incorporation. Place identity expressed through heritage is both a reflection of the social identity as well as an instrument for its creation or support.

The pursuit of this goal is justified as being simple, easy to understand and fostering a unity that is all-inclusive for those within and all-exclusive for those without. There is no need to manage potential internal frictions because no such conflicts are permitted to exist. There is a collective commonality of shared values and place identities. Thus, an assimilation policy, ostensibly at least, avoids internal separatism and external threats of irredentism from neighbours. It may also actually be cheaper, saving government expenditure on the costly apparatus of translations and separate cultural provision. This cost argument is, however, very rarely used.

Official heritage frequently plays a central role in the operation of this model. Promoting the heritage of the core society is the main instrument of socialisation, assimilating 'outsiders' into the values of the core while continually reasserting and reinforcing it to insiders and outsiders alike. The principal instruments used in striving towards this goal are now described, followed by an account of policies towards the continued existence of deviant cultural elements that prove resistant to assimilation.

ASSIMILATION POLICIES

Defining the issues

As argued in Chapter 5, integration can be used to mean assimilation of minority groups into the dominant culture or the effective functioning of minorities within the dominant society. The assimilation thesis assumes a link between the two processes, often with the fundamental assumption that acculturation is the active causative element and economic and social functional integration is the effect. This remains unproven, however, and can even be demonstrably incorrect in some instances in that well-known non-acculturated groups can be economically successful. The long-term Chinese and more recent Vietnamese communities in many North American and European cities, or indeed the London Polish community, described in Chapter 9, typically retain a cultural separation from the majority society while usually functioning effectively within it economically. Conversely, some highly acculturated groups are less successful in economic terms, as is borne out by comparisons between long settled African-Americans and many recent Asian groups in the United States.

Government policies frequently fail to distinguish between acculturation and functional economic integration, sometimes regarding the terms as being interchangeable and the pursuit of one goal as contributing to the other. This becomes most evident in the problem of defining the target group in policies designed to integrate minorities into the core. Recent experience in the Netherlands is worth relating in detail as it is representative of government perceptions in a number of other European countries. The Dutch experience is not unique, but the intensity of the public debate and the rapidity of the change in popular mood from a vague toleration of an imprecisely defined multiculturalism to support for cultural assimilation probably is. Consequently the Netherlands has become something of pioneer in confronting the practical issues of integration and devising practicable policies for its attainment, many of which are being adopted in other European countries.

In the Netherlands, there has been an increasing popular perception since about 2000 of relatively high levels of social and economic dysfunction among some visible ethnic minorities. Anti-social behaviour, lagging educational attainment and social welfare dependence have all become associated in the popular imagination with immigrants, most especially from Morocco, Turkey, Surinam and the Antilles. This has been combined with disquiet among elements of the majority culture that behaviours and

values perceived as being traditionally Dutch were being undermined by new and culturally different groups. The popular press and opportunist politicians have both reflected and encouraged the conflation of these two areas of concern. The existence of both perceived problems has been blamed on official policies of multiculturalism. This term has never been clearly defined and rarely discussed in a public forum, but is generally understood to refer to a toleration of cultural differences and official support for the institutions and cultural practices of non-Dutch ethnic groups. Such policies of official toleration and support for separate group development owe much to the longstanding 'pillar' model of society, discussed in more detail in Chapter 9.

The charge that multicultural policies have failed and the consequent need to 'integrate' cultural minorities rather than foster their separateness was focused by the murder of the charismatic, populist, anti-immigration politician Pim Fortuyn in 2002 (and later of the media personality Theo van Gogh by an Islamic militant in 2004). The government formed in 2002 was a coalition of Christian centrists, free market liberals and far right ethno-nationalists. A new 'Ministry of Immigration and Integration' was established, which set about the task of *inburgering*, literally 'citizening'. The central idea was that all members of non-Dutch minorities should be taught and tested upon a chosen set of Dutch cultural attributes, most prominently language but including history, geography and state structures. Success in this test would be a requirement of acquiring not just naturalisation but even permission to remain in the country, or to enter it to marry a resident. This is not only an unalloyed policy of assimilation through mandatory acculturation but is also a clear definition of the nature of the problem as a failure of minorities to integrate into Dutch society.

Delimiting the cultural groups

The main practical difficulty in framing policies of assimilation in the Netherlands has been simply to find ways of identifying the cultural minorities to be so treated. National citizenship fails to isolate the perceived problem groups, many of whom are now largely second-generation immigrants from the former Dutch colonies of Surinam and the Antilles. They are acculturated into Dutch society in terms of language, customs and, usually, also nationality. It is precisely these groups, however, that are seen consistently as economically and socially dysfunctional as measured by unemployment, educational attainment, street crime and family stability statistics.

As nationality fails to divide society into 'Dutch' and 'non-Dutch' in terms of desirable values and behaviour, other distinctions were sought. A definition based on the number of years of education within the Netherlands was suggested as isolating the perceived retarded linguistic and social acculturation seen as the cause of the social dysfunction. This was ultimately rejected when it became apparent that such a definition would include within the 'non-Dutch' category many Dutch citizens who had been educated partly overseas due to the requirements of government, military or multinational company service. The definition would also have excluded second-generation, Dutch-educated North Africans and West Indians who are, nevertheless, popularly viewed as being socially dysfunctional. The third criterion – the one currently used – is place of parental birth. The term *allochtone* has been adopted officially to describe an individual with a parent or both parents born outside the Netherlands: its converse is *autochtone*. The assumption is that an *allochtone*, even if born and educated in the Netherlands and of Dutch nationality, has a tendency to social and economic dysfunctionality due to insufficient acculturation to Dutch indigenous culture. This perceived deficiency is to be corrected by mandatory *inburgering* teaching and testing. Such a definition has the advantage of not being based on citizenship and, therefore, cannot be challenged legally as a breach of European Union equality laws. This is convenient as the largest immigrant groups in the Netherlands are not, as popularly imagined, from Morocco or Turkey but from other EU countries. It remains unclear whether the application of such a categorisation of society would actually identify the expected social groups, and there has been opposition from, for example, multinational companies and universities that need to import specialised labour from overseas. From a heritage perspective, however, the more serious point is whether national acculturation, including the teaching of a national language, a set of national cultural attributes and customs, and a smattering of national history can be effective as part of a solution to perceived social and economic problems.

THE HERITAGE INSTRUMENTS

National histories

Chapter 3 discussed the idea that nationalism as a political ideology depends upon the creation and widespread acceptance of that imagined entity, the nation. There is an intimate historical relationship between concern for the

past as expressed through heritage and the goal of national legitimation. An instrument of this is the deliberate use of the academic discipline of history in the shaping of a convincing, widely accepted and self-justifying national historical narrative. Indeed this has often been regarded, especially by non-historians, as the principal task of history as an academic study and the main justification for its prominent inclusion in school curricula. If we do not share a collective history, then we are not a collective people.

In theory, at least, such a national history should trace the discernable unbroken path of the clearly defined nation through time from a selected beginning ('the birth of a nation') to now. This describes and accounts for the formation of the character of the unique people and their relation to territory and neighbours and, ideally, should contain no ambiguities or dissenting, contradictory voices. In practice, of course, this is rarely the case and there may be a multiplicity of narratives, which matters little if these can be accommodated without disturbing the core discourse. Three ingredients are generally essential – or at least widespread – as determinants of the effectiveness of such narratives. These are: a thesis of progress, a 'Golden Age' and a foundation struggle mythology.

First, the linear narrative of the thesis of progress structures not only national history teaching but also much museum exhibit interpretation. A time-line is drawn from a primitive, unenlightened past to the best of all possible presents. Evolution through stages is expressed as inevitable and deviations as merely interruptions in this process. This justifies the present, its values, attitudes and, most especially, structures of governance. It also, of course, reassures and flatters the recipient, who may well be grateful to exist in the optimum present rather than an undesirable past. A major task is to extend the time-line as far back as convincingly possible into the past. This can be far distant. Two examples of such 'time-collapse' in Europe are provided by gigantic and visually prominent statues of heroic warriors, each erected some 2000 years after the events and people they commemorate, in an attempt to legitimate new and insecure empires. The first is the statue at Alesia (Alise-Sainte-Reine) in Burgundy of Vercingetorix, the leader of the Gallic revolt against the Romans in 52BC, which was dedicated by Napoleon III in 1865. The second represents the equally romantic hero Arminius (or Hermann), who in AD19 defeated a Roman Army at the Teutoburgerwald near Detmold in central Germany. Wilhelm I, the emperor of the then new German Empire, dedicated this in 1875. Although very little is actually known about either of these historical characters, they have still been credited with qualities of steadfastness

and courage in the defence of the homeland against foreign invasion. Both statues quite explicitly link the present to a past in an unbroken succession, inviting observers to identify with their heritage and be inspired by it in the defence of the present nation. This phenomenon is by no means confined to Europe: interestingly, some of the most assiduous cultivation of ancient time-lines is presently to be found in the museums of the 'offspring' nations of European colonialism such as Singapore and Australia as they seek greater distance from that identity (Henderson, 2005).

Second, there may be some contradiction between linear narratives of progress and time-collapse and the notion of a past 'Golden Age' which encapsulates the essence of the nation. In the Netherlands there is a strong popular belief in the seventeenth-century *gouden eeuw* when the country's 'embarrassment of riches' (to use Schama's 1987 book title) was globally evident in economics, politics, science and the arts. It is unlikely, however, that most Dutchmen at what was also a time of economic depression, agricultural change, religious and political turmoil, and wide disparities of income were aware that their age was so gilded. The concept of a golden age and the phrase itself were actually coined in retrospect by historians in the nineteenth century, anxious to legitimate the new kingdom of the Netherlands (only created initially in 1815 and fragmented by the separation of Belgium in 1830). Harnessed to romantic nationalism, the mythology was employed to differentiate the Netherlands from its neighbours, while including within the nation those who shared a common language and broad historical experience. Interestingly, the dominance of the seventeenth century in the restoration of buildings and the presentation of artefacts has provoked something of a reaction in peripheral regions which favour a different golden age as better expressing their regional identity.

Thus, the concept of golden age is flexible, changeable, rejectable and re-usable in different contexts. The idea of Poland was kept alive after partition and disappearance from the political map by the golden 'Jagiellonian' age of the Polish-Lithuanian Commonwealth. A modern, small, relatively poor and politically weak Portugal finds reassurance and self-confidence in the commemoration of the fifteenth-century 'Manueline' age of exploration, trade and development, personified by Prince Henry the Navigator and marked by the dramatic Monument to the Discoveries on the banks of the Tagus at the seaward approach to Lisbon. A 'Gustaf Adolphian' Sweden, after the seventeenth-century arbitrator of much of Europe, or 'Christianian' Denmark, after Christian IV (1588–1648), the founder and builder of cities, would now seem

somewhat absurd, not least to the citizens of the countries concerned. Still, they were important notions a century ago while the Scandinavian peoples were establishing and promoting their existing modern, separate state identities. Republican France is uneasy and ambivalent about identifying with the seventeenth- and eighteenth-century political, cultural and linguistic dominance of the age of *le roi soleil*. Secular Kemalist Turkey has made very little use of the Golden Age of Ottoman dominance in Central Asia or in the Arab lands, which may be seen as diluting the purity of an Anatolia-centred Turkishness, as well as potentially evoking unease in neighbouring countries.

The final element in an effective national history is the mythology of the foundation struggle. The nation is born out of the resistance, ideally without external aid, of its nascent citizens against oppression. The more suffering and struggle there was in the birth, the greater the justification for the nation's continued existence. An effective founding struggle should contain memorable massacres, atrocities, assassinations and the like, which serve to unite and strengthen resistance and render the resulting victory the more justified and the more fulfilling. They also can provide a focus for a 'remember the x atrocity' historical narrative.

This latter element can be extended into an idea of a permanent sense of victimhood. An 'all hands against us' model strengthens the cohesion of the group in self-defence. The narratives of Polish history since the eighteenth-century partitions are an unrelenting chronicle of failed insurrections and subsequent oppression, memorialised in public statuary and place nomenclature. The Warsaw Home Army Uprising Museum, opened in 2005, continues the theme of the doomed and unaided 1944 insurrection against impossible odds. The outcome was heroic tragedy, followed by oppression (by Germany and then the Soviet Union) and then abandonment (by the West). There is perhaps a strong element of this 'ourselves alone against the world' heritage mindset in contemporary Israel and even in some Islamic groups who see the world community of Moslems (the *Umma*) as being under sustained attack by hostile forces. Again, the 'laager' mentality of apartheid South Africa encapsulated a historical Boer defiance of British and Black and extended this into first cold-war Red and, ultimately, global paranoia.

Dutch national history (*vaderlandse geschiedenis*) has at its core the '80 years war' (1572–1648) in which good (that is patriotic, Protestant burgers) triumphed over evil (that is Hapsburg, Catholic, feudal tyranny) but not without suffering atrocities (such as the sack of Naarden) while creating martyrs (such as Counts Egmond and Hoorn), folk heroes (the

'sea beggars', the House of Orange) and folk villains (Alva, Phillip II). In 2006 the Dutch government adopted an official 'canon' of national history, 'The story of the Netherlands', which is to be taught in all schools as the basis of the history curriculum, with the explicit objective of strengthening an idea of national unity (Ashworth, 2007).

States that have emerged without a notable 'freedom struggle' have a major problem in this respect and often need to invent one, even when the historical materials for such invention can be exceedingly thin or, indeed, contradictory. For example, in sharp contrast to the Netherlands, Belgium has only the initial public disturbances in Brussels during 1830 and the short, half-hearted six-day campaign of the Dutch field force before the intervention of the great powers imposed independence upon it. Such an unconvincing and largely unusable 'founding struggle' has left something of a legitimation vacuum that has, at least facilitated, the later rise of Flemish nationalism. This is grounded in a more convincing struggle for freedom against the French (extending from the battle of Kortrijk 1302, mythologised by Hendrik Conscience's 1838 novel, *Lion of Flanders*, to the present economic and political resentments). At least Switzerland, another state born more of convenience than of conviction, could in the early nineteenth century construct the myth of a founding struggle around the personalities of Wilhelm Tell and the Hapsburg tyrant, Gessler. The poignant and memorable story of the apples and crossbows at Altdorf in 1388 has been perpetuated by Schiller's romantic play of 1804.

The Dominions of the British Empire that evolved incrementally into sovereign states without principled disagreement with the imperial power are especially unfortunate in this respect. Australia has little more than an anti-social misfit (Ned Kelly), a mythical tramp accused of theft and embodying class antipathies ('the jolly swagman'), an externally manipulated labour dispute and civil disturbance (Eureka Stockade), and a diffuse resentment about the casualties of imperial wars. It is difficult to combine these into a convincing and memorable struggle for freedom without dubious retrospective identification with Aboriginal grievances. Canada has an additional problematic in that the threat to its sovereignty came from its continental neighbour rather than the colonial power. The founding 'freedom struggle' is thus not against the latter but actually in its support of the colonial power against a real or supposed predatory neighbour. Significantly, New Zealand has not so far even tried to construct such a founding mythology.

Only the Union of South Africa could construct a form of freedom struggle and that applied only to a portion of its white population in

the narrative of the simple God-fearing Boer, desiring only to be left undisturbed, but forced into a struggle against annexation and oppression by the expansionist British Empire. After a century of hardships – the Great Treks, the Anglo-Boer wars and their aftermath, and sustained economic and cultural marginalisation, mythologised in the Blood River, Voortrekker (Pretoria) and Women's (Bloemfontein) memorials (Figures 6.1 and 6.2) – the Boers emerged triumphant as the government of South Africa in 1948. The self-image of the victimised Boer was of central importance to creating and sustaining the idea of the Afrikaner *volk* but cast the other main white group as collaborators with, and beneficiaries of, the memorialised oppression. This was unhelpful in shaping a Union identity after 1910 and in forging white solidarity in the later apartheid *laager*.

It is as important to determine what to exclude as what to include in such national histories, national museums and national commemorative statuary. Clearly the heritages of groups detracting from the common core are to be excluded, but even within the core heritage there will be episodes and personalities that, to say the least, fail to support the central message. These elements may bear upon internal or external events. Internally, civil wars are particularly dissonant to the common core. In Britain, the Civil War and the Jacobite rebellions created enduring discordances. The US Civil War remains a national preoccupation and a source of tension, still intermittently surfacing in the reluctance of some southern states to relinquish the symbols and supposed values of the Confederacy. Ensuing national identities must be convincingly reunited, strengthened and cleansed by such ordeals. The English/British constitutional advance and the ideals of Lincoln's Gettysburg address must outweigh dissent. Externally, both countries' national identities are also burdened by negative retrospective assessments (not least their own) of their global hegemony. In the present intellectual climate, the British Empire and Commonwealth Museum in Bristol has set itself a challenging task of incorporating a balanced assessment of this critical subject and its personalities into the contemporary national identity. In the United States, similar national accommodations to its intemperate global interventionism will ultimately have to be made. Both cases are the more sensitive because they are subject to national political polarisation.

Governments have at their disposal a wide array of vehicles for conveying such national histories to two main target groups of new citizens. For children there are school curricula and museum educational programmes. For immigrants, national historical tests of the kind

Figure 6.1 Bloemfontein, S.Africa: Women's Memorial. Deaths in each Anglo-Boer War concentration camp are recorded on path-side markers (2006)

Figure 6.2 Bloemfontein: Women's Memorial. 'Volk' representation of departing soldier, wife and child (2006)

described earlier may be set in the belief that these communicate and inculcate a set of common cohesive norms and values. In addition, there is a wide array of government instruments for expressing a national history. These include: place nomenclature, public statuary, built heritage, officially sponsored memorial events and days, and illustrated banknotes, coins and postage stamps. Some countries have also attempted more creative methods, such as a list of officially recommended or even approved forenames, derived from the national pantheon, or passports containing illustrations of selected formative episodes in national history. Whether such instruments are effective in creating a common collective memory, and whether this in itself has the beneficial impacts upon society that the policy makers intended, is debatable but it is so universal and commonplace as to be a normal practice of most governments.

National geographies

The creation of a national geography provides an arena for the operation of a national history, but it most often goes further. It stimulates patriotism through a knowledge of the *patria* but may also attempt to transfer properties of the physical environment to the people. A harsh or challenging nature evokes a hardy and innovative people. There may also be echoes of the historical 'freedom struggle' in the taming of the wilderness idea. Not only is this 'our land' because we have subdued it through hardship, by this process we have become the people that we are. National geographies also demarcate the territorial extent, whether actual or claimed, that the nation occupies or should occupy.

In Germany this national geography was known and taught in schools as *Heimatkunde or* the study of the homeland, which succinctly links a particular people with a particular space. This idea was perhaps most eloquently expressed in Ratzel's *Deutschland: Einführung in die Heimatkunde* (1898), written specifically for school use. He purposely linked German culture (*das Volk*), in terms of agricultural practices, architectural forms and even social attributes with a demarcated space (*Lebensraum*) and its physical character (*der Boden*). Together with national history and national language, this formed part of a wider *Vaterlandskunde* ('Fatherland studies'). However, because *Heimatkunde* focuses upon the differences between the people of the *Heimat* and others, and also often describes in detail the rich cultural variations among the *Heimat* peoples themselves, it frequently tended to dwell

upon the distinguishing regional details of traditions and customs, thereby slipping easily into an account of a vernacular regional geography.

There were parallels in many other countries. In Hungary, it was called *Honismeret and* was used as part of active Magyarisation education policies among Slav and Romanian minorities after 1867. A British example would be Halford Mackinder's *Britain and the British Seas* (1902), which contained an implicit geographical explanation, if not justification, for British imperial expansion overseas. Islands are easier to treat in this way, giving a distinct geometrical satisfaction in the idea of 'one island – one nation'. Continents, similarly, may provide a certain completeness: it appears no less than a manifest destiny for the nation to occupy the whole space provided by nature. Products of British imperial expansion illustrate this well, above all Australia; North America's even greater continental unity was precluded only by US independence and its subsequent ideological divide from Canada, which thwarted the complete continental consummation of US nineteenth-century expansionism. Australia and Canada are also striking illustrations of the aforementioned appropriation of harsh, and in Australia's case, unique, physical environment to national identity: Australia's 'Red Centre' and Canada's 'Great White North' evince national icons of swagmen and lumberjacks, none the less enduring for their remoteness from urban realities.

France, neither island nor continent, devised a different geometrical construction in the 'hexagon', defined by the famed *limites naturelles*, to justify conquest to the Rhine, Alps, Mediterranean, Pyrenees and Atlantic. Conversely, of course, nation-states such as Poland that are not clearly delineated by physical boundaries, have more difficulty in creating and defending a national geography that legitimates the long-term occupation of a demarcated area by a defined people.

It is even more difficult for nations that lack a national geography. There are so many self-defined national groups lacking territorial control that an international body, the Unrepresented Nations and Peoples Organisation, exists to advance their interests. Aside from aboriginal groups in European-settled territories there are migratory peoples such as the Roma and settled groups lacking national self-determination. Some among these, notably Palestinians and Kurds, have greater geopolitical significance by virtue of their international fragmentation in sensitive regions. In the case of the Jews, the problem was partially resolved by the invention of the near mythical homeland which was subsequently secured at the expense of other inhabitants of that same region.

THE TREATMENT OF NON-CORE HERITAGE

Denial

A simple and generally effective method of handling variants from the core heritage is merely to deny their existence: if there is no variance then there is nothing to assimilate. A simple denial that minority groups and their heritage exist now or indeed ever in the past can be effective. The naming of cultural groups has obvious significance: what has no name has no recognised existence. The Kingdom of Siam changed its name in 1938 to Thailand as a part of a deliberate policy by the ethno-nationalist dictator, Pibul, to shape a monocultural state around the majority Thai population. This effectively ignored and marginalised the non-Thai minorities. The assimilation model ignored these cultural minorities (including the Man and Khmer groups who amounted to more than half a million people) if they were seen as not being a threat. The various 'hill tribes', who currently number in excess of 700,000, are called *Chao Khao* ('people of the hills') rather than by any tribal epithet. The Chinese minority, which is larger and more widely spread (comprising about 10 per cent of the national population, or over 6.5 million in 2004), and the Moslems in the south (about 3 per cent in 2005) were seen as more threatening to such a monocultural state and were not only provided with no culturally specific facilities but were also subjected to active acculturation policies. These included, for example, the compulsory changing of personal names from Chinese to Thai forms. A parallel national name change from Ceylon to Sri Lanka (1972), which reflected Sinhalese Buddhist heritage singularity at the expense of the mainly Hindu Tamil population, is implicated in that country's ethnic tensions and consequent civil war. Turkey's similar denial of its Kurdish 'Mountain Turks' minority has also engendered conflict, with serious geopolitical implications, most particularly in Iraq.

A 'failure to mention', if less drastic than absolute denial, is of course a commonplace in heritage interpretation, which by its nature is inevitably selective. For example, the city now called Thessaloniki, and part of Greece only since 1912, was a cosmopolitan mix of Jews (about 40 per cent of the population in 1900), Turks, Armenians, Greeks and others until well into the twentieth century. This historical multicultural Salonika receives scant mention in the official tourism guides or in heritage tourism marking, which portrays only the Greek heritage of the city, especially its links with the Hellenistic world. The naming of 'The Museum of Thessaloniki and Macedonia' is an attempt to ward off any

claims upon the area by the 'Former Yugoslav Republic' of Macedonia (as Greece insists on naming the state). Similarly the 'freedom struggle' against the Turks and Bulgarians (related in 'The Museum of the Macedonian Struggle') fails to mention that at that time Greeks constituted a minority and the city was at least as much Turkish as Greek. Thessaloniki's internationally most famous inhabitant in modern times was Mustafa Kemal, who, as Atatürk, was the founder of modern Turkey. He was born here in 1881, attended military academy and was part of the 1908 'Young Turk' revolution that began here. Again no mention is made of this in official promotional literature. The house that is Atatürk's birth-place is not accorded any Greek legal protective designation and it does not appear on the map of the city's heritage, the building being occupied by the Turkish consulate and managed as a museum by the Turkish government.

Similarly archaeology can have important political dimensions, being used to assert or deny the previous occupation of an area by a particular group. Evidence supporting occupation by one group is assiduously sought and propagated and that of another is either not sought or, if found, ignored. It also affects the argument from the standpoint of primacy of occupation (the 'we were here first' claim to support group recognition and proprietorship).

Palestine, unsurprisingly given the age, significance and variety of its heritage endowment, provides a plethora of cases. The World Archaeological Congress famously issued a blanket condemnation of the actions of the Israeli government in 2002, accusing it of the destruction of Moslem and Christian archaeological sites, specifically in Bethlehem, Hebron and Nablus. This resulted both from deliberate design and from neglect during military operations and, more recently, the construction of the 'security barrier'. Israeli archaeology has been accused of operating in tacit support of Zionist land claims (Dalrymple, 1997) by focusing upon the discovery of supporting evidence, such as the Second Temple, or validating martyrdom, such as Masada. Also the Israeli state has been charged with not seeking or ignoring evidence of previous non-Jewish settlement; and ultimately even destroying such evidence in the essentially destructive archaeological process. In turn, Israeli authorities and archaeological institutions not only vigorously dispute these charges but also counter-claim that the Palestinian Authority is similarly guilty of at least a culpable indifference to Jewish sites. Specific instances include the undermining of the Temple Mount in Jerusalem by the construction of new access to the Al Aqsa Mosque.

The eradication of non-core heritage

There are stages, however, beyond denial. The heritage of a deviant group can simply be eradicated, by either removing or destroying it while leaving the associated people *in situ*. The intention is that they will subsequently adapt to, and associate with, the remaining dominant heritage. Alternatively, the people can be removed and it can be then be assumed that, inevitably, their heritage will become disused and ultimately destroyed. In Foote's typology of American sites of tragedy and violence (1997), such heritage constitutes a site of obliteration where the evidence of death and tragedy – or more commonplace everyday life – is effaced or removed from view so as not to impede the desire to forget.

The eradication of the heritage but not the people is relatively simple in so far as tangible aspects are concerned. Indeed historically, churches, mosques, synagogues and temples, together with their associated burial grounds, have often been among the first buildings destroyed when the ruling ideology has changed through conquest. Commonly their obliteration has been sealed by the construction of the new order's sacred places upon their foundations, as in the Christian–Inca superimposition in Cusco, Peru, or the Moslem–Hindu case in Ayodhya, India, where a Moslem mosque, built on an original Hindu shrine, was demolished in the 1990s (Tunbridge and Ashworth, 1996). A less drastic option in which the sacred place of one faith is converted through conquest, emigration or eradication to that of another is historically abundant. Perhaps the single best-known example is the Islamicised Hagia Sophia in Constantinople/Istanbul.

Certainly, numerous claims are currently being made by governments and private organisations that the physical heritage of the cultural groups they represent is being deliberately destroyed by the authorities who represent a different cultural group in order to further claims over disputed territories. For example, in Cyprus, divided since 1974, Greek interests accuse the Turkish Republic of North Cyprus (TRNC) of church and icon destruction. A well-publicised *cause célèbre* was that of the Kanakaria mosaics, which disappeared from the church at Kanakaria on the Karpasia peninsula in 1976 and appeared for sale in the United States in 1989. Subsequently, the Cypriot Orthodox church was successful in establishing a legal claim to the mosaics but, significantly, they were not restored to their original site. The TRNC reciprocates by claiming that the Greek Republic of Cyprus has destroyed more than 100 mosques and Moslem graveyards in the south (Scott, 2002). Heritage

thus becomes an instrument in furthering political, and in this case also financial-compensation, claims in a continuing dispute. Similarly in Kashmir, mutual recriminations between Hindu and Moslem populations focus upon claims of damage to their respective heritage structures, usually religious, in the areas controlled by the other.

Advocates of the indigenous populations of the United States, Canada and Australia have also claimed that their heritages were deliberately destroyed through the destruction of symbolic places and artefacts in order to de-tribalise these peoples and forcibly integrate them into the majority society and economy. Inevitably, the settler appropriation of the best land and a failure to recognise native symbolisms had this effect, whether deliberate or not (Windschuttle, 2004). Past appropriation of 'primitive' peoples' artefacts and human remains by museums in the world's major cities, also now a matter of redress, may not have been intended to undermine aboriginal heritages by their delocalisation, but it has obviously had this effect.

Although deliberate destruction has an enormous symbolic impact in demonstrating that change has occurred, disuse and neglect may be as prevalent and effective as deliberate destruction. Changes in governments and ideologies leave many heritage structures without an appropriate use, and looting, pilfering, the re-use of materials, and an indifferent neglect by current authorities who have no interest in preservation, will over time be as effective a strategy of obliteration.

Changes in political regime are often associated with changes in economic systems and can be gradual as often as abrupt. Take the widespread European phenomenon of the country manor house. In rural Ireland a combination of changes in land tenure and in the agricultural economy as a result of tariff-free food imports left numerous estate houses in rural areas bankrupt and often abandoned to looters and the physical elements, from the late nineteenth to the twentieth centuries. The existence of social, cultural, political and often religious differences between the owners and the succeeding governments provided little motive for the preservation of the heritage of the previous 'protestant ascendancy' regime (Genet, 1991). A similar case, familiar in much of Eastern Europe, would be the Polish manor house occupied by a landowning squirearchy, the *Szlachta* class of minor but politically privileged aristocrats that had effectively governed, or misgoverned, Poland in their own interest since the seventeenth century. The incoming communist regime in 1947 instituted land-holding reforms that removed the economic support of the house and frequently also physically dispossessed the occupiers. Even when they adapted these houses

for official functions, the new authorities had little interest in the preservation of the heritage of what was to them decadent, and now fortunately extinct, social class and its cultural expression. Again vacancy, neglect and re-use of building materials determined that very few such buildings survived into the twenty-first century in a condition suitable for restoration once public attitudes and the political regime changed after 1990.

Intangible heritage has proved much less amenable to such direct drastic action. Buildings, objects and even iconic spaces and sites can be physically appropriated or destroyed more easily than language, customs, traditions and folk cultures. Public expression, however, can be regulated. Scottish highland dress was banned for a time after the Jacobite rebellion of 1745; in 1977 Quebec's notorious Bill 101 attempted to minimise the public display of languages other than French. The visual appearance of public space is thus used to assert or deny a cultural claim upon an area.

An extreme manifestation of a policy of eradication of a culture is to remove not only the culture and its expressions but also the people who create, use and transmit it. Although the term 'ethnic cleansing' is recent, the phenomenon is not. The term was first used by Croatian nationalists with reference to the Serb minority in 1941, and was popularised in English during the Yugoslavian civil wars of the 1990s (Gutman, 1993; Glenny, 1996, 1999). The phenomenon is of course as old as written history itself, there being numerous Old Testament biblical references to the genocide of non-Jewish cultural and political groups in Palestine.

In the modern world, the exchange of populations between Turkey and Greece agreed at the Treaty of Lausanne (1923), at the conclusion of the Greek military adventure in Anatolia, has been seen as something of an exemplar and archetype for the succeeding resolution of perceived problems of the existence of minority populations. In fact it was not totally novel, as the previous Treaty of Neuilly in 1919 had included an exchange of Greek and Bulgarian populations in Thrace. In both cases, however, the populations concerned were never consulted, and the exchanges were therefore in practice organised deportations with the assent of governments. During the discussion between the Allied leaders at Yalta in 1944 and Potsdam in 1945 on the redrawing of the eastern boundaries of a defeated Germany, the necessity of removing substantial (10–15 million) longstanding ethnic German populations from East Prussia, Danzig, Pomerania and Upper Silesia was justified by reference to the Greek–Turkish population

exchange of 20 years earlier (Hastings, 2004). This was seen as a simple (at least once the logistics had been solved), relatively humane, complete and permanent solution. It avoided the complex and fraught discussions, plebiscites and detailed region-splitting cartography that resulted from applying the Wilsonian principle of self-determination after the First World War. Such ethnic cleansing is not a preserve of totalitarian governments in quest of territorial compensation or simple aggrandisement. Democratic Czechoslovakia issued the so-called 'Benes decrees' in 1945 which accused 2.5 million ethnic Germans of collective treason to the Czechoslovak state through their support of separatism. Regardless of individual political or military records, property was confiscated, citizenship revoked and the people expelled to Germany.

However, even these drastic solutions were rarely as satisfactory in creating ethnic homogeneity as their instigators expected. The definitions used to define ethnic groups were usually crude and uni-dimensional. In the 1923 case, 'Greek' and 'Turk' were defined by religion (Orthodox Christian and Islamic respectively); the Anatolian 'Greeks' were generally Turkish in culture and language, while Macedonian or Thracian 'Turks' were European in many aspects of their culture and lifestyle. Each formed something of a new estranged minority on 'return' to their designated 'correct' but culturally unfamiliar 'homelands' (as described, memorably in Louis de Bernières' 2004 novel, *Birds without Wings*).

There is a moral chasm between ethnic cleansing through population transfer by forced or induced deportation, and genocide. The former has been justified and even perpetrated by liberal democratic governments on the basis of the ultimate well-being of the populations concerned, whether migrating or remaining. Indeed, historically it has often been no more than assisting and channelling what otherwise would have been an uncontrolled voluntary migration. Obviously genocide has never been justified by such arguments. The distinction may become blurred when a forced population movement is mishandled by design or by neglect. Although the estimates are contested (ranging from around 2 million to more than 20 million), it remains the case that the 1945–46 migration of ethnic Germans caused huge mortality. Again, it is estimated that the forced deportations of Armenians in Turkey between 1915–8 led to more than a million deaths, apparently as much through Ottoman indifference and incompetence as by design. The outcome for the victims may be much the same, but whether genocide requires

expressed intent rather than only a culpable neglect has clouded the discussion of many of the historical events mentioned above.

The removal of the people, whether through deportation or extermination, still leaves the problem that traces of their heritage survive in the areas that they formerly inhabited. Indeed such relics become dissonant in a number of respects. They clearly no longer relate to the current population, among whom they may evoke feelings of unease or even guilt, and could form the basis of later claims, whether political or financial, upon the successor occupants. It is not surprising, therefore, that the removal of populations is often accompanied by the physical eradication of their principal heritage landmarks. In the Yugoslavian case the International Criminal Tribunal Yugoslavia has painstakingly documented the damage and destruction of major buildings and come to the simple conclusion (Riedlmayer, 2002) that the destruction of buildings associated with Catholic, Orthodox and Moslem populations occurred at, or soon after, the departure of the Croat, Serbian and Bosniak populations that respectively used them. Preservation and alternative re-use has been exceptionally rare.

However, the complete eradication of vernacular structures and their heritage associations is scarcely a practical option. Even today, the highway through Pomerania to Polish Gdansk (formerly German Danzig) passes through quintessentially Germanic townscapes. There is already extensive German tourism investment in former German property in the lake country of what is now Polish East Prussia. Equally, there is also a latent if currently legally frustrated German demand, not least from the descendants of their former owners, for second homes in the Sudentenland of the Czech Republic. The residual Germanic landscape in and around Kaliningrad (Königsberg) has perversely engendered a sense of place in its Russian population, who have been disoriented by their post-cold war physical separation from Russia. Even major heritage structures may be accepted, appropriated and restored (with detail adjusted) when the successor states/populations can claim a historical identification with them: this is classically so in Poland, as the painstaking restoration of the great cathedrals (and much else) in Gdansk and Wroclaw (Breslau) testifies (Tunbridge and Ashworth, 1996). The castle of the Teutonic Knights, prime villains of the Polish national historical narrative, at Malbork (Marienburg) was successfully nominated by the Polish Government for inscription on UNESCO's World Heritage List in 1997 (Figure 6.3).

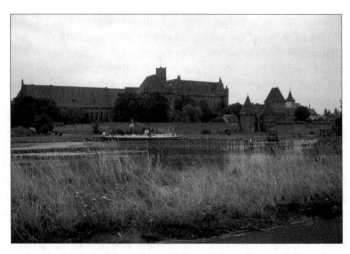

Figure 6.3 Malbork Castle, Poland; formerly Marienburg of the Teutonic Knights, German East Prussia (1992)

Physical containment

An historically widespread alternative policy to eradication or denial is the creation of accepted physically demarcated 'zones' or 'quarters of toler-ance' (Vance, 1977) isolated in various ways from the majority population and thus non-threatening to it. The Jewish ghetto provided the best exam-ple in pre-industrial Western urbanism but there have been many others. The *millet* system of separate administration and taxation for cultural and religious minorities within the Ottoman Empire resulted in a fairly routine designation of specific quarters in most cities for self-regulating cultural minorities, generally defined by religion (Karpat, 1982). In Western Europe, sixteenth-century Norwich had a 'strangers' guildhall and district for immigrants, largely from the Low Countries. Within such zones, tangi-ble and intangible expressions of heritage may be articulated without contaminating the majority culture.

The negative resonances of ghettoisation, culminating in its associations with the Jewish Holocaust, negate such containment as an intentional policy option in contemporary democratic societies. Never-theless, the heritage significance of the former *Judengassen* or *Rues des Juifs* and non-Jewish equivalents frequently persist, whether welcome or not. The simultaneous recording of attainments and persecution in the

Jewish Museum in Berlin may be seen as a warning to German society against a reversion to an assimilation–containment model in its present uncertain progress towards more open heritage pluralisation; the Museum draws a specific parallel with the present-day Turkish minority.

Museumification and vernacularisation

Potential challenges to (or distractions from) the single core from other non-assimilated heritages can also be handled though policies of 'museumification' or, closely related, 'vernacularisation'. These strategies seek to depict perceived deviant groups as harmless and non-threatening. Their heritages are contained and marginalised as curious colourful and somewhat quaint survivals from the past, which can be treated as museum artefacts or folklore. In the museumification of heritage, the intent is to break any possible connection between the viewer's present and the displayed past. The exhibits are presented as interesting for their antiquity, ingenuity, beauty or strangeness, but they possess no intrinsic ideological message of any significance to the present or the future. The viewer is not supposed to identify with the exhibit, or trace any significant connection between then and now, between 'it and me'. In the extreme case an explicit negative connection may be intended, as in Hitler's unrealised Jewish Museum in Prague, which would have used looted artefacts to depict an extinct race.

On attaining power, all successful political and social revolutions confront the dilemma of their attitudes towards the superseded *ancien régime* and especially their treatment of its memories, and its physical and even human survivals. The 'year zero' option that ignores, denies, conceals and destroys all that preceded it is, however attractive, rarely completely practical or sufficient. The Soviet system, for example, was confronted in 1917 by numerous large churches and mosques whose presence directly contradicted central tenets of the new atheist ideology. An alternative to vacancy or demolition was to turn them into museums of art and history devoid of any religious or ideological significance. Museumification may be a device to avoid ideological conflict. Hagia Sofia (Istanbul/Constantinople/Byzantium) is arguably Christendom's most significant church but also since 1453 important to Islam as the mosque of conquest. The current secular Turkish regime tries to maintain it as a neutral, historical museum, devoid of religious meanings and forbidden for religious ceremonies.

There is a further difficulty in that denial or destruction is impossible if the heritage of the revolutionary struggle and its ultimate triumph is to

be used as the heritage underpinning and justifying the new regime. In this narrative there must also be an enemy whose existence and actions provoked and then legitimated the struggle. Martyrs and heroes require oppressors and villains. The palaces and prisons of the oppressor, far from being concealed or ignored, become centre-pieces to be preserved, interpreted and promoted to visitors as important vehicles for the transmission of the new heritage of the new state to its new citizens. A particular link between the present and the past needs to be re-established.

This is particularly characteristic of postcolonial states, in which an unprecedented number of new political leaderships have sought legitimacy through the rhetoric of 'struggle' against their former rulers. Artefacts of colonial oppression are good for credibility. Cape Verde preserves Salazar's Portuguese torture chambers: India preserves the British prison on the Andaman Islands. More generally, a pattern of colonial islands of banishment exists which can be interpreted in a similar vein (Tunbridge, 2005). Aside from Devil's Island (Cayenne, French Guyana), the most infamous among them is South Africa's Robben Island, where, in the interests of a reconciled national pluralisation, the villainy is ascribed to an extinct system (apartheid) rather than to extant states or settler populations (see Chapter 10). Colonial heritage can also involve sequent oppressors, at whom the motif of struggle can be selectively targeted. In Melaka (Malacca, Chapter 8), it is the Portuguese rather than the Dutch or the incidental British who are thus demonised (Worden, 2001), while, in Havana, it is the Americans who are culpable rather than the Spanish (Lasansky, 2004).

Vernacularisation is a process similar to museumification and conducted for similar reasons. The vernacular counterpoises the common people against the elite, the unselfconscious craftsman against the self-conscious artist, the hand-made against the industrially mass-produced. The Hazelius idea of the open-air folk collection, known after its first (1891) Stockholm location as the *skansen*, lends itself particularly well to the transformation of cultural groups into folk objects. In fact they were from the beginning intended to be defensive, preserving objects and ways of life that were already obsolete and disappearing. The inclusion of a cultural group in such a *skansen* marks it immediately as of no significance to the visitor's present or to modern society:

> Visitors were encouraged to go to such *heimat* museums in order to see themselves and identify with a larger collective, albeit usually in a romanticised, nostalgic and essentialised form; [further] the

democratisation of culture [thereby] was promoted as a mechanism for the re-civilisation of a society which had demonstrated how close to the surface lay barbarism.

(Mason, 2004: 56–7)

These remarks relate to traditional folk museums following the Hazelius philosophy (such as: St Fagan's, Wales; Szentendre, Hungary; or Hjerl Hede, Denmark) and not to all building collections or museums of everyday life, whether open-air or not. Some among the latter, including Ironbridge (Shropshire, England), Beamish (near Newcastle upoon Tyne, England) or the open air oil museum at Gorlice (Poland) have a reverse intent in that they are memorialising and usually celebrating the origins of a future success rather than preserving and mourning past failure. To vernacularise heritage is to render it irrelevant to the present and thus to remove any threat from it. If history is written by and about the winners, then the losers are generally to be found to have consigned themselves or been consigned by the winners to appear in the folk museum.

Eastern and Central Europe is particularly rich in ambiguously and contradictorily defined and delimited social and ethnic groups that inevitably exist uneasily with the fluctuating nationalisms and erratic state structures and boundaries of this region. One among many such entities may illustrate the changing roles played by a sporadic attention to heritage. The Lemks (or Lemkos/Lemkovice/ Rusini/Rusyn, as even their nomenclature is a matter of dispute) migrated as herders into the northeastern Carpathians between the thirteenth and the fifteenth centuries. The longevity of their land occupancy is an important claim upon territory and thus varies with the political agenda of the historical source. From a Ukrainian perspective, they are just a westward extension of Ukrainian-speaking, Eastern Christian peoples. From a Habsburg perspective, they were Ruthenes, different from the Ukrainians especially in their widespread adoption of the so-called 'Uniate' or Greek Catholic religion after the agreement of 1595. The post-1919 Polish state saw them largely as one of many regional Polish variants (alongside the Lachs, Boyks, Pogorzanie, and many others who were grouped together as being merely Polish 'highlanders'). In the early post-1945 communist period, they became suspect, whether justifiably or not, as sympathetic to Ukrainian nationalist groups (including the UPA armed resistance). In addition, the post-1945 boundary changes had allocated the historically, and still largely ethnically, Polish areas of Eastern Galicia (especially Lwow/Lviv/Lemberg) to the Ukraine, which

exacerbated Polish–Ukrainian relations over boundaries. Consequently, the Lemks were peremptorily ethnically cleansed in 1947 (in 'Operation Vistula') through mass deportations of around 200,000 people away from the sensitive frontier area to elsewhere in Poland. Since 1957, many have emigrated, especially to the United States, and a considerable number have voluntarily returned to southeastern Galicia. Current population estimates range from 5800 (2002 official census) to 50,000 (EU education/ training directorate report, 2004).

The Lemks' material heritage is strongly represented in the *skansen* at Nowy Sacz (Sacz Ethnographic Park founded in 1975), where they are represented as colourful if primitive peasants, and in the Magursky National Park. This folklore approach receives much encouragement from a tourism industry strongly promoted, most especially in the United States, by diasporic groups. The stress is upon language, clothing and gastronomy (including some Lemk restaurants). The annual Lemk festival at Zydnia Vatra is still largely for internal consumption but is also generating some tourist trips, especially from expatriates. There is very little official Polish recognition of the existence of this distinctive cultural group (Council of Europe, 2002) and it remains a folkloristic survival rather than a living culture. This is feeding into a growing self-awareness and local assertiveness which, increasingly, is somewhat resented by non-Lemks, who feel excluded economically or politically in southeast Galicia. The memorialisation of Operation Vistula remains private (most Uniate churches have recently erected memorials to the deportations in their own grounds) rather than official, and the topic remains difficult in the light of still sensitive relations between Poland and Ukraine.

A variant of vernacularisation was the tribalisation policy of the apartheid regime in South Africa which did not ignore the heritage of the majority black African population, but attempted to vernacularise and re-tribalise it. The government stimulated and promoted the languages, traditions, ceremonies and craftwork of the various tribes, treating them as anthropological survivals and folklore curiosities. Conversely the urbanised, industrialised, de-tribalised black Africans were left out of the promoted heritage, though all efforts were made (as in the gold-mining compounds of the Rand) to sustain their awareness of their competitive tribal origins. This had the obvious political advantage of *divide et impera*, separating the black majority into smaller, competing and more manageable units, linked to the 'homelands' policy. Vernacularisation and re-tribalisation also encouraged the propagation of a sub-text of black Africans being traditional, untouched by modernity, and thus in need of white guidance and protection in the complex contemporary world.

An additional benefit lay in the creation of an attractive tourism product. Alongside the experience of the exotic, colourful, primeval and unspoilt wildlife, there was also the visit to view the 'natives' to whom very similar adjectives could be applied in tourism brochures.

CONCLUSIONS

Pluralist policies based upon assimilation models of one sort or another are probably the most widely encountered on a global basis and are found in many otherwise quite different types of society. Although they all have in common the idea that there is only one legitimate and universal set of core values, they vary considerably in their recognition and treatment of variations from such a core. Policies range from an active propagation of core heritage to a passive, complaisant acceptance that it just exists. Official reactions to non-conforming groups can similarly range from a total denial of their existence, through indifference or a begrudging tolerance, to policies designed to incorporate or eliminate them from public expression and consciousness.

Among the many variations of single core models are places that accept the existence of only a single core but make little attempt to assimilate variants from it. The majority culture effectively ignores minority variants to the extent of deliberately excluding them. Assimilation is regarded by the majority as impossible or undesirable. In such models there is little point in promoting core heritage outside the core group, so it is just not attempted. Such heritage is regarded as simply not available to, or suitable for, outsiders. In Japan, for example, the indigenous Utari minority on Hokkaido (numbering about 50,000) are largely ignored, or more recently tourism-commodified, and misnamed 'Ainu' by the majority (Cheung, 2005). The much larger and more recent Korean minority is similarly largely invisible and ignored in official policies, with no effort being made at assimilation.

There are several cases, which could be labelled 'two-directional' variants, in which there is a single core identity, strong homogeneity and few deviant groups. This cultural identity may, however, be projected in two different versions to two different groups of recipients, usually one internal and one external. Malta, for example, is a classic expression of the assimilation model, with no significant minority issues and no ostensible basis for dissonance. Its national heritage identity has assimilated layer upon layer of external elements extending back over five millennia. This has resulted in a strongly cohesive society, a clear and distinct identity unique to the island

group, but also a remarkable endowment of historic relics and associations relevant to an international public. Consequently, Maltese heritage is expressed both locally and globally. The local is irrelevant and literally unintelligible to outsiders (Figure 6.4), while the global links Malta to international historical events on a world stage (see for example Elliott, 1980; Pollacco, 2003). The point is not that Maltese society is divided for, on the contrary, it is remarkably uniform. It is that heritage and tourism agencies serve two separated and different markets using quite different messages, in Maltese or English as appropriate (Ashworth and Tunbridge, 2005).

Assimilation policies can also be applied consistently over the long term or be sporadic and temporary reactions of the majority to specific circumstances. Although the logical purpose of all such policies, the shaping and public expression of a universally accepted monopolistic single core, appears clear, the attainable objective may not be. Multiple cultural identities may continue to exist and be accepted either in a hyphenated hybrid form or in some type of hierarchical relationship, whether a 'Russian doll' family of non-conflicting spatial scale identities or merely a distinction between public and private expression. Ultimately, the persistence of unassimilated minorities may make it difficult to distinguish these models from core+ models or even multiple-core pillarised societies, both considered in later chapters.

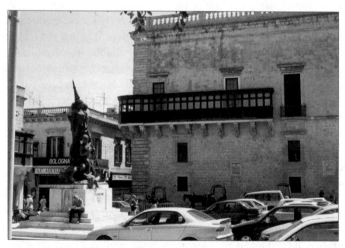

Figure 6.4 Valletta, Malta: martyrs' monument (in Maltese) by Grandmaster's/Governor's Palace (English plaques) (2003)

7 HERITAGE IN MELTING POT MODELS

While assimilation models aim to incorporate diverse ingredients into an existing core without substantially changing it, melting pot models result in a new single core that is not the same as any of its constituents. The process, whereby different groups distil a new culture significantly different from that of any of its constituents through interaction and adaptation of selected attributes from each other, is often referred to as 'creolisation' (Hannerz, 1992). This term originates from the Caribbean where French, English, Spanish, African and other influences have produced new cultures that differ from island to island (Augier et al., 1960). Equally, the idea of the English language and culture emerging from a fusion of Celtic, Saxon, Scandinavian and Norman French ingredients was central to Victorian novelists and social commentators such as Walter Scott and Mathew Arnold. Although creolisation is the process that occurs in the melting pot, it is a far wider topic than our primary concern here, which is less to do with cultural interaction as such than the devising and implementation of the melting pot model as an act of deliberate and official policy, with a clearly envisaged role for heritage.

Three broad applications of the melting pot model are considered in this chapter: settler societies absorbing large long-term immigrant flows from ethnically diverse sources; societies engaged in nation-building in newly independent, usually postcolonial, states; and, third, its use in social engineering to create an élite in a population.

In theory, heritage has as clear and important a role in the operation of the melting pot as it had in the assimilation models considered in the previous chapter. Much the same instruments are also used for its expression and propagation. A 'birth of a nation' mythology is employed as the central idea that describes and justifies the new society, together with its new values and destinies. Conversely, old heritages must be disowned, or reduced to a subordinate position as a variant of the new, rather than competing with it. In settler societies, the heritages to be discarded would be those of the 'old

country', which were imported with the immigrants. In postcolonial societies, two heritages must be rejected: that of the colonial regime which must be discarded or rendered harmless, and also that of the cultural or regional minorities that are to be subsumed into the new nation.

In both types of society, the old heritage must be denigrated as inimical to the new, or at least depicted as being of lesser value. The flawed heritage of the old country was one justification for settler migration, while the new postcolonial state is rising above the divisive tribalism of colonial times. Both the positive and negative roles are expressed by official agencies using the same educational, cultural, spatial planning and design agencies of government as do assimilation models.

SETTLER SOCIETIES

The societies which developed as repercussions of European settlement overseas provide the most notable examples of the first application of the melting pot, often implemented through officially sanctioned policies. The diversity of these societies stemmed from two sources: the immigrant streams themselves and the existing indigenous populations encountered in the colonies of settlement. Frequently, different policies of assimilation were applied to each of these sources of difference.

The United States

In this context, 'melting pot' describes the process of immigrant adaptation to mainstream US society and the emergence of a new national identity, sharing common characteristics and values that are distinctly different from those of the immigrants' societies of origin. The origins of the expression are generally attributed to a play performed in New York in 1908, written by a first-generation immigrant, Israel Zangwill. The place and time are significant and explain the rapid acceptance of 'melting pot' as a descriptor, most particularly of the eastern seaboard cities of European arrival. The preceding two or three decades had witnessed the largest wave of immigration, predominantly from central and southern Europe and specifically to these cities. In this sense, the phrase was describing what had already occurred but it also quickly acquired connotations of a desirable future end-state. The dominant 'pioneer mentality', even among those who were following some generations behind the first settlers, stressed the newness of the country and the continent and the necessity of it being inhabited by a new people.

The major preconditions for the success of a melting pot are that its ingredients must be both willing and eager to 'melt' and also must not be too dissimilar. In the US case, the migrant streams often shared in their rejection of, or being rejected by, their places of origin whether for religious, ideological, social or economic reasons. In turn, they might willingly abandon old political and cultural allegiances in exchange for new opportunities. Second, the ethnic and racial characteristics of the migrants did not differ substantially either from each other or from the existing society. This was a relatively homogeneous population in some respects, in which neither black slaves nor indigenous peoples were assumed to be eligible for citizenship. English, Irish, Poles, Italians and Russians migrants may have had many obvious cultural differences but they had more cultural, religious and racial characteristics in common with each other and with the existing host society than did subsequent immigrant streams from outside Europe. The possibility of major change in this relative homogeneity generally resulted in action being taken to maintain it, either through legal actions designed to prevent a particular migration, or by the introduction of wide-ranging racial and ethnic quota systems. Individual states introduced laws from time to time in response to local circumstances, as for example in the unease over Chinese and Japanese migration in the West Coast states that led to the Federal 1882 Chinese Exclusion Act and the 1907 agreement with Japan to restrict Japanese migration (Hill, 1993; Wallenstein, 1998).

The logical development was a quota system that determined that the ethnic composition of the inflow would mirror that of the existing society, thus stabilising the product of the melting pot. The United States developed the most comprehensive system in the 1921 Quota Act, in which the desirable overall national migration rate was arbitrarily set at 3 per cent. Each existing ethnic group in the US was allowed to increase by this percentage. An allowable maximum number of potential migrants of each ethnicity could now be calculated. The recipe for the melting pot product was thus fixed, at least until the legislation was repealed in 1943. Establishing the statistical base for such a calculation is of obvious significance in a changing society. Originally based on the 1910 census, The Quota Act was backdated to 1890 in order to favour the original countries of origin, principally in northern and western Europe.

The 'White Dominions'

Similar policies were ultimately pursued in the British 'White Dominions' of settlement: Australia, Canada, Newfoundland, New Zealand, and even,

to an extent, in the explicitly racially defined South Africa, and the semi-autonomous Southern Rhodesia.

Nevertheless, it can be questioned whether a melting pot policy was consciously operated in Australia, at least for the first 150 years of its settlement. It was ethnically more homogeneous than the United States, viewing itself as Britain overseas. There were few intentions of modifying this by the addition of other ingredients or by the evolution of a distinctively different society. Consequently, a 'white Australia policy' was as old as the Commonwealth of Australia itself. The term 'white Australia' was not officially sanctioned, largely due to British concerns about its effect on a multi-racial empire. Nonetheless, the Immigration Restriction Act of 1901 explicitly maintained the racial and, as far as possible, also cultural homogeneity of the population in the face of a perceived threat of immigration from populous Asian neighbours signalled by an earlier influx of Chinese gold miners. The tension between these fears of ethnic change, social instability and competition from cheap labour, on the one hand, and the need for immigrants on the other, led to the 1929 National Origins Act. This established arbitrary, if flexible, border controls based upon the ethnic and racial acceptability of the immigrant. By the second half of the twentieth century, however, the widening of the sources of immigration, together with a growing self-confidence, had contributed to a distinctive Australian identity that incorporated elements such as location, historical experience (especially of the World Wars) and the natural environment. A melting pot model came into existence incrementally, with a widening of the variety of ingredients to include, first, other European and, later, Asian and Pacific immigrants. Although governments may not have explicitly introduced such a policy, they tacitly allowed it to evolve by revising the White Australia policy in 1952, effectively abolishing it in 1965 and formally renouncing it in 1973 (Windschuttle, 2004).

Officially, contemporary Canada rejects the idea of being a melting pot. This is regarded as an American concept with little resonance north of the 49th parallel where the contrasting idea of the mosaic or salad bowl is embraced as something distinctly Canadian (see Chapter 10). It is worth noting, however, that up to a point there is a distinctive Canadian identity that is not British, French or even American. It could be argued that the vociferous Canadian rejection of the melting pot and equally loud promulgation of the salad bowl model describes no more than an inefficient melting pot, resulting from the absence of a clear single identity focus for the melting process, and operating at least for most of its history upon an ethnically narrow range of ingredients.

[120]

Melting the 'recalled' diaspora in Israel

Israel can also be regarded as a colony of settlement superimposed upon a large existing indigenous population. The conditions surrounding the establishment of the state of Israel in the territory of the Palestinian mandate in 1947 led almost inevitably to the adoption of a melting pot model as official government policy. The existing Jewish population was composed entirely of immigrants and a central justification for the establishment of the state was to encourage the Jewish populations from around the world to settle there. The only common feature of this diaspora was that of being Jewish, whether in terms of religious philosophy or, more usually, sets of traditions and customs. Every other racial, ethnic or cultural feature was inevitably different. There was no doubt about the need to deliberately create a new identity from these diverse elements to suit the new conditions; the only discussion was over the form this should take. The numerical and political dominance of the Eastern and Central European Ashkenazi communities favoured a Yiddish-speaking, urban-European, national cultural identity. This was rejected, however, as being too reminiscent of the marginalised and subservient ghetto society and of the Holocaust experience. To some at that time, this was a traumatic past that was better forgotten than remembered and used as a justification for the creation of the new society.

Instead, the modern Israel would have a distinct identity that deliberately distanced itself from the role of Jews in European society and from the tragedy of recent history. This was done by appealing to an older history, that of the previous Jewish occupation in Palestine before AD70. The revival of Hebrew as a spoken language, the encouragement to change personal names into Hebrew and to use biblical forenames, the creation of a landscape of sites and names referring back to a previous state of Israel, all appealed to a distant past in support of a present and future. Two of Israel's five World Heritage Sites relate directly to this conceptualisation of identity. The hilltop fortress of Masada (inscribed in 2001) is the site of the Jewish last stand during the revolt against Rome in AD73. Again, the 'White City', Tel Aviv (inscribed 2003), represents the architectural production of the largely Ashkenazi Zionist immigrants in the pioneer return period between 1920 and 1950. The other three World Heritage Sites are more ambiguous in that they encompass other ethnicities. The Negev 'Incense Route' is largely Hellenistic while the 'Biblical 'Tels Route' (i.e. burial mounds) includes various Old Testament Jewish and non-Jewish sites such as Megiddo and Beersheba. Perhaps the strangest inclusion on the list is the crusader town of Acre/Akko

(2001) where Christian heritage, now largely inhabited by Moslems, is conserved by a Jewish state. The incongruity is possibly explained by the modern relevant echoes of the narrative of the Christian Crusader state to an implanted and embattled Jewish state in a hostile Moslem world

These policies can be judged successful in so far as they have shaped a single distinctive Israeli Jewish identity that is quite different from that of traditional European Jewry. This has also proved capable of assimilating large numbers of later migrants from quite different ethnic and racial origins. The melting pot did not, however, instantly eliminate all cultural differences. The religious–secular tensions persist and have probably intensified: minority cultural groups such as Ethiopian or southern African claimants of Jewish identity remain, whether temporarily or permanently, as incompletely smelted 'residuals' characterised by race or by language. Furthermore, Israelis of Arabic origins, who constitute almost a quarter of the state's population, have an ambivalent relationship between their cultural identity and citizenship.

Other melting pots

Many variants of the melting pot can be found in the Caribbean and Latin America. Most Caribbean societies are locally unique composites of various European, African and Amerindian ingredients, often in longstanding mulatto and *mestizo* mixes, in some cases later augmented by Asian immigrants. While some function unselfconsciously as mini-melting pots, African–Asian tensions persist in others such as Trinidad and Guyana, despite state commitments to national fusion. Most Andean countries are characterised by a white–*mestizo*–Amerindian spectrum which, superficially, may resemble a centripetal melting pot but can be depicted more realistically as a sharply demarcated social hierarchy. In both Caribbean and Andean states, where marked social stratifications and tensions exist, they are also associated with polarised heritage perceptions, particularly concerning the European conquest and its cultural displacements and, more recently, imported religious rivalries. These may persist in spite of state commitment of scarce resources to creating a common heritage, as has been the case in Guyana since independence.

In Brazil, the apparent melting pot of white European immigrants, descendents of African slaves and the indigenous Amerindian population is again, more accurately, a white-dominated social hierarchy. However in southern Brazil, Uruguay, Argentina and Chile, diverse, predominantly European populations have melted much as their peers have done – and

visible minorities have less clearly done – in the United States. In Argentina, for example, Italian and Welsh heritages are remembered, and indeed the British connections were used as blandishments to attract the islanders' allegiance prior to the Falklands War in 1982. These cultural minorities are first and foremost part of an essentially Spanish-speaking state. In all these cases it could be questioned where the line might be drawn between melting pot and assimilation.

Outside the melting pot

The success of the melting pot in settler societies should not be underestimated for it did produce, in no more than a few generations, new social orders that were self-consciously and assertively different from their origins. Large numbers of migrants from diverse origins were absorbed without serious economic problems, social instability or political collapse. Later criticisms and modifications tended to revolve around the widening of the range of ingredients and the changing of the product rather than the process itself. However, in almost all cases there were groups whose absorption was incomplete or who were merely outside and untouched by the melting pot process.

Melting indigenous populations

Indigenous populations in the original colonies of settlement were frequently viewed as being too different to incorporate into the shaping of the new societies and as undesirable to the melting pot. The indigenous populations of North America and Australasia were regarded as existing outside 'white' society. In general, they were not consulted as to whether they wished to be so included. Therefore neither passive consent nor active willingness on the part of the constituent group, an important part of the melting pot process, was present.

It was only later in the evolution of colonies of settlement that these groups attracted attention through their continued existence, population growth (in some cases), and often geographical dispersal from their former spatial isolation in largely unproductive peripheral regions. This led to the development of the two completely incompatible approaches and policies of either assimilation or cultural preservation.

Policies of assimilation, de-tribalisation and functional integration were supported as being, it must be remembered, beneficial to the groups

themselves who were offered a place, often whether they wished it or not, within the new society being created. Frequently, they were even carried out by religious and charitable agencies inspired by the apparently commendable motive of assisting the incorporation of such groups into mainstream society and economy. Such processes are now viewed by many as a form of cultural genocide, as the idea of conserving indigenous cultures has superseded that of destroying them. As in the Aboriginal reaction to the White Australia policy (Windschuttle, 2002, 2004), this complete reversal of previous policies inevitably directly compromised the melting pot idea, which is incompatible with the idea of preserving and fostering indigenous cultural minorities.

The case of New Zealand demonstrates interesting differences, for its indigenous Maori population constitutes nearly 15 per cent of the national population, rather than the 1 or 2 per cent shares of the aboriginal population in either Canada or Australia. Like other indigenous peoples (and interactively with them) the Maoris are currently seeking a restitution of land and resource rights, in their case largely a redress of *Pakeha* (white) bad faith in adhering to the terms of the Treaty of Waitangi (1840) whereby New Zealand was ceded to the now mainstream society. This restitution is now in progress (Hickey, 2006; O'Regan, 2006). Additionally, however, the Maori cultural presence is being variously inserted in mainstream society through widespread linguistic borrowing and the incorporation of Maori greetings and prayers into academic gatherings and sport, as well as by the introduction of Maori themes and iconographic references into the urban environment (Figure 7.1). They may thereby constitute the leading edge of melting pot creation in New Zealand, as its presently smaller Asian and Pacific Island populations grow.

Unmelted immigrants

The effective operation of the melting pot assumes a willingness to melt, which can to an extent be assumed to exist with most of the Atlantic migrations, but there was also forced involuntary migration. Black and, more recently, Hispanic groups were not only racially separate from the mainstream but also economically and politically marginalised through slavery on the one hand and conquest and peonage on the other. While the Hispanic groups have not been subjected to forced migration, their economic or political condition has often made their inter-American migration to the United States a matter of desperation. As well as victims of slavery and conquest, there were also groups whose presence in the New World was less than

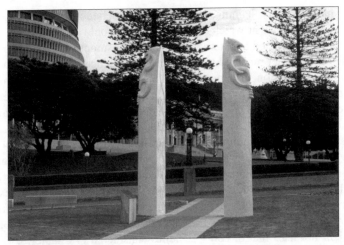

Figure 7.1 Wellington, New Zealand: Maori symbolism of peaceful boundary, on old shoreline, by Parliament (2005)

entirely voluntary, such as indentured labour and transported convicts. These latter groups may or may not have later accepted their migration and embraced their new social situation.

Although the black population of the United States has been present since the inception of the independent state itself, and could therefore consider itself one of the founding groups, it was always tacitly excluded from the melting pot (Wirth, 1928; Borchert, 1998). The deeply engrained black–white polarisation, which has characterised US society since the time of slavery, has been the cause of heated discussion, has motivated numerous initiatives – often to questionable effect – and has undoubtedly created racial double visions of heritage. The development of 'African/Black heritage trails' in Charleston, Savannah and other cities, often in quest of niche tourism revenue, has perhaps exacerbated this by the very process of promoting the formerly marginalised heritage (Tunbridge and Ashworth, 1996). However, race-related pluralisation of a truly, rather than supposedly, unified American past requires more than reconciliation of two or more racially defined heritages. Alderman (2002; 2003) has pointed out the different commemorative visions within the African-American population with respect to Martin Luther King, Jr., even where fundamental agreement on the heritage significance exists. These differences, illustrated for

example by street renaming, can largely be understood in familiar terms of the spatial scale at which commemoration should occur and whether it should be directed at external or internal consumption. The larger the scale of the street renamed, the greater the audience reached. Likewise, external orientation to engage the white population (which we might consider the pluralising perspective) can be in tension with internal concern to enhance black community cohesion, affecting the geography of street selection in cities in which marked racial separation typically persists. 'A street-naming struggle in Eatonton, Georgia (USA) exposes how the scaling of memory can become a point of division and contest within the black community as activists seek to fulfil different political goals' (Alderman, 2003: 163). This tension between goals of cohesion within a particular group and a wider inclusion beyond it is not confined to melting pot models but will reappear in different guises with other models, not least that of core+ societies considered in Chapter 8.

One resolution to the problem of incompletely incorporated social groups is cultural hyphenation, whether adopted by the group concerned or imposed upon them by others. The group both retains the original culture and simultaneously assumes that of the new society. This may be no more than a transitional phase easing the reception of new groups, as illustrated perhaps by Italian-Americans or Polish-Australians. Conversely, it may be a strategy for the, at least partial, inclusion of hitherto largely excluded groups, such as African- or Chinese-Americans.

There has been a notable increase in what could be called hyphen-specific heritages, even in the archetypical melting pot society of the United States. Museum exhibitions, policies for public statuary and commemoration, tourism packages and trails as well as long-term educational and cultural programmes have been widely devised around particular groups of culturally hyphenated Americans. There is some evidence that these developments are responses to popular demands that indicate some weakening of the willingness to melt into the mainstream among both the most recent immigrants, who are dominantly non-European (Branigan, 1998), and also among longer-established immigrant groups for whom a rediscovery and reassertion of 'roots' has become a fashionable preoccupation. It remains unclear whether such programmes are mainly targeted at the designated groups, with the intention of fostering greater self-awareness or cohesion within those groups, or at a wider market with the purpose of demonstrating the varied constituents of the end product. Either goal could be read as easing or, conversely, compromising the operation of the melting pot. This may depend on which of the

two hyphenated cultures is regarded as being substantive and which is merely a subdivision of the other. If both parts are of approximately equally weight, a hyphenated melting pot product elides seamlessly into the core+ model considered in Chapter 8.

In theory the production of the melting pot is dependent upon the nature of the ingredients added to it. If those ingredients change then so also will the product. Experience in the United States, however, suggests that this change does not occur. The melting pot of the first 150 years processed immigrants who were racially and, to the extent of being dominantly European, culturally homogeneous. The existing black and Native American communities were largely ignored, killed or regarded as being invalid ingredients. The American identity produced from this process then became the idealised end product. Later migrations have been composed of much larger numbers of Afro-Caribbean, Latin American and Asian elements, which some fear threaten to change the racial and cultural character of US society. These new groups were generally expected to adapt to and associate with the identity produced by the much earlier melting pot. Indeed concern has long been expressed in culturally conservative circles that although the new society was produced by past migration, this process was now complete. The idea of an 'arrested' melting pot is of one that has in the past created the new society but where change must now be discontinued so as to defend that society from the dilution of new and different ingredients. This found political expression in the 'America Party' of the mid nineteenth century and the 'Immigration Reduction League' of the early twentieth century, and is echoed by some contemporary popular sentiment. It could be argued that the imposition of the ethnic quota system was not just a fossilisation of the existing ethnic composition but an attempt to return it to that of some years earlier, as it began by basing its figures upon a 30-year-old census.

The persistent pursuit of the melting pot idea, despite its many difficulties, is rather remarkable, as is the popular support it still receives from many, if not most, sections of US (and increasingly Australian) society. For example, in describing the clash of global civilisations, Huntingdon (2002) regards US society as still being essentially unified, despite all the caveats mentioned above and the persistence of incompletely incorporated elements. This reflects not only the past operation of a melting pot but also its continuing capability to handle even more diverse ethnic and racial ingredients. However, contrary to that view is the idea that evolutionary change is not only permissible but is usually inevitable in a true melting pot model. The

end product will be determined by changes in the ingredients. Resistance to this idea, and not only in the United States, suggests that melting pots tend to be short-term experiments, often triggered in response to extraordinary circumstances. They either fail, in which case they rapidly evolve into other models which can accommodate greater pluralism; or they succeed, in which case they are likely to become indistinguishable from the assimilation model considered earlier.

POSTCOLONIAL MELTING POT EXPERIMENTS

Decolonisation after the Second World War left successor states with diverse and competitive ethnicities and cultural traditions, within externally determined boundaries, some of which clearly conflicted with indigenous population patterns. Western colonial control had also often permitted or encouraged migration flows of subject and other peoples, which introduced new minorities. The process of de-colonisation was also frequently contentious, both during the conflict against the colonial government and in the inter-ethnic struggle for power that often followed. The result was often a legacy of distrust and animosity between ethnic groups. Responses to the management of such plural populations and their pasts have spanned the range of possibilities, including some attempts at the creation of new national personas from diverse ingredients. Two cases from among the many new nation-states to emerge from the de-colonisation of the European empires overseas – Indonesia and the Philippines – are considered in detail here. Both are located in Southeast Asia, a region which has been referred to as a 'shatterbelt' (Cohen, 2003) of competing human flows and cultural influences. On this was superimposed an external colonisation by a variety of Western countries, sometimes sequentially, as early Portuguese or Spanish control was replaced by Dutch, British, French or US hegemony. In both cases, faced by this plurality of ethnicities, the postcolonial states have attempted to forge new national consciousnesses.

The Indonesian experiment

Although Malayan and Islamic influences are predominant, Indonesia's immensely fragmented archipelago contains great indigenous diversity in language and religion. The European overlays added buildings, town

plans and water control systems of Dutch origin, and Christian minorities as well as a large Chinese trading community. Dutch colonialism created the country almost as a by-product of the pursuit of trading interests over 400 years. A vast physical extent of islands, with enormous cultural and ethnic diversity, was assembled into a single polity. In sharp contrast to British India, however, the Dutch largely failed to shape a unity through the involvement of a local elite in government institutions, language or, more generally, a civil society. The passage to independence was also abrupt, unplanned, fractious and confrontational, and the unity subsequently achieved largely one of rejection of the colonial power, both as government and also as originator of any surviving valued cultural legacy. The government of the newly named Indonesia, proclaimed independent in 1945 and recognised by the Dutch only in 1949, faced wide cultural diversity, strong regional sentiment and an almost total absence of inherited governmental structures or experience in operating them. This resulted in the temporary political separation of the South Moluccas and the continuing presence of the colonial power in Western New Guinea.

Part of the solution to the plurality of the newly independent society was seen as being national unification through the superimposition of a standardised culture that would, in effect, be a melting pot. This was expressed through the *Pancasila*, the principles first expounded by President Sukarno in 1945, which were a clear attempt to find a common ground between religions and ethnicities. The state was to be monotheistic but not explicitly Islamic. The principles did not include *Sharia* law, which has provoked opposition from the beginning. There was a statement of belief in the idea of 'one nation' overriding racial, religious or ethnic distinctions. To the unifying principles of *Pancasila* was added a 'new' language designed explicitly to break with the past and create a binding medium for the new society. That *Bahasa Indonesia* (literally 'the Indonesian language') is linguistically only a variant of Malay, and not a distinct language or a deliberately revived ancient language such as Hebrew in Israel, does not detract from the significance of its purpose. Although spoken as a mother tongue by only 7 per cent of the population, it was selected in 1945 in preference to the numerically dominant Javanese as a clear symbol of, and instrument for, the shaping of a new society.

In many new postcolonial societies, the traditional ruling class was often excluded from nation-building and shaping of the new identity, in part because of its frequent association with the previous colonial power. The rulers of the princely states in British India were so elided, in part because

they represented separation and a division of wealth, status and power that was seen as inimical to the shaping of a new homogeneous national identity. In Indonesia, however, as in Malaysia, (Worden, 2001), the traditional ruling caste was largely incorporated into the new nationalism, and the persons and heritage of the sultans and kings were interpreted as living symbols of the new society and as preservers of local heritage during the colonial period. Courtly tradition thus became central to post-independence heritage reinterpretation. For example, the Sultan of Jogjakarta or the King of Solo are profiled as bastions of previous anti-colonial resistance and custodians of the expressions of a distinctive national culture. The palaces (*kratons*) and the vernacular artistic traditions they fostered, especially in music (*gamelan*), dance, drama (*waygang kulit*) and craft design (*batik*), are central to contemporary expressions of Indonesian heritage rather than marginalised obsolete curiosities from a previous age.

In tourism terms, Indonesia undoubtedly profits from the selling of plural pasts; each, however, is locationally discrete, usually reflecting and being marketed as the heritage of a particular island. This is most obvious in the Hindu island of Bali, the nearest exotic resort for Australians. Java markets itself through the World Heritage Sites of Borobodur and Prambanan (both inscribed in 1991), respectively Buddhist and Hindu and thus symbols of the incorporation of cultural and religious diversity into the Indonesian national narrative.

To many observers, however, it is clear that the experiment of an Indonesian melting pot has palpably failed. The *Pancasila* principles have to an extent become diluted through Islamic pressures for official recognition and subsidies. Many of the cultural minorities regard the concept of Indonesia as, in practice, little more than the imposition of a Javanese colonialism in place of that of the Dutch. This is associated with the exploitation of the resources of the outer islands, which were also used, at the expense of local groups, to absorb surplus population from Java and adjacent Madura. These settlers usefully served to outnumber or acculturate local populations. Government planned resettlement programmes, especially in Borneo (Kalimantan), Celebes (Sulawesi) and West New Guinea (Irian Jaya, renamed West Papua in 2002 after local representations) served both to relieve population pressure in Java and to spread Javanese culture throughout the archipelago. This colonising behaviour extended to the attempted acquisition during the past half century of Dutch New Guinea (acquired as Irian Jaya by diplomatic pressure in 1963), British northern Borneo (claimed and unsuccessfully infiltrated in 1962–66), and of post-Portuguese East Timor (invaded in 1975 and annexed until 1999).

The challenge to cultural and political unity has come both from the residual and possibly not absorbable groups inhabiting the spatial extremities of the archipelago, and also from what has been viewed as the 'enemy within'. Most usually identified as the large and longstanding Chinese community, and located largely in Java, this group has suffered discrimination and intermittent ethnic cleansing on various pretexts since the 1960s (Cohen, 2003).

In recent years, the failure of the attempt to singularise identity has resulted in some half-dozen peripheral areas experiencing internal turmoil and degrees of insurrection, variously combined with tangible local grievances (Cohen, 2003). Christian East Timor separated successfully from Indonesia in 1999, and escalating pressures in New Guinea for recognition of Papuan languages and cultures have led to some autonomy. Aceh, the northern extremity of the island of Sumatra, is somewhat different, being both Malay-speaking and fervently orthodox Islamic. It was also one of the last areas brought under Dutch control, after a series of long drawn out and bitterly fought colonial wars between 1873 and 1904. It has continued an uneasy relationship with the central government since independence. In sharp contrast to Aceh, the population of the Minahasa peninsula of North Sulawesi was dominantly Christian and developed a tradition of Dutch colonial service. Thus, these people have a longstanding suspicion of central rule from Java and have tended to support ideas of federalism and local autonomy.

The southern part of the Moluccas island group had two characteristics that rendered it exceptional and especially difficult to include in the melting pot. As a result of its especially long association with Portuguese and later Dutch influences, it has a large Christian population, who traditionally provided many of the personnel for the locally recruited Royal Dutch Indies Army (KNIL). This association with the colonial power provided an internal cohesion and external separation from nationalist sentiments. In reaction to the nationalist accession to power, an independent state of the Republic of the South Moluccas (RMS) was proclaimed in 1950. It was overthrown by Indonesian military force in 1951 but the continued existence of a government in exile in the Netherlands provides a focus for non-assimilation and the aspiration for separate statehood. The 40,000-strong exiled Moluccan community in the Netherlands, now third-generation descendants of ex-KNIL personnel, not only encourages the non-assimilation of Moluccans into Indonesian society but also forms a cohesive and still spatially concentrated non-assimilated group within Dutch society.

Indonesia appears to have three alternative futures. National fragmentation or at least an unravelling of the extremities is possible, a destabilising option that is unattractive to the neighbouring regional powers. Second, it may more or less survive but with an acceptance that the melting pot was no more than a Javanese-dominated assimilation or perhaps core+ model in disguise. Finally, the possibility exists of a continuation and refinement of the melting pot experiment, but this seems unlikely with the rise of a politicised Islam.

The heritage response: Jakarta

The Indonesian capital, Jakarta, which is located on Java, is the nexus of cultural pluralisms including: the direct European colonial legacy, its indirect consequences in settlement of non-Indonesian Asian minorities, and the continuing colonial and postcolonial interaction between Javanese and outlying Indonesians. In addition it has the problem of representing politically sanctioned versions of national identity in growing tension with the imagery of globalisation (Jones and Shaw, 2006). The European heritage includes Portuguese ethnic elements but is primarily the legacy of centuries of Dutch control. The original Dutch capital of Batavia, a port established by the Dutch East India Company (VOC), was superseded administratively after a Dutch government takeover by a nineteenth-century, inland, planned contiguous extension. This resulted in the older, more crowded and insalubrious port city becoming a zone of discard long before the colonial period ended in 1949, and dual urban inheritances which have been differently treated in the postcolonial era.

Following local political and community group intervention, some significant Dutch structures in the old city of Jakarta that survived redevelopment in the 1970s have been restored, even though plans for a tourist-oriented historic district failed through financial constraints and development pressures. However, Dutch relics in the old City Hall are juxtaposed with Indonesian displays, and a former VOC warehouse houses the national maritime museum. Some other Dutch colonial buildings are identified and have a tourism use, although a number of notable European structures, including a seventeenth-century Portuguese church, receive relatively little official acknowledgement. Nevertheless, as Jakarta is increasingly incorporated into the global economy, the wider role of non-governmental agencies in supplementing and potentially pluralising official heritage values is evident; examples include the

activities of the expatriate *Ganesha* Society in assisting restoration of the City Hall and publication of an ethnically more inclusive city guide. The Chinese minority identity, however, intermittently a target in the past, has been largely eclipsed from tourist-historic reference. In contrast the Hindu heritage is strongly promoted, through the early Javanese harbour, a continuing focus of intra-national commerce (Jones and Shaw, 2006).

The later Dutch government/residential precinct has been so recast for Indonesian national administration, iconography and media-focused events that its colonial origins have been largely erased, although mosque-over-shadowed churches remain. To the south, the 1962 Asian Games provided a hallmark catalyst for redevelopment of a monumentalised cityscape and elite residential area. This district was politically pluralised through the overlay of Suharto's capitalist imagery on Sukarno's socialist realism, which compounds the international versus nationalist identity tensions in the 'mother city' of Indonesia. In addition to the dissonances above, Jakarta, like Singapore, has experienced heavy top-down urban redevelopment in which community identities in many poorer areas have been obliterated.

The Philippines: a partially successful melting pot?

The Philippines is an archipelago similar in many respects to Indonesia, with a similar need to create a postcolonial national identity from a culturally diverse population. There are differences of language, with eight major languages being used by more than a million speakers and many small groups and other dialectic variations; of religion, with 80 per cent being Catholic but with a 5 per cent Moslem population in Mindanao and the southern islands; and of race, with *Mestizo*, ethnic Chinese and even some 30,000 indigenous 'hill tribes' (*Aetas*) (Cohen, 2003).

The perceived need to create a homogeneous national identity was expressed primarily through official policy towards language. As early as 1935, discussions began about the adoption of a distinctive 'Filipino' as the national language. *Tagalog*, which is spoken in the northern and central islands, is the dominant language in terms of number of speakers (29 per cent of the total, 1995) and also economic and political dominance. This was purified and standardised and in 1987 was formally declared as *Filipino* to be the main national language alongside English, which func-tioned effectively as a *lingua franca*. Another policy instrument is the devising and teaching of a national history focusing on the theme of the national 'freedom struggle' against, first the Spanish and, later, after 1898,

the United States, which culminated in independence in 1946. Curiously little of this is reflected in the Philippines' nominations for World Heritage Sites. The 'Baroque Churches' (inscribed 1993) and the historic colonial town of Vigan (1999) are from the Spanish period and only the 'Rice Terraces' of Ifugao province (1995) can be seen as distinctly Filipino in the sense that they are unrelated to any colonial occupier. Such nominations are often motivated, however, as much by the needs of the tourism economy as by those of national identity.

The Philippines can be regarded as a partially successful melting pot. There is a distinctive Filipino identity, even if this is viewed by some in the central and southern islands as little more than a *Tagalog* nationalism concealed beneath the cloak of national unity. However, most of Mindanao and the islands in the extreme south remain largely outside this national entity, primarily on the basis of their religion and consequent affinity with Indonesia. This has resulted in sporadic unrest and separatist demands over the past 150 years, which have been met by oscillating central government responses of suppression and partial accommodation (Cohen, 2003).

THE MELTING POT AS SOCIAL ENGINEERING

The idea of shaping a new society, composed of new citizens pursuing new ways of life and adopting new attitudes, through the instrument of a new settlement form and residential environment, is as old as Plato's *Republic* (360 BC) and More's *Utopia* (1516). These are melting pots in so far as the central objective is the production of new people, different from their origins in various critical respects. The difference between this variant of the model and those discussed above is largely one of scale. Typically, it reflects the desire of a national socio-political elite to inculcate an ideology with melting pot implications at the national scale.

This idea has been manifest in many different forms and was powered by many different motives throughout history, but, in almost all cases, there was a strong element of environmental (usually architectural) determinism in which the physical surroundings were both a reflection of the values of the new society being brought into being and also an instrument of communication and socialisation to the inhabitants. Consequently it is not surprising that many of these experiments, however short-lived and regardless of their degree of success, resulted in notable structures, building patterns and

even whole settlements. Many of these later become important heritage assets and major visitor attractions.

The main advantageous characteristic is often a unified plan and a one-period building style. Both contribute clarity and legibility. When governments were involved and large investments of creative talent and finance were harnessed to what was seen as a critical political task, then these qualities could be combined with impressive monumentality. Interestingly enough, the interpretation of such sites tends to focus upon the architectural expressions of the founding ideas rather than upon the ideas themselves. The architecture is more readily appreciated than is a previous and now probably long obsolete political philosophy. The ideas are usually left only vaguely explained and related to the architectural forms.

The British 'new towns'

While many such utopian concepts never proceeded beyond their literary expression, two British examples which did result in functioning settlements were inscribed as World Heritage Sites in 2001. Robert Owen's New Lanark, built from 1784, was motivated by a utopian socialist vision of a new order (Figure 7.2). Titus Salt's Saltaire (1853) represents a philanthropic utilitarianism in which a shared concern for

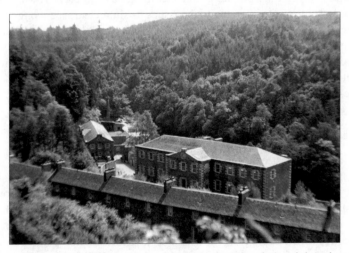

Figure 7.2 New Lanark, upper Clydeside, Scotland: model industrial community (1989)

the well-being of the workforce and profitability of the enterprise was combined in a new woollen mill and surrounding company town. This benevolent tradition of well-housed and thus productive workers also resulted in William Lever's Port Sunlight (1888), and, with the addition of a strong Christian humanitarianism, Richard and George Cadbury's Bourneville (1895) and Joseph Rowntree's New Earswick (1902).

The much wider New Town movement, so influential in British planning and so widely imitated elsewhere, originated in the idealist reformist socialist reaction to industrialisation and urbanisation. Ebenezer Howard's seminal work (1898) was entitled *Tomorrow: A Peaceful Path to Real Reform*, and there was no doubt that it was people, and through them their society, that were to be reformed through spatial and architectural instruments. People were to be removed from their existing city environments, which were seen as the contaminating cause of sickness, crime, and anti-social behaviour and attitudes, and subjected to new benign influences upon their attitudes and social behaviour.

These ideas were first implemented by private individuals and associations in the earlier part of the twentieth century, notably at Letchworth (1904) and Welwyn (1920). The idea was then adopted by the post-Second World War reforming Labour government in the New Towns Act of 1946. The utopian idea of shaping a new people for a new society distanced from and better than the old became increasingly diluted by practical planning considerations, as the New Towns were seen as solutions to such mundane issues as slum clearance, congestion relief, more functional land-use patterns and social housing provision. Some 33 examples were built between 1946 (Stevenage) and the dissolution of the New Towns Development Corporation in 1990, significantly on the grounds that its basic ideology was contrary to the free-market liberalism of the government.

The Soviet experiment

Perhaps the most extreme variant of the New Town as instrument and expression of the melting pot was the idea of the *Sovgorod or* socialist city in the Soviet Union and, later, other parts of the Soviet Empire in Eastern Europe. This concept was seen both as an instrument for shaping a new and different Soviet society and also as a demonstration of its effective functioning. It was intended as a visible melting pot, reproducing *homo sovieticus* through a combination of architectural and social determinism:

[an architect] is not merely an engineer creating edifices and streets but an engineer of human souls. ... [A building] ... had to express social ideas, arouse the feeling of the power and persistence of the people's state, its mass collective character, its democracy and humanism, the idea of true freedom and the versatile possibilities it gives to people.

(Declaration of the National Council of Party Architects,
Poland 1949)

The socialist New Town was notable for what it was not as much as what it was. First, it was intended as a clear rejection of the historic cites of Europe, with their legacies of the now superseded and discarded pasts. Again, it was to be uncontaminated by the religious and political ideological baggage of the past, while nurturing and demonstrating the socialist values of the present and future through 'socialist realism', formulated in 1934 by the First All Union Conference of Soviet Writers as the only acceptable approach to art and design.

Poland's Nowa Huta is perhaps the most impressive of these towns in its magnificent, monumental building structures and renaissance radial town plan. It was deliberately located close to Kraków, which had functioned as the religious, political and cultural centre of fifteenth-century Jagiellonian Poland and particularly as the centre of the revived bourgeois nationalism of the nineteenth century. The economic *raison d'être* of Nowa Huta was the Lenin Steelworks, employing 43,000 workers at its peak in the 1970s (Stenning, 2000), which represented the new industrial Poland peopled by the new industrial proletariat. The social and economic contrast with Catholic, intellectual Kraków was underlined by the physical manifestations of the contrasting skylines and driven home by the pall of polluting smoke.

Churches represented the worst aspects of the nationalist, class-ridden, superstitious old Poland and thus had no place in the new Nowa Huta. However the labour force for the steelworks was largely recruited from the surrounding rural areas and tended to be actively Catholic. A struggle ensued between the authorities and the residents over the provision of a church to service the religious needs of some 220,000 practising Catholics in the new town. Open-air masses were held in defiance of the disapproval of the authorities from 1957, but only in 1977 was the Ark of Our Lady built, the church rapidly becoming a symbol and focus of opposition. The irony was that, in reality, a town intended as the vanguard of socialism became the centre of resistance to it, encouraged by the same economic and design features that were intended to foster support. The

close camaraderie of the steel workers allowed the development of the unofficial trade union, 'Solidarity', and even the neighbourhood units and communal facilities that were designed to increase social interaction among residents instead served to spread and reinforce their dissent. The dominating statue of Lenin in Central Square was regularly vandalised and eventually removed in 1989.

There is a close similarity between the social purpose and history of Nowa Huta and Donaujvaros (originally Sztalinvaros), near Budapest in Hungary. Both were constructed from 1949, centred on steel works and located near a major historic city. Both were intended to foster and house the new proletariat and separate it from the contamination of a discredited past, but both became centres of resistance to the regime, dating back in the case of Donaujvaros to as early as 1956 and specifically the failed uprising of that year.

Towns such as Nowa Huta raise important issues of preservation or demolition once their ideological significance is rendered irrelevant by political change. The scale and monumentality of the buildings and the overall design argues for preservation, even if many of the original features of communal neighbourhood and block facilities no longer operate. The arguments against are largely those of the costs of renovation of structures now more than 50 years old, the unsuitability of the housing stock for present demands and, above all, the dissonance that such heritage evokes. However, the heritage demonstrated by such towns as Nowa Huta is both that of the failed communist social experiment and of the resistance to it.

Tourism is not a new phenomenon in Nowa Huta, which from its inception was a showpiece of the new regime and firmly on the official list of sites to be visited, usually as a counterpoise to royal Kraków. More recently, as the painful or embarrassing memories recede and are replaced by curiosity and nostalgia, there has been a growth in what can be called 'Trabant tourism', in which the visitor is invited to experience the 1950–80 period, its buildings, domestic artefacts, fashions and designs. The call to replace Lenin's statue is no longer regarded as offensively eccentric. 'Socialist tourism' in Nowa Huta has joined 'Holocaust tourism' in Kraków's former Jewish quarter, Kazimierz, as a standard ancillary product to the Baroque 'churches and castles tourism' of the old town. The instrument of the socialist melting pot has now been incorporated into the conventional historical narrative as one episode in national development, a resolution found in some parallel cases, notably including the former German Democratic Republic (East Germany).

The opportunist case of the IJsselmeer polders

The Netherlands has two peculiarities relevant to this argument. First, it developed in the nineteenth century as a conservative, largely rural and deeply polarised society. The divisions of social class (the landless and the landowning) and of religion (Catholic and Protestant) had been resolved, or at least contained, by the model of consensual pillarisation (see Chapter 9). Second, by the end of the nineteenth century, technological progress rendered possible a substantial advance, if not final solution, in the centuries-old struggle against the incursions of the sea.

The plan formulated by the engineer Cornelis Lely and initiated by the Zuiderzee Act of 1918 was ambitious in time and space. It was to be executed over 50 years and was completed on schedule in 1968 (with the exception of the last remaining, and probably now abandoned Markerwaard Polder). The enclosure of the Zuiderzee and the reclamation of four new polders enlarged the country's agricultural area by 20 per cent, constituting what was to be a single new province, with its capital at the new town of Lelystad. With the exception of the island of Urk in the Noordoostpolder, the newly reclaimed land had had no previous settlement and there were no indigenous groups to disrupt the creation of a new society (except perhaps the fishermen now displaced to new fishing grounds). The planning of the new settlements provided a rare opportunity for applying general functional and social models upon a *tabula rasa* (Wal, 1997). Technocratic and economic efficiency was combined with social engineering based upon a Christaller-inspired (1933) hierarchy of residential and service centres, carefully spaced at optimum distances. These ranged from clusters of individual farms through the village, small town and, at its pinnacle, the new provincial capital. The new population to work the large (by Dutch standards) and efficient agricultural units was selected on the basis of educational achievement and family circumstances. Regional and religious differences were to be ignored and were expected to fade away in the melting pot of a new society for a new land. The young, meritocratic 'poldermen' would replace a population traditionally divided by class, region and religion. The exhibits in the 'New Land' heritage centre at Lelystad (*Nieuweland erfgoedcentrum*) built by the development corporation relate the story of reclamation and pioneering settlement through an interpretation that combines technological triumphalism and social optimism.

The idea, however, was short-lived and its implementation was overtaken by events before it could be completed. A combination of agricultural

and social change altered the whole purpose and thus population of the IJsselmeer polders. The mechanisation and declining economic significance of agriculture eliminated the land worker and the land shortage that had justified the whole reclamation scheme. Increasing personal mobility rendered the service centre hierarchies and spacing of farms and houses irrelevant. There was little similarity or unity between the polders. The last, (Markerwaard) was never built leaving an incomplete potential new province with an eccentrically located capital. The Noordoostpolder was incorporated into the province of Overijssel, the Wieringermeerpolder into Noord Holland and the remaining Flevoland was now used principally to house an overspill population for Amsterdam in Almere and Lelystad. The new 'polderman' was now no more than an exiled and probably commuting Amsterdammer. However, the mythology of the pioneering new polder population retains a niche in the national and regional psyche.

CHANGE AND STABILITY

It is important to remember that in many cases where melting pot models might exist, and some where they are supposed to exist, they have more or less failed. Melting pot models are essentially unstable and transitory. They have often been devised as short-term solutions to particular situations and have frequently been born of revolutionary change and attendant revolutionary fervour. When such situations change or the fervour cools, then the model loses much of its perceived relevance. This could be said even of the classic US expression of the model. If it succeeds, in the sense of producing a new society from diverse ingredients, this society then tends to become atrophied by its own success and there is a growing reluctance to allow further additions to change what is now regarded as a satisfactory end-product which has, in effect, converted plurality into a new singularity. It then becomes an assimilation model. If the melting pot fails, usually as a result of a failure to incorporate some groups into the mix, then it tends to evolve into a core+ or even a salad bowl model.

8 HERITAGE IN CORE+ MODELS

As discussed earlier in Chapter 5, core+ models are notably diverse. This type of model, often with quite different origins, is found in developed Western democratic societies with longstanding agreed national unities, as well as in emergent postcolonial societies in the process of shaping more or less agreed state identities. The model is characterised by a consensual core distinctiveness to which other different cultural identities are added. To reiterate, the critical relationship is that of the core to these add-ons.

The add-ons are accepted as having a valid and continuing existence and may be viewed by the core society in one of two ways. They may either be perceived as something apart, of no especial relevance to the core, but equally as unthreatening to it. Thus, there is no need for the majority to adapt, participate in or even particularly notice the minority cultures. Alternatively, the peripheral add-ons can be viewed as in some way contributing to or enhancing the core. They may be: sub-categories of it, contributory (often regional) variants, or more or less exotic embellishments, which can be added selectively on to the core as and when desired. In practice, some of these minority additions can relate to different core identities in quite different states. As well as constituting the *leitkultur* in Hungary itself, Hungarians are present as a recognised 'national' minority in three different central European countries (Romania, Slovakia and Serbia), each of which has a different core. The Saami (Sami, Lapps) have no state in which to form the core, existing only as a loose transnational cultural association: they do, however, have a legally recognised existence as a cultural minority within three different Scandinavian states (Norway, Sweden and Finland) as well as the Russian Federation.

Heritage, often by circumstance rather than design, has multiple roles in such societies. It may be used as the instrument for creating and sustaining the leading culture. It can be adapted to a defensive position in preserving the integrity of the core, preventing the dilution of its perceived essential

character from being subsumed by the periphery. Simultaneously, it can be used to promote the values and norms of the core among the peripheral add-ons, thus preventing society from fragmenting into non-communicating cells. Conversely, it can also be adapted to a core enhancement role by promoting the heritages of the peripheries to the core populations.

These minority add-ons are of various type and origin. They may be spatial (see Chapter 5) but may also be ethnic – involving racial, religious, linguistic or other variations from the core which are not spatially concentrated, but are often added as a qualifying adjective to the core noun. Such hyphenation is not usually seen as a weakening or qualification of identification with, and participation in, the core culture. There has been some discussion in the UK, as in other European countries, about how to refer to its Moslem citizens, especially after the 7 July 2005 bombings in London. 'Moslem-British', 'British Moslems', 'British Asians' and other combinations are being used, none of which are satisfactory descriptors.

Unlike some of the other cultural models discussed in this book, core+ models have generally not been created as a result of deliberate official policy. They have more usually emerged as a consequence of ad hoc reactions and adjustments of governments and individuals and, again, unlike many of the models discussed here, have received little formal attention from theorists, policy makers or polemicists. As noted in Chapter 5, they may even be seen as a default form, reluctantly accepted in lieu of an alternative assimilation or multicultural salad bowl model.

Some bi-national and international treaties impose obligations upon states with regard to cultural and ethnic minorities within their borders. These, however, are usually concerned with specifically identified and defined groups, which points to a major difference between autochthonous and allochthonous minorities. The former are sometimes called 'national' minorities, in the sense that they have a recognised status within the national entity, while the latter are composed of more recent immigrants who lack such a historically validated identity and legally recognised status. There are many international conventions, usually formulated through UN agencies, which call for the granting to minorities of various rights of legal protection, education, social and political participation and the like. These almost always apply, however, to individuals rather than groups. Again, the so-called Copenhagen Criteria (1993) for assessing the suitability of prospective EU members include the 'respect for and protection of minorities', although the explanatory notes of the published documentation emphasise that this provision relates only to longstanding 'national' minorities. There is no general requirement in EU legislation to protect the cultural integrity

or expression of minority groups or even tolerate their continued existence as such.

A CLASSIFICATION OF CORE+ MODELS

The incidence of core+ models around the world can be classified according to their two main origins. First, and currently prevalent in Western Europe, are long established societies with a relatively homogeneous racial, linguistic and religious composition that often also include longstanding, spatially concentrated minorities. To this consensus have been added, over a short time period since 1950, immigrants with quite different ethnic and cultural characteristics. The assimilation and acculturation of these new groups was impossible, at least in the short and medium terms, and substantial adaptation in the existing indigenous culture was politically unacceptable to the majority. Thus the only practical, partial alternative to the emergence of excluded, isolated, culturally marginalised and spatially ghettoised minorities was the evolution of some variant of the core+ model, in which the historically dominant culture remains paramount and largely unchanged, but to which new cultures can be added. This may even be regarded as a transition stage in the ultimate pursuit of a different policy objective and thus be accepted as a temporary holding position.

Second, many of the new states that emerged from the dissolution of the European empires in the second half of the twentieth century were composed of diverse ethnic groups, whether because colonial boundaries had been drawn on criteria other than ethnic composition, or because imperial policies encouraged multi-ethnic migration. As we have noted in the context of other models, the result was commonly the perceived need to create a new national consciousness and identification with new state structures from different and potentially fissiparous groups. Commonly, one culture, usually that of the numerically, economically or politically dominant group, was selected as the lead, while others were added in a core+ model. A spectrum can be seen in the sustainability of this model. Malaysia (discussed below) remains stable so far; in Fiji, the core dominance has been asserted through political coups and indifference towards minority heritage in a plural society where groups mix but do not combine (Harrison, 2005); Sri Lanka, conversely, has descended into a ruinous civil war, the outcome of which is likely to assure the minority Tamil culture a territorial autonomy sufficiently powerful, perhaps, to create a core+second core structure within the same state.

A further distinction can be drawn concerning the relationship of the minority add-ons to the core. 'Inclusive' additions are regarded as both embellishing the core and open to it, in the sense that a minority culture can become a part of everyone's culture. All may, if they wish, participate at least selectively in aspects of the minority cultural expression and to an extent regard it as also theirs. This is exemplified, for example, in the 'Irish for a day' phenomenon apparent in many St Patrick's Day festivities around the world, and by events such as London's Notting Hill carnival. Originally locally conceived and organised by West Indians, this has become a major street festival in which all can participate as 'West Indians for a day'.

Conversely, 'exclusive' additions to the core culture are regarded as relating only to the group concerned and are commonly only accessible to that group. They provide community cohesion within the minority but have little significance to the wider society, which may not even be aware of their existence. Such minority cultures typically do not promote themselves, let alone proselytise, in the wider society.

Understandably perhaps, the inclusive variant is more generally encouraged by public policies and supported by public funds while exclusive variants more usually result from unofficial initiatives. Indeed some public policies have recognised that so-called 'enclaving', or the existence of separate exclusive cultural groups, is a phenomenon to be avoided and countered through outreach policies. These are designed to promote mutual recognition and the participation of ethnic groups in the heritage expressions of the core culture.

CORE+ MODELS IN LONG-ESTABLISHED SOCIETIES

Inclusive variants

Inclusive add-ons are more likely to be created or at least actively encouraged by official agencies motivated by concerns about community cohesion within culturally heterogeneous areas or even with ideals of enriching the core culture. There is an additional dimension in that the all-inclusive consumption of the heritage of minority variant cultures that is sought can include tourists as well as participants from the core culture. These variants may thus be serving not only the cohesion goals of the host society but also its tourism economy. The two markets may well interact as is demonstrated in a number of the cases described below.

Heritage policies for social inclusion in England

The official and non-governmental heritage agencies in England, led and often coordinated by English Heritage, have long pursued policies aimed at what they call social inclusion. The largely unargued assumption is that such inclusion will be furthered by the application of what we call inclusivist core+ models. The other 'home nations' (Wales, Scotland and Northern Ireland) have their own such agencies and similar, but generally less focused, policies due to different immigration experiences and numbers.

There is some ambiguity and possible contradiction in objectives in heritage policy as it applies in England. Most policies are deliberately and often stridently inclusive and begin to take on the character of salad bowl rather than core+ models. The clearly stated objective is to recognise, develop and promote minority heritages as part of a general universal heritage in which all are invited to participate. Usually, there is an implicit but sometimes stated fear of 'enclaving', which is seen as the opposite of inclusion and regarded as self-evidently undesirable. English Heritage's strategy statement, *England's Heritage – Your Heritage*, makes the clear assumption that 'the historic environment is a resource from which every-one can benefit' (English Heritage, 2000b: 123). Examples of other similar programmes would include the Historic Environment Local Management (HELM) scheme, a consortium of three ministries acting through the national agency, English Heritage, and charged with encouraging, assisting and publicising local authority initiatives and stressing particularly local and cultural diversities. The aim is to arrive at 'a shared understanding of diverse histories' because 'variety and diversity are among England's most positive attributes' (HELM, 2004: 123).

Again, numerous projects are run by non-government agencies that are represented in English Heritage's 'Heritage Link', an umbrella group-ing that focuses on ethnic minority access. The 'Hidden British Histories Project' was formed in 1998 as a consortium of a number of ethnically defined organisations. The idea was to 'discover' hidden or, it is some-times hinted, suppressed histories, especially those that relate to the expe-riences of ethnic and cultural minorities and their places, traditions and personalities. There is a clear assumption that once found, these heritages then belong to all and not just the particular groups concerned. Indeed, a heavy stress is placed on the contribution that minorities as groups and individuals have made and are still making to the mainstream core society of which they are identified as an integral part. Thus the Anglo-Sikh Heritage Trail, which marks key sites around the UK related to the Sikh

experience and individuals in Britain, is intended as much for the society as a whole as for the self-confidence of the minority involved.

However, many programmes and initiatives also emphasise increasing the cohesion within specific minority communities. The stated objective of the HELM programmes is both 'increased community cohesion and greater social inclusion' (HELM: 2004). These two aims are potentially conflicting. Some projects appear to be encouraging minorities to discover their own heritages and appreciate their values in order to develop self-confidence and self-awareness within the group. As early as 1926, 'Black Heritage Month' (February) began as a private initiative with the objective of inculcating what later became known in the United States as 'Black Pride'. It was later taken over by a NGO, the 'Black Environment Network', but remains almost unknown outside the communities for whom it was intended. These approaches seem to be moving towards, or at least accepting, the idea of exclusive add-ons that do not detract from but, equally, do not particularly enhance the majority core.

The point raised earlier about the differences between, on the one hand, the stated objectives and even assumptions of official agencies and NGOs and, on the other, the actual reactions of the recipients of such policies in the areas in which they operate, perhaps needs reiteration. Although the agencies involved in the English case appear committed to what we call a core+ heritage model, the people themselves may be unaware of this, or even antagonistic to it. In parts of London, to many observers a bottom-up multicultural 'salad bowl' already seems to exist while, in other less metropolitan parts of the country, assimilation models are assumed to exist or be more favoured by public opinion.

A single district of London has acquired an international reputation for ethnic variety and has become something of a test-bed for many of these policies as well as absorbing much government financing in subsidies through programmes such as the 'Ethnic minorities enterprise project'. Brick Lane has achieved an almost iconic status (reflected in and further boosted by Monica Ali's 2003 eponymous novel) and has become the flagship of recent government cultural diversity policies. Traditionally, it was an immigrant reception area, the French Huguenots and European Jews giving way to the Chinese and, more recently, large numbers of Islamic Bengalis (hence its current self-designation as 'Banglatown'). Some Brick Lane projects, such as the street festival that has operated since 1996 (imitating to some extent the older, larger and better known Notting Hill carnival), project heritage outwards to outsiders, including tourists, as well as inwards towards the coherence

and support of the distinctiveness of the local community. Some conflict has arisen, however, between representatives of the local population and the official heritage listing agencies (Gard'ner, 2004). The buildings currently listed in Brick Lane do not relate to the heritage of the existing populations but are dominantly Protestant Christian or Jewish, for example the 1743 Huguenot church, later Methodist chapel and later synagogue, which now functions as the London Jamme Masjid (Great Mosque). The official listing agencies responded that buildings and sites reflecting from their inception the culture and experiences of the currently dominant Bengali population were 'unsuitable' for listing because they did not fulfil the existing criteria of age and appearance. Such buildings as the East London Mosque and the Jagonari Community Centre were in short too young and too artistically uninteresting.

The add-on tourism ethnic district

Selected ethnic districts have long been visited by tourists as part of the tourism experience in particular cities and are thus archetypically inclusive. These areas were once largely confined to the major settler societies of North America and Australasia but are now almost equally evident in many European cities. Few such districts were created for tourism purposes and, initially at least, many were unattractive if not antipathetic to casual outside visitors. However, they may evolve from being discovered as exotic and possibly even dangerous environments for a few enterprising tourists into a routine experience. If they are accessible, seen as safe and offer an intelligible and consumable tourism experience, whether gastronomic or folkloristic, then they may evolve into guidebook recommended 'musts' for the average visitor. New York City's Harlem district, for example, has evolved from a place to be avoided at all costs to one that, at least in part, can be discovered. Indeed, the ethnic add-on district is so attractive to tourism product-line development that it has become a standard urban tourism experience.

The delay inherent in the process of widening the tourism market often means that the cultural minority concerned has in whole or in part departed and been replaced by a different, possibly newer group. Once the ethnically labelled tourism area has been established, its marking in tourism guides may perpetuate its perception beyond the reality on the ground. The contradiction is that immigrant residential areas are, in essence, transitory and unstable as processes of familiarity and integration disperse the immigrants through the host society. Tourism

labelling and recognition have an inevitable inertia, which persists long after its original cultural impetus has departed. This may not matter if the institutions and facilities of the area remain relevant and visit-attractive to the earlier population. The area will thus sustain its tourism identity, provided no conflict ensues with the later occupiers. Preston Street, co-named as 'Corsa Italia/Little Italy', in Ottawa, Canada, is one example among many. Tourism could be seen as an instrument in the transformation of exclusive cultural enclaves into inclusive ones, or merely as a response to such change and a symptom that it has occurred.

It should be noted here that such minority cultural add-ons to the standard tourism product and heritage identity are not confined to Western cities or indeed to cities at all. Rural add-ons to a national tourism product are common, for example in postcolonial countries engaged in nation-building. Thus Smith (2003) has noted how major tour operators such as Kuoni Travel market packages (largely to Western Europeans) in which the three Thailand products – Bangkok, the restful beaches of the south, and the culturally exotic hill tribes of the north – are combined in various ways during the holiday. There are many similar cases elsewhere. Also, the minority culture can become little more than a souvenir linked with a place-bound culture. An example would be the tourism use in Thailand of the distinctive Mon cultural artefacts, especially pottery, on Koh Kret Island in the Chao Phraya River within easy reach of excursions from Bangkok. Tourism's interest in different and exotic minorities may conflict with the nation-building requirement to stress the common national characteristics. As the markets for the two are, however, quite different, they can usually be successfully kept separate.

Exclusive variants

Throughout the world there are many illustrations of exclusive add-ons to the main core culture, which illustrate a varying and evolving degree of official toleration and support of what such groups have created, largely through their own initiatives. Here, we discuss three such examples: a long standing and well-integrated immigrant community, the ways in which national minorities within Germany have been variously treated by the host community, and a quite specific small-scale example of the local implications of a minority expressing its exclusive culture.

The Polish community in the UK

This is a long-standing community originating with the settlement of 200,000 stateless discharged military personnel after 1945. After three generations it had become very difficult to estimate numbers; the 2001 census estimated the community at some 250,000, of whom only 60,000 were born in Poland. The accession of Poland to the EU in 2004 led to an influx of an estimated further 300,000 Polish migrant workers who may or may not permanently settle in the UK. This development has more than doubled the size of the community and, more significantly, raised its profile within the country as a whole. What had been a largely invisible, self-regulating community became a topic for national discussion about its economic, social and cultural impacts upon the core. The extent to which the newcomers interact with the established community and cause an evolution in its status as discussed here will undoubtedly be the subject of future research.

Long before the recent influx, Poles in the UK formed a clearly defined and viable community with a strong cultural coherence based dominantly upon language and religion. Prior to 2004, this had evolved many of the agencies and attributes of a distinctive cultural group, almost all through the efforts of the group itself. These included 113 community centres, 82 Polish language church parishes, 67 'Saturday schools' for language/culture learning, a recognised university in London, a cultural centre in London with the largest Polish library outside Poland and, most remarkably, a daily newspaper with an attested circulation of 10,000.

However, despite a strong cultural coherence, survival through three generations and this institutional support, the Polish community is highly integrated functionally with the core British society, even to the extent that its presence is barely visible. There is no noticeable spatial concentration and little attempt to encourage participation in Polish activities by the wider community. Although its members play a full role in British life they make little or no contribution as Poles. The existence of this community occasions little or no implications for heritage policies. There is no recognisable or promotable 'Polish quarter' nor any distinctive buildings, set of architectural styles, place nomenclature or even commemorative statuary. It is thus an archetypical exclusive add-on and is, apparently, an example of the 'enclaving' feared by English Heritage. The Polish case demonstrates, however, that it cannot be assumed, as governments in many countries tend to assume, that such culturally exclusive communities are functionally poorly integrated into their host societies.

The case of autochthonous cultural minorities in Germany

The Federal Republic of Germany is a relatively culturally homogenous country with an undisputedly dominant core culture. It does encompass, nevertheless, several small but well-established cultural minorities that have been accorded the status of 'national' minorities alongside more recent *Gastarbeiter* immigrants from the Middle East and North Africa. The three main national minorities are: the Slavonic Catholic Sorbs of southeast Germany (whose more northerly and Protestant groups are known as 'Wends') who number, according to different authorities, between 30,000 and 100,000 people; the Danish minority of about 60,000 around Flensburg in Slesvig/Schleswig; and the northern branch of the Frisian people who number about 12,000 and inhabit some villages in Ostfriesland.

The Sorbs survived the creation of a unified German state in the nineteenth century without cultural assimilation, but were largely ignored and accorded no special rights. Attempts were made to 'Germanise' them during the Nazi period and they actually petitioned the Allies in 1945 for independence. They were, however, favoured by the DDR for unclear reasons ('Honecker's spoiled brats') and developed many special status cultural and even nascent political institutions. The Danish minority was separated from Denmark by the war of 1864. Subsequently, minorities on both sides of the resulting new border were accorded mutual educational and linguistic rights by treaty, an arrangement that survived later border changes. The Frisians are a part of the fragmented Fries culture group, distinguished mainly by language, whose largest part survives with some cultural autonomy in the Dutch province of Fryslân (Friesland). All these groups are constitutionally recognised, have separate and nationally subsidised educational, cultural and politically representative organisations, and are generally accepted by the majority German population (in so far as it is aware of their existence). Thus, they are tolerated as a possibly interesting diversity that poses no threat to the leading culture as there is obviously no question of Sorb, Danish or Fries supplanting the dominant German language, history or cultural norms. In contrast, the more recently settled Turkish minority, which constituted 1.7 million people or just over 2 per cent of the total German population in 2000, lacks the official status and institutions accorded to the 'national' minorities.

Much of the heritage of these autochthonous minorities is essentially intangible, involving language and folklore expressed especially through dance and festivals. Rural settlement pattern and form has also become a focus of heritage identity for both the Sorbs and the Fries. In

Sorb areas where strip-mining for brown coal has threatened the destruction of settlements, cultural resistance has focused on the village of Horno (Rogow in Sorb) in Brandenburg, which was faced with destruction and resettlement in 1977. It yet survives but the village was, and still is, a symbol of opposition to change in the 'recognised ancestral Sorb settlement area' (*angestammtes Sorbischen Siedlungsgebiet*).

All these groups could be considered as exclusive minority additions. Their partial cultural autonomy has few implications for outsiders, many of whom would be unaware of their status or even existence. They make little noticeable contribution to the core culture and are uninterested in promoting their cultural artefacts or expressions within that core culture They have not even been, at least until very recently, considered as potential resources and images of place for commodification into tourism products and place promotion. Few tourists who do not have prior association with the group are motivated to visit the areas inhabited by Sorb, Dane or Fries minorities because of their distinctive cultures, and those tourists attracted by other features are generally unaware of the existence of these cultures during their visit.

Local planning for exclusive heritage: the case of the Barnet eruv

On a quite different scale, the attempt to create an exclusive heritage at the local level may cause controversy from those excluded or even some of those arbitrarily included. A specific and localised clear case of this has arisen because some Orthodox Jewish communities require an extensive area around their residential areas to be visibly marked as their *eruv* (or hearth). This marked area is by religious law considered to be inside, rather than outside, the extended home and therefore traversable by Orthodox Jews on the Sabbath. In the Barnet area of North London, home to a number of different communities of Jews, a request was made in 1992 to the planning authority for permission to erect a series of poles joined by wire in order to mark such an *eruv*. This provoked considerable controversy both from non-Jewish residents, who felt estranged and even repelled by the idea of a visible change in their residential environment, and also from some more secular Jews who felt the idea held them up to public ridicule as legalistic pedants. The local authority was compelled to choose between the heritage requirements of one exclusive religious group and the opposition of other groups who resented being excluded as well as fearing the effect upon property values. Such marking had previously occurred in

a number of US cities, as well as in Toronto, Canada, and Sydney, Australia. Permission was finally granted in Barnet in 2001 and has had few noticeable deleterious effects on the neighbourhood.

CORE+ MODELS IN POSTCOLONIAL NATION-BUILDING

Malaysia

The postcolonial states that emerged in Southeast Asia in the second half of the twentieth century provide several examples of core+ models. These include Malaysia, where a dominant Islamic Malay culture is supplemented by various Chinese (especially 'Straits Chinese' and Chinese/Malay Peranakan) and Indian cultural groups. In the case of Singapore, the existence of a postcolonial Chinese majority gave rise to a separate state that eschewed the Islamic Malay core in favour of a Singaporean identity.

Malaysia, created in 1963 as a postcolonial federation of some widely different British possessions on the Malay peninsula and the island of Borneo, has maintained more peaceful inter-group relations than Indonesia (see Chapter 7). However, there is evidence of growing centrifugality as, rapid modernisation notwithstanding, conservative Islamic values are now far more visible among the dominant Malay population than they were before independence. This is evident from such diverse markers as women's attire, with subtle conservative pressure being applied even to Chinese Malaysian women, and new expressway rest-stop signs, which invariably feature a mosque icon symbolising culturally exclusive prayer facilities. Indeed, a more assertive Islamisation may intensify the long-standing hegemony of the Malay language and cultural and political institutions over the national identity of the federation, which was structured mainly from traditional Malay sultanates.

This Malay hegemony is most striking in Melaka (Malacca), one of the former British Straits Settlements, which was originally a dominant Malay sultanate and was reinstated as a cultural focus by its ceremonial role in Malaysian independence (Worden, 2001). This city, a moribund backwater port in 1975, was unrecognisable by 2005. New development extends from the inland national expressway through a grandiose entrance arch which initiates the visitor to ubiquitous Malay architectural motifs. It has become a tourism centre, primarily of Malay culture, as in the Independence Museum (formerly the British

Malacca Club) and other museums, notably in a replica of the Sultanate Palace where the courtly feudal traditions of an idealised Malay monarchical state are the focus of a display that is harnessed to nationalism (Worden, 2001). The Casado Malay-Portuguese and Peranakan Malay-Chinese minority heritages are favoured as useful 'add-ons' to the Malay core, by virtue of their long, reinforcing associations with it. Official intentions to move Malaysia's identity away from this historic and courtly focus, and its ethnic favouritism, towards a modern industrialised state symbolised by the huge Petronas Towers in Kuala Lumpur, have yet to alter heritage representation in Melaka (Worden, 2001), although a modern commercial leisure image is now emerging there (Figures 8.1 and 8.2).

The Chinese and Indian populations constitute a marginalised and diminishing (given lower birthrates) third of Malaysia's population with equivocal 'add-on' heritage status, even though the Chinese outnumber Malays in the urban centres and are disproportionately the economic mainstay. The Chinese are essentially absent from heritage representation in Melaka, where even a culturally important Chinese burial site was threatened with expropriation in the 1980s. World Heritage Site applications for Melaka have met with UNESCO criticism, in part because, despite local conservationists' efforts, official policy has failed

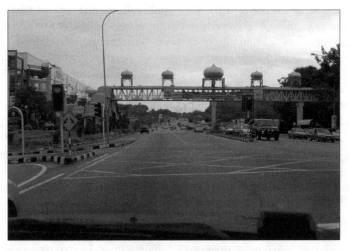

Figure 8.1 Melaka (Malacca), Malaysia: Malay heritage motifs dominating main road access (2005)

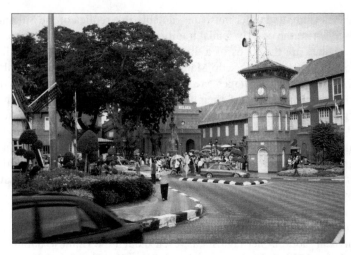

Figure 8.2 Melaka: Dutch central townscape (with added windmill) (2005)

to adequately pluralise its communities' pasts (Worden, 2001). In contrast, in its northern counterpart George Town, Pinang (Penang), Chinese and Indian iconography is prominent in the streetscape and the Penang Museum portrays the wide multicultural diversity of the city's heritage. Chinese Malaysian sources, however, point out that for them this represents a diminution of what was traditionally known, like Singapore, as a Chinese city

European heritages retain varying add-on status for external tourism but also their national/local tourism value. In Melaka the relict Portuguese, Dutch and British buildings which structure the historic core have primarily been re-used as Malay museums, only the Dutch (including the East India Company) receiving favourable heritage recognition (Worden, 2001) They have been joined by a replica Portuguese man-of-war (the Maritime Museum) and windmill which add to the tourist kitsch/honey-pot quality of the old city centre. The British heritage is not demonised in Malaysia, although in Melaka (a British backwater) it is detectable only in some structures and wall plaques. Elsewhere it is more prominent. In Penang – like Singapore, a British foundation – it is present in some surviving mansions (despite redevelopment attrition, Shaw *et al.*, 1997) and in recently restored Fort Cornwallis, the city hall and cathedral, the Eastern

and Oriental Hotel, and elsewhere in street names and Penang Hill (Figure 8.3). The British architectural inheritance is most visible where it was most pointedly applied, in the quasi-half-timbered cottage 'home' style created in the Cameron Highlands hill station. Here, the Smokehouse Hotel not only draws national tourists for its photogenic 'exotic' quality but also provides the idiom for modern hotel developments (Figure 8.4).

Singapore: core+ with a third-party imported core

This variant of the core+ model occurs when a plural society adopts a leading culture which is not the culture of the majority or, indeed, even that of any of the diverse cultural groups involved. This so-called 'imported core' is not so much a leading culture in the sense argued above as merely a set of postcolonial survivals – such as a *lingua franca*, familiarity with governmental agencies and practices, and even sport – that facilitate the efficient functioning of society. It is thus not so much a core in the *leitkultur* sense as a convenient binding mechanism. This may be recognised as only a short-term transitory situation pending nation-building around an indigenous or created core culture.

Singapore provides one notable example of this variant. Historically part of British Malaya, it differed in two important respects. First, Singapore

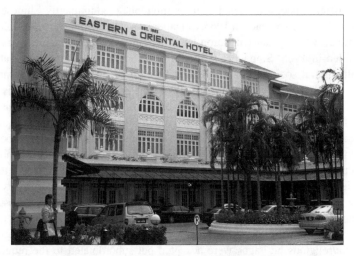

Figure 8.3 George Town, Pinang (Penang), Malaysia:
Eastern and Oriental Hotel, restored British heritage (2005)

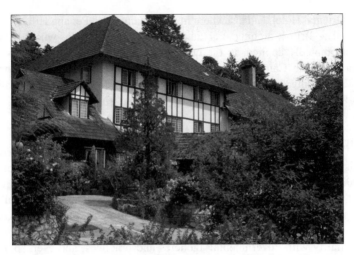

Figure 8.4 Cameron Highlands, Malaysia: Smokehouse Hotel.
1930s British hill-station architecture (2005)

was founded deliberately as an entrepôt in 1819 by the East India Company representative, Stamford Raffles. It thus lacks the pre-colonial heritage of Malaya, except where recently created in retrospect. Second, its great commercial success attracted many immigrants, predominantly Chinese in origin. On independence in 1963, Singapore was included in the new Malay-dominated Malaysian federation but, after several uncomfortable years, it seceded in 1965. Singapore's official positioning as a state-orchestrated multicultural society has been extensively documented (see for example Perry *et al.*, 1997; Yeoh and Kong, 1996). The policy adopted to establish a specific Singapore identity has been referred to as the '4Ms': multiracialism, multilingualism, multiculturalism, and multireligiosity. This raises the question of whether it should be considered under the melting pot or salad bowl scenarios discussed respectively in Chapters 7 and 10. Its geographical circumstances are, however, radically different from 'New World' settler societies. Singapore attained independence as a small island of human diversity with few resources. It is surrounded by large and potentially hostile Islamic Malaysian and Indonesian states. As in Israel, national interests and cohesion were therefore paramount. In Singapore's case, the different ethnic/religious heritages were accepted but subordinated to the requirements of citizenship and, ultimately, the creation of a new national fusion culture.

[156]

This culture draws primarily from the three principal local ethnic ingredients, but also from the colonial legacy of English language and Western institutions which contributed to Singapore's attainment of primacy as a global business centre. To this extent it relates to the third-party core variant discussed above. In Singapore, however, the colonial legacy does not constitute a transitory rearguard mechanism but, paradoxically, has been regenerated and appropriated. The decade after independence in 1965 witnessed an unparalleled urban redevelopment programme, in which the zeal to re-house the population in sanitary high-rise public housing threatened to destroy the city's historical identity of shop-houses and village *kampongs* (along with their strongholds of ethnic political opposition) as well as landmarks. While protest was widespread, it took a subsequent decline in tourist arrivals to trigger a policy change that incorporated Western thought on the importance of structural continuities and sense of place in supporting socio-economic stability. Conservation, with limited public involvement, was then used to reinforce nation-building by stressing the multi-ethnic nature of the built heritage. The Urban Redevelopment Authority has since designated over 50 conservation areas, including Chinatown, Kampong Glam, Little India and Emerald Hill (representing the mixed Peranakan) (Figure 8.5), creating many cultural tourism attractions that some regard as a contrived heritage pastiche (Shaw et al., 1997). The state's trademark preoccupation with cleanliness has given a literal edge to the sanitisation of its cultural heritage tourism product.

The colonial imprint remains strong, however, in street and place-names and some buildings, particularly in the government/institutional area, which has been revalorised as the Civic District. Innovative public art and marking have further re-created this historical identity. The Raffles Hotel, perhaps the ultimate oriental colonial icon, was restored in 1991 and designated as a national monument (Figure 8.6). Henderson (2001) argues, however, that although it trades on colonial nostalgia, it has been distanced from its British origins and effectively appropriated as a Singaporean institution, open to all within economic rather than social limits. The hotel has thereby been absorbed into the common heritage resources latterly seen as essential to the integrated stability of a plural nation.

This national appropriation revalorises the colonial heritage more widely. The Civic District, now a conservation area, is recognised as providing dignity and historical context as well as functional continuity. Indeed there is little historical baggage to obstruct this reading. The British were elitist and had structured the city according to Raffles' orderly notions of

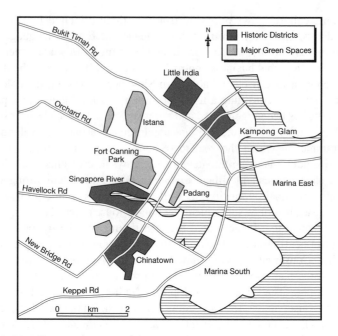

Figure 8.5 Singapore: central area

Source: based with permission on an original diagram by Roy Jones and Brian Shaw.

functional and ethnic areas (Home, 1997) so as to sustain colonial rule and values (Yeoh, 1996). However, the enterprise and institutional framework created by the British was a *sine qua non* for the successful development of a confident and dynamic city-state with little place for postcolonial recrimination. This is notably apparent in the extensive use of the Raffles name: unlike Rhodes in Zimbabwe, Sir Stamford is justly remembered as the founder-figure; his name is now used to market the business class on Singapore Airlines and much else. 'Raffles' has become a globalising brand, central to Singaporean corporate identity (Henderson, 2001).

Waterfront revitalisation adds to the fusion identity, albeit with global connotations. As late as 1975, the Singapore River remained an insalubrious waterway, crowded with lighters ferrying goods between ships moored offshore and riverside warehouses (*godowns*). These have now been replaced by contemporary waterfront leisure amenities, with riverside pedestrian paths,

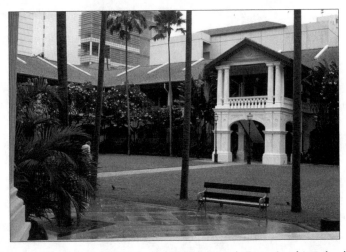

Figure 8.6 Singapore: Palm Court, Raffles Hotel. From 'cockroach alley' (1975) to super-rich enclave (2005)

underpasses and bridges and the surviving boats harnessed for cruises. Upstream, Clarke Quay (Figure 8.7) and part of the central area waterfront have been revitalised as restaurant/nightlife areas. The statue of Raffles not only survives but is also interpretively enhanced, anchoring a series of life-size cast metal figures depicting the historical transactions of the waterfront. Thus, a historical waterfront has been replaced by tourist/local waterfront revitalisation replete with historical references (Figure 8.8).

After the destruction of so much of its built heritage resource base, Singapore has become more widely adept at continuing heritage creativity, facilitated by its 'Remaking of Singapore Committee' (Saunders, 2005). This raises the question as to how much of this creativity addresses its fusion core needs and what constitutes 'add-ons', principally serving its tourism economy. Since the two concerns are interconnected, there can be no clear answer to this question but it would be surprising if heritages were not exploited for more than internal needs. Two examples illustrate the point. Singapore is positioning itself as a global arts/cultural heritage centre (Saunders, 2005), further to the creation of a major arts complex on reclaimed land originally offshore of the inner city. On a different plane, the 60th anniversary of the end of the Second World War in 2005 focused on the development of a heritage

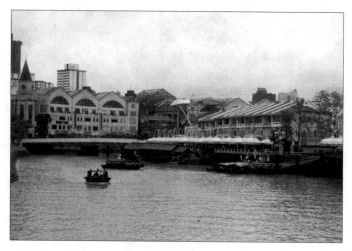

Figure 8.7 Singapore River: revitalised Clarke Quay (2005)

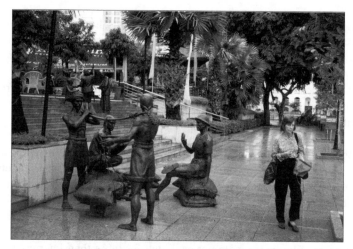

Figure 8.8 Singapore: multiracial historical re-creation on city-centre
riverside walk (2005)

network that is being marketed overseas, notably in Australia and New Zealand. This included battle and POW sites, among them the former British naval base and, in particular, Battle HQ Malaya Command ('The Battle Box') beneath Fort Canning in the inner city in which the British decision to surrender was taken on 15 February 1942. School groups visit this presentation of a fateful event in national history, but much of the wartime network may be an extraneous 'add-on': someone else's heritage of disaster. Nevertheless, the date of the British surrender has entered the national core heritage as 'Total Defence Day', which stresses the need for vigilant self-reliance against foreign threats. This national educational theme is also present in the recently opened Changi Museum, which commemorates Singapore's experience of the Japanese occupation. Moreover, a war interpretive centre has been opened in a preserved colonial bungalow by the National Archives, further pursuing national heritage development by commemorating the heroism of the Malay Regiment before the fall of Singapore (Brunero, 2006).

How successful and stable is Singapore's core+, relative to alternative international pluralist models? In discussing the role of its Asian Civilisations Museum in promoting national memory, identity and destiny (and cultural tourism), Henderson (2005) points to the continuing tension between recognised, tourism-serving, ethnic identities and the overarching construction of the national fusion culture, particularly with the growth of Islamic fundamentalism around and within Singapore. Beyond this difficult and uncertain balancing act, however, Singapore's ongoing redevelopment in pursuit of its global standing could end up destroying icons upon which the national fusion has been founded. Despite strong opposition, the original National Library (1957–60), in effect the first postcolonial building to embrace a unified, equal, educated and commonly motivated citizenry, was recently demolished to develop facilities for the Singapore Management University (Ling and Shaw, 2004; Jones and Shaw, 2006). Thus Singapore's global corporate identity has destroyed an icon of local independence, even while it exploits in Raffles a relic of the colonial past.

Singapore is exceptional in the many historical and cultural respects described above, but it can be speculated that importing a neutral core culture to provide at least some common ground between competing groups could assist conflict transformation or resolution in other societies. For example any possible future reunion of the Republic of Cyprus and the Turkish Republic of North Cyprus could be facilitated by the use of the one common feature that is shared by the two otherwise very distinct cultural groups. The common inheritance of the

idea of a unified if culturally divided state, a language of government, experience of – and to an extent participation in – previous colonial government might provide a sufficient basis for operating within an otherwise pillarised society. This argument could apply to other ethnically divided successor states of the former British Empire, in particular. However, before we are accused of neo-imperialism, it should be recognised that this common inheritance has an uneven record so far in this respect. One reason for this is that there are past ethnic inequalities in adapting to and benefiting from the colonial culture (as in Sri Lanka/Ceylon), which is not, therefore, always perceived as a neutral inheritance.

CHANGE

It was argued in Chapter 5 that core+ models are essentially unstable because change is an inherent characteristic of the dynamic processes described above. However, being in this constant state of flux does not diminish their importance. The cultural additions to the core may be increased to include new, hitherto unrecognised groups. These may, conversely, also become less distinctive, losing their internal coherence through acculturation into the dominant core, to the point where they are reduced to no more than historically interesting curiosities, of value most especially to tourism. Equally the relationship between the leading core and the minority additions, whether inclusive or exclusive, is likely to change through time. The distinction drawn above between inclusive and exclusive add-ons is particularly relevant to this relationship. Encouraging inclusion may itself destabilise the model by threatening the integrity of the minority in the sense that it loses control over its own culture. But this also changes the core culture. There is a contradiction in that the core is enhanced by the additions to it while remaining substantially unchanged, with its hegemonic position intact.

Core+ societies may just be the pragmatic compromises that result from long-term failures of attempts at assimilation or the creation of a melting pot. The unassimilated elements that remain can become the grudgingly tolerated additions to the dominant core of the assimilated. The core+ model could be interpreted as a defensive reaction to the continued existence of relict, incomplete or unsuccessful 'semi-nations', which failed either to develop as sovereign political entities or to be fully assimilated into the dominant culture. These groups may be seen as posing a

potential, if currently dormant, threat to the integrity of the state through their latent potential for political separatism. Similarly, multicultural salad bowl policies (see Chapter 10) may fail to attain a situation of a parity of esteem for all the diverse cultural groups, and thus begin to take on a resemblance to core+ ideas. Equally if the core diminishes in importance, losing its function as a common binding medium while the minorities consolidate, demarcate and strengthen their exclusive integrities, then the result begins to resemble a pillar model to which we now turn.

9 HERITAGE IN PILLAR MODELS

In the core+ models discussed in the previous chapter, it is assumed that the existence of a leading core determines the fundamental values and overall cohesion of a society to which non-threatening add-ons, whether inclusive or exclusive, are attached. In contrast, in 'pillar models' it is assumed that multiple cores – each held to have both internal integrity and equivalent value to each other – are bound together by some collective commitment to the maintenance of the social structure and superstructure of the state as a whole. This unified state functions to distribute resources equitably to the pillars and manage such matters as fall outside the remit of the pillars, largely through the consensual agreement of the constituent parts.

As explained in Chapter 5, the pillar idea originated in the Netherlands, during the religious upheavals of the sixteenth and seventeenth centuries. As the Netherlands has the longest experience of its application, much of the terminology encapsulating the primary characteristics of the model is of Dutch origin, although it has since acquired overtones which detract from the inherent and original meanings of the terms, most notably *verzuiling* and *apartheid*. *Verzuiling or* 'pillarisation' defines a society consisting of distinctive cultural groups, each existing within its own self-contained *zuil or* pillar. There is no necessity for cultural or social interactions between the pillars: the only necessary attitude of those in one pillar to those of another is the toleration of their right to equal existence. The basic principle of sovereignty within one's own group (*soevereiniteit in eigen kring*), an idea articulated especially through Calvinist theological concepts of religious freedom, can be interpreted as the freedom of individuals to seek out and practice their own *weltanschaung*. Thus each group can develop and manage its own cultural, social, educational, political and even economic institutions. But this also precludes the participation of

outsiders or what could be construed as external interference. The idea of *apartheid or* separateness is supported by the idea of equality in terms of the contributions of the pillar to the whole, and of the whole to the pillar. Consequently, in this original sense, there is no sense of hegemonic privilege, and equality is strongly linked to sovereignty within, and parity of esteem between, the pillars.

The pillar model was a reaction to cultural differences, at first religious and later of economic ideology and more general philosophy of life. Originally, and in some of its later applications, it was an attempt to avoid cultural fragmentation and political conflict within deeply divided societies. The general roles of heritage in such a model are quite simple. While there will be a common heritage of the state as a whole to which all can subscribe, additionally, each group is free to create, manage and consume its own heritage without interference from, or indeed participation by, others.

Theoretically, the model is relatively stable. Although change may occur within the pillars as cultures evolve, the basic structure remains unaffected. Hypothetically, the emergence of new ideological or cultural groups, perhaps through immigration, can be accommodated relatively easily by the construction of additional pillars, which will not affect either the existing pillars or the overarching state structure as a whole. In practice such assumptions have not been sustained, as is demonstrated by the examples below. The most commonly cited cases of the pillar model have resulted from deliberate policy, or emerged through incremental compromises and, once recognised as existing, have been supported by policy. They were in that sense intentional. There are various other cases, however, where aspects of the model seem to have emerged unintentionally or are aspirational stages towards a different model.

THE ARCHETYPAL CASE OF THE NETHERLANDS

The Low Countries are located astride the religious fault line that fractured Europe following the Reformation and Counter-Reformation of the sixteenth and seventeenth centuries, the repercussions of which extended well into the nineteenth century and beyond. A Protestant ascendancy was established in the northern part of the Low Countries from the end of the 80-year conflict with the Hapsburgs in 1648, a

legacy still evident constitutionally in relation to the 'Orange' Protestant monarchy. Nineteenth-century liberalism, combined with a growing confidence and assertiveness among the large Catholic minority, led to the compromise of the pillarisation of education (in schools, colleges and universities), culture (especially broadcasting and print media), politics (including political parties and trades unions) and, more generally, society (through a myriad of health, leisure and sporting associations). The economic and social changes of the nineteenth century introduced a new dimension of liberal capitalist and democratic socialist divisions, which became superimposed upon the religious. Pillars for Protestants, Catholics, socialists and liberals were even supplemented by a non-sectarian pillar for those who felt unattached to any of these or were, indeed, unsympathetic to the whole model (Lijphart, 1968).

The role of public heritage in shaping or just expressing these religious and ideological pillars was always somewhat muted. This can be explained by the seeming paradox that cultural fragmentation coexists with administrative centralisation. The pillars were developed to accommodate individual religious and ideological differences and to allow groups based upon these to exist free from the intervention of the state or of other groups. The state, however, was remodelled after the creation of the Kingdom of the Netherlands in 1815 on the French example of governmental centralisation with little devolution of administrative authority to the provinces or localities. Consequently, while private and non-official heritage expression was a voluntary task of the pillars, most official tangible aspects of heritage, including, significantly, monument policy, were almost exclusively assigned to central government ministries and their agencies. This was justified by seeing these activities as technical and impartial, and thus outside the responsibility of the cultural pillars. The central government cultural agencies defined their role as preservers and conservers of ideologically value-free resources and as even-handed distributors of cultural subsidies to the pillars.

It is only quite recently, with devolution of governance to lower-tier authorities, that the state has encouraged official heritage expressions other than that of the national. In the course of the 1980s and 1990s, much national responsibility for heritage, especially that of the monumental built environment, was devolved to provinces and districts. Although this was done largely for budgetary reasons, nevertheless it allowed local expression by giving localities a role in the selection and interpretation of their heritage. In Chapter 4, we discussed the long-term 'Belvedere' programme, which was launched in 1999 by a consortium of four national

ministries with the explicit objective of identifying, preserving and promoting local place identity as expressed though landscapes and cityscapes. In the first five years of its operation, more than 100 local projects were approved and financed (Kuipers and Ashworth, 2001). This decentralisation of government functions in heritage emphasised local cultures and identities and not the national pillars as such. It did, however, open these latter to possible expressions of regional identity. In many respects, these reflected the religious pillars, the southern provinces being predominantly Catholic while the Calvinist Protestant 'bible-belt' stretches through the centre and north of the country.

As has been argued at greater length elsewhere (Ashworth and Tunbridge, 2000), the style and period of building restoration overwhelmingly favoured in the Netherlands by the responsible national agency (the State Service for the Care of Monuments – *Rijksdienst Monumentenzorg*) was that of the seventeenth century – the so-called 'golden age' of international economic trading dominance and cultural achievement. The selection of monuments and interpretations emphasised the structures and ideas of a merchant class located predominantly in the western provinces (especially North and South Holland and Zeeland). The image portrayed, and reinforced by the Dutch genre painters of the period, was of a sober, diligent, commercial, self-governing, essentially Protestant, urban merchant class, which contrasted with the tyrannical, feudal, Catholic Hapsburgs. The archetypes were Delft, Leiden and Haarlem, or Amsterdam's successive canal side extensions (*grachtengordels*). This national school of urban conservation, supplemented in rural areas by the polder landscape with its *dijks*, canals and windmills of the same historical period, became the epitome of 'Dutchness' both internally and as projected to the world. This image is clearly present in the world heritage inscriptions of the island of Schockland (1995), the windmills of Kinderdijk (1997), the Woudagemaal pumping station (1998), and the Beemster polder (1999).

This choice and style of conservation was replicated in local conservation not just in the Holland provinces but also throughout the country, even in regions with quite different histories and cultural composition. In particular, the overwhelmingly Catholic southern provinces, annexed by military force in the seventeenth century and governed until the middle of the nineteenth century as near-colonial *Generaliteitslanden* rather than autonomous provinces, became more assertive of their cultural and regional distinctive character in the last decades of the twentieth century. They have selected a different and non-Holland 'golden age', that of the fifteenth century. This represents the 'Burgundian period', a term that

conveys not just a particular period of history and architecture but also a more relaxed, southern-oriented and, significantly, Catholic lifestyle. The restoration, and in some cases re-restoration of buildings previously restored to the 'wrong' century, of cities such as Maastricht, Roermond, or s'Hertogenbosch is archetypical. The Catholic pillar has thus now adopted an architectural expression that is self-consciously different from that of 'Protestant' Holland, and that also stresses its wider links with Flanders, France and continental Europe.

Similarly, at the end of the twentieth century, the northern provinces began to assert a certain northern identity, in opposition to what might be called the 'Vermeer-Holland' conservation style. Frequently, this has a Hansa connection that consciously evokes a northern orientation to the historical period of the Hanseatic trading league and thus links, more widely, with North Germany, Scandinavia and the Baltic coast.

The imminent demise of pillarisation in a Netherlands that is increasingly less collectively ideologically committed and more individualistic has been regularly predicted throughout most of the twentieth century. Yet the model has proven remarkably robust and capable of adaptation. De-confessionalisation and secularisation occurred later than in much of the rest of Western Europe. Curiously, the more important challenge to the pillar model has arisen more from its supporters than its opponents. In particular, the large-scale immigration of largely low-paid workers from North Africa and the Middle East has been and remains a Western European phenomenon, but it has had a distinctive impact in the Netherlands as a result of its historical experience and compromises. The numerical increase in the Moslem population, largely from Turkey and Morocco, its second-generation self-confidence and its more recent politicisation and thus activism, have led to their demanding a suitable Moslem or Arab pillar (or possibly pillars) to be added to the existing structure. This call for appropriate institutional recognition and equality in provision is difficult to deny when it has already been granted to others. Equally, it is difficult to grant because of fears that such a Moslem pillar, practising educational and social traditions dissimilar from and even contradicting the Dutch liberal consensus, would less contribute to the overarching state structure than undermine it.

The problem of the Islamic pillar has now become compounded within a much wider review of cultural differences. Acculturation and functional integration are seen by many as increasingly desirable, and under-currents of xenophobia have been fostered and exploited by the emergence of ethno-centrist political parties in parliament. The group sovereignty within the pillar is now seen by many as a form of isolation which is threatening to

the state rather than supportive of it. An irony of the political situation is that contemporary resistance to the idea of an Islamic pillar, and increasing central government intervention within Moslem institutions, stem from a prime minister and majority party (Christian Democrat) that are themselves products of the Catholic–Protestant Christian pillars.

The contemporary Netherlands can thus now be interpreted as a partially pillarised society. The traditional pillars remain largely intact and can operate effectively for part of society, often on a selective 'pick and mix' basis. Meanwhile, other parts of society, possibly constituting a majority, have largely opted-out in favour of quite different models based on a more homogeneous society. The pillar model was placed at the stable end of the spectrum considered in Chapter 5, largely because it is intended, however unrealistically in some cases, to be an end-state rather than a phase in further evolution to another model. It has also proved to be robust and adaptable so long as there is sufficient consensus between the pillars stemming from at least some shared values, especially the acceptance of the rights of other pillars to exist.

APARTHEID SOUTH AFRICA

Not least because the terminology used originally derived from the Netherlands, as did the largest portion of the white population (the Boers), it is tempting to consider the case of apartheid South Africa as an extension of the Dutch exemplar using race rather than religion and economic ideology as the basis for pillarisation. The similarities with the Dutch case are more evident, however, in the theory than in the application of the model. Although the application of apartheid as a conscious, systematic strategy dated only from the electoral victory of the National Party in 1948, its ideological underpinnings were developed in the first half of the twentieth century by political philosophers in South Africa, the Netherlands and Germany. Many of its detailed provisions concerning land tenure, employment discrimination and the like were already in place by 1948 (Christopher, 1994).

Apartheid violated a number of the basic principles of pillarisation defined by the Dutch exemplar. The physical separation was based exclusively on defined racial characteristics, rather than on religion or political ideology as in the Netherlands. There was no equality of provision or of esteem between the pillars, nor was their separation as complete, because the

white pillars depended domestically and economically upon black labour. Only the white pillar had effective control over its own affairs, the tribal 'homelands' being only partially endowed with cultural self-determination. Furthermore, the 'homelands' contained ethnic minorities which, in becoming the focus of tension, served to undermine cohesion within these supposed autonomous areas while maximising the 'divide and rule' advantage of the white pillar. Finally the pillars did not, and were not expected to, contribute equally to the support of the state as a whole, which espoused a hegemonic white racial ascendancy.

A pillarisation based ostensibly upon physical, visible racial characteristics would be expected to divide into 'white', 'black', 'coloured' (mixed race) and 'Asian' pillars. In some respects, such as housing law, this was the case. In most cultural matters, however, these simple categories were further subdivided. Within the white pillar, both Afrikaner and British heritages dominated place nomenclature, public statuary, monumental buildings and the visual arts. They formed, nevertheless, separate heritages with little connection between them, serving different and historically opposed communities.

Afrikaner heritage was strongly focused upon delimiting and strengthening the solidarity and separateness of the Afrikaner *Volk*. It depended heavily upon the mythologies associated with the 'Great Trek' of the 1830s and 1840s, the commemoration of which was greatly intensified during and after the centenaries of its associated events. For example, the Voortrekker Monument outside Pretoria (now Tshwane), was dedicated on 16 December 1938, 'the Day of the Vow', the covenant between God and a chosen people, which in Boer/Afrikaner mythology led them to the iconic victory over the Zulus at Blood River in 1838. The Paarl language monument, sited conspicuously near a major national highway, celebrates the Afrikaans language, which remains closely identified with Afrikaner cultural identity and supremacy, and ultimately with apartheid.

British heritage is less focused upon specific historical events and more upon imperial and monarchical connections, and also British economic ascendancy in most of South Africa's mining and commerce. It is especially evident in urban heritage resources, notably government buildings, Victorian port waterfronts, and in industrial heritage.

Public statuary relates to both groups, with the nineteenth-century Transvaal resistance leader and later president Paul Kruger for Afrikaners, the entrepreneur Cecil Rhodes for the British (Figure 9.1), and Union prime minister Jan Smuts ambivalently for both. Except for the

Figure 9.1 Kimberley, South Africa: Rhodes' statue still in place (2006)

addition of some representations of the apartheid leadership, this monumentalisation has essentially survived the democratic transition. The principal common features are the war memorials and battle sites of the Anglo-Boer wars of 1881 and 1899–1902, which were, and are, jointly interpreted and managed but with significantly different meanings.

The non-white population was not included in a single pillar as such but tribalised into a number of groups. Although long referred to collectively as 'Bantu', Africans were ethnically divided. Their heritage expressions were rigorously excluded from urban identities and were tourist-commodified (under the rubric of 'a world in one country') in ethnographic museum presentations, or displays of dancing or crafts in the 'homelands' and in some of the townships. The coloured (mixed-race) group never possessed a heritage identity clearly distinguished from either 'white' or 'black'. In Cape Town, it is expressed positively in the inner-city Bo-Kaap district (Figure 9.2), which is receiving an increasing tourism-related recognition, and negatively in the dispossession from the now demolished District Six, the memorialisation of which has done much to generate a coloured consciousness. The Indian identity was chiefly marked by mosques and temples, again now tourist-commodified in Durban. This identity, like that of other non-whites, was largely excluded from city centres, which were viewed as white 'sacred

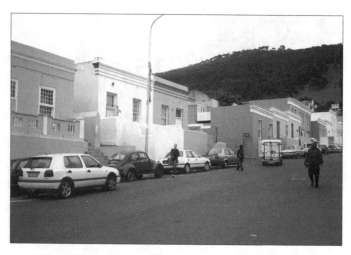

Figure 9.2 Cape Town, South Africa: Bo-Kaap, Cape Malay quarter, on slope above city centre (2006)

space', in which any reference to other races would most likely be to their defeat in colonial wars. It could be concluded that apartheid was a historical episode that has itself become a heritage, welcome or not, the significance of which lies in drawing possible lessons from the past. However, the heritage created during the apartheid period is still largely in place and largely unmodified in its interpretations (see Tunbridge and Ashworth, 1996). The implications of this and the attempts to create a new heritage dimension representing and supporting quite different visions of post-apartheid South Africa, notably the 'rainbow' analogy, will be considered in Chapter 10.

THE TEMPORARY CASE OF CANADA

Contemporary Canada is the archetypical example of the multicultural salad bowl model. For a period, however, in the evolution of these ideas, a rather hesitant and reluctant pillar model existed, at least at the federal level. Social change and political assertiveness in the dominantly Francophone province of Quebec in the course of the 1960s led to the promulgation by the federal government of an official policy of 'biculturalism'. This adopted the position

that Canada was culturally bipolar, with two official federal languages (English and French) and with the heritages of two 'founding peoples' (the British and the French). This was a clear and deliberate application of the pillar model, albeit the pillars being asymmetrical in size and also in their internal cohesion and executive operation. The province of Quebec, which dominated the Francophone pillar, acquired sovereignty over its own cultural affairs and promptly exercised these powers by an exclusive and, to many, oppressive, monolingual language policy. The other pillar (whose vague labelling as 'rest of Canada' betrays the imprecision of its definition) had far less cultural cohesion, and was in any event administratively fragmented across nine provinces, several of which had Francophone minorities. The federal government retained bilingual responsibility for a 'national' heritage promoted explicitly to create and sustain an idea of Canada. This was orchestrated largely through its Parks Canada agency, and the national museums and galleries concentrated especially in Ottawa.

The constituents of the two pillars were separately motivated and saw their relation to the central state in quite different terms. Neither group conceived of the pillar model as a desirable objective in itself. Many in Quebec viewed biculturalism as a stage in the attainment of cultural autonomy on a route to a fuller sovereignty, which would end in political separation from Canada. The 'rest of Canada' was largely unaffected by – and was to a considerable extent indifferent to – the whole biculturalism policy. This indifference increased with distance from the Quebec epicentre, possibly even to the point of hostility west of Ontario. The federal authorities viewed pillarisation as a defensive mechanism for solving the 'Quebec problem' while maintaining the integrity of the confederation.

The excluded groups and their supporters also attacked the bipolar cultural idea. In addition to the indigenous peoples, these included increasingly numerous immigrant cultures from Asia and even Africa. The plurality of Canadian culture actually prevented any real development of the idea, which was replaced in federal documentation with a multi- rather than bi-cultural policy objective in 1971, and ensuing decades saw the progressive legislative entrenchment of this concept.

However, shades of the pillar idea remain in so far as the multicultural salad bowl policies considered in Chapter 10 really only apply at the federal level and, in practice, in some of the provinces outside Quebec. Ontario, the most populous and multiculturally committed province, at least in its major cities, has resisted the adoption of official bilingual/bicultural policy at the provincial level for the million Franco-Ontarians adjacent to Quebec, opting instead for pragmatic local

compromises. New Brunswick, small and remote from the contemporary immigrant stream, remains the only truly bilingual jurisdiction in Canada. It constitutes a scarcely noticed remnant of the pillar compromise between the French (Acadian) and British components. Moreover, the resolution of aboriginal land and political claims in northern areas of Canada, particularly the creation of the substantially autonomous Arctic territory of Nunavut (1999), may yet consciously promote another element in linguistic and cultural pillarisation in addition to the settler heritage identities (Van Dam, 2005).

BELGIUM: THE CASE OF A 'RELUCTANT' PILLARISATION

If religion was the divisive element that led to the creation of Dutch pillarisation, it played only a supporting role in neighbouring Belgium, where language has marked the primary divide. The short history of the Belgian state since 1830 has witnessed the evolution of a state structure shaped by tensions between its Flemish and Francophone communities. Pillarisation was not overtly envisaged as a constitutional goal but has emerged as an ad hoc policy from a series of political compromises between the two main cultural groups. This has produced what must be one of the most complex constitutional arrangements of any Western democratic state. The country, officially a federal state with a federal government holding residual powers, is administratively divided into three spatially demarcated regions (Flanders, Wallonia and the Brussels Capital Region). It is also divided, however, into three cultural communities (Flemish, Francophone and German-speaking), which are not coterminous with the regions. The logic of the division of functions between the institutions is that aspects of government relating to people, including education and most cultural matters, are the responsibility of the three official communities, while those relating to spatial entities (such as physical planning) are performed by the regions. Such an arrangement would be confusing enough, but has been compounded since by the merging of the Flanders region with the Flemish community into a single agency under the Flemish Parliament, while the other agencies have remained separate with their responsibilities intact.

The question at issue here is not the effectiveness of Belgian government but the extent to which a pillar model of society has been created and how and why this occurred. Certainly, the Flemish and French-speaking

communities exercise sovereignty over their own cultures in a way that is more officially sanctioned and complete than that of the Netherlands. With a few exceptions, heritage policy is concentrated at the community level and is used quite explicitly in Flanders in support of an ethnic self-identity that extends to aspirations of national independence among a substantial sector of the population.

Differences from the Dutch historical compromise begin to become apparent when considering another defining characteristic of pillar models, namely the contribution to an accepted over-arching state. As a result of legislation that long predates the regionalisation of Belgium, the federal government has only a minor and somewhat relict role to play in heritage. It manages the listing of important monuments and both owns and manages a set of 'national' cultural museums, galleries and the like, almost all located in Brussels. The familiar national government use of heritage to create and promote the distinctiveness and unity of the nation was always problematic in Belgium. The Southern or Austrian Netherlands came into existence as a result of the division of the Low Countries along a military rather than a cultural fault line of the major river barriers in the seventeenth century. The short-lived reunification of the two parts in the post-Napoleonic settlement of 1815 ended in 1830 with the separation of modern Belgium from the Netherlands. Independence was achieved by a Francophone commercial and intellectual elite, with the active connivance of the major powers who needed a powerless neutral occupant of a strategic region.

The subsequent attempt to create a state-supporting heritage was always difficult and never completely successful. A founding mythology and national historical narrative drew heavily upon a supposed distinctiveness of the Iron-Age *Belgae* tribe and supposed behavioural and attitudinal differences between Belgium and the Netherlands. National museums and commemorations of national liberation (from the Netherlands) were established in the course of the nineteenth century. Simultaneously, as mentioned earlier, the 'golden age' mythology was being formulated in the Netherlands, distancing it from its southern neighbour. However, the rise of Flemish self-awareness, combined with demographic and economic change that favoured Flanders at the cost of Wallonia, undermined the relevance of the independence narrative, leaving the monarchy and its associated symbolisms as, effectively, the only remaining focus of a national Belgian heritage.

Logically, the pillar idea should be capable of extension to include new additions but in Belgium, as in the Netherlands, there have been

considerable difficulties in accommodating cultures widely different from the indigenous. There is no North African, Islamic or Arab pillar in the same sense as a Flemish and French one. It would also be tempting to add the 70,000-strong German community to the other two as a third pillar. Although this minority has considerable internal autonomy in education and many other cultural matters, it remains administratively part of the Walloon region. It thus lacks the size, political power, regional autonomy and, perhaps, even commitment to Belgium to qualify as a pillar. The 'Eastern Cantons' were a political and strategic acquisition and, although no doubt content with their cultural autonomy, have expressed an wish for ultimate re-incorporation into Germany. This community has many of the hallmarks of an exclusive 'add-on' in a core+ model (as considered in Chapter 8), the core in this case consisting of two elements in uneasy alliance.

Again unlike the Dutch case, Belgium, although ostensibly possessing many of the characteristics of pillar models, remains essentially unstable in this respect as neither of the two main communities regards this model as a particularly desirable objective. The Francophones have declined from being the leading culture in 1830 to an embattled minority today. Reluctantly, they have had to accept not just equality of esteem with the Flemish but increasingly a subordinate political and especially economic role. While the Flemish have forged a cultural identity related to, but distinctly different from, their northern Dutch neighbours, the Francophones have experienced more difficulty in shaping a specifically Walloon identity that is more than being simply a northern linguistic and cultural extension of France. It is difficult to recognise a Walloon heritage in the same sense as a Flemish one. They lack the mythologies of medieval and renaissance Flanders, together with their heroes and villains. The former include Flemish popularist liberators (such as Philip van Artevelde, leader of the 'weavers' revolt against the 'French' nobility in 1381) and the latter all too often come from the Francophone governing class. Wallonia certainly does play on the heritage of nineteenth-century industrialisation and accompanying urbanisation, which is increasingly being used as in similar regions elsewhere in Europe. The Walloons are often portrayed as victims of exploitation by both domestic and foreign capitalists. Their support for the pillar model as it has emerged is effectively defensive, not least of the considerable financial transfers from the now more prosperous Flemish north. The Flemish, in contrast, view the existing pillar structure as one further and logical step towards a fuller expression of Flemish sovereignty, which will continue

to evolve as internal and external conditions permit. For neither group, therefore, is the pillar model seen as a desirable end-state.

PILLAR MODELS AS POTENTIAL SOLUTIONS TO ETHNIC CONFLICT

It is very tempting to speculate about the possible future use of pillar models in the resolution of many long-standing ethnic political divides. They seem to offer the possibilities of combining autonomy of cultural and political expression with a tolerance or even apathetic acceptance of others, albeit based upon non-participation and even indifference and a tacit support of a unifying state.

Switzerland has successfully accommodated two main religious denominations and four language groups in a highly decentralised state structure in which only very limited powers have been delegated to the central government. The 26 cantons exercise sovereignty in many matters, including almost all cultural and education affairs. This raises the possibility that it is an illustration of the evolution of a pillar model, which appears to have prevented conflict. If this is actually so, then it could serve as an example to other countries with such plural societies. In Switzerland, linguistic, religious and other cultural differences are accommodated at the canton level while the central government retains responsibility only for a few national museums, national monuments and some distribution of national cultural subsidies. Notably, it does not engage in the shaping and promotion of a distinctive Swiss heritage to legitimate the confederation. Thus, in an administrative sense, it could be said that Switzerland comprises 26 different cultural pillars. However, the pattern of jurisdictions and cultural groups does not coincide so simply. Of the four languages, only Italian corresponds spatially to a canton (Ticino) and another, Romansch, is confined to, but is not dominant in, another (Graubunden/Grisons). German and French language groups are each dominant in a number of cantons. Catholic and Protestant religious adherence also does not correspond exactly to the linguistic divides. Switzerland is thus composed of separate cultural communities that have little interaction with each other but also possess cultural autonomy at the cantonal rather than cultural community level, with the central government playing a very limited role. Paradoxically, given this heterogeneity, Switzerland has an external image that is sharply defined. Its distinctive location controlling inland trading routes mostly defined by

mountain passes, its aloofness from international alliances, and its commercial acumen in exploiting its positional resource, all these and more contribute to a sharp if simplistic external identity.

Cyprus has a Greek, Christian majority (*c.* 80 per cent) and Turkish, Islamic minority (*c.* 20 per cent). The constitution of the postcolonial state was carefully pillarised in 1960 so that each group had a degree of cultural autonomy but was also represented at the national level. The overthrow of this constitution in 1974, by a Greek Cypriot coup, led to Turkish military intervention and the division of the island into two states on the basis of ethnicity and associated religion, reinforced by communal expulsion, migration and expropriation. Reunification is actively being sought, not least by the EU, but its attainment is being hampered by the distrust, especially of the Turkish Cypriot community, who fear being overshadowed and even eclipsed by the more numerous, richer and generally more dynamic Greek Cypriot community. A return to an institutionally grounded pillar model might assuage these misgivings allowing religious, linguistic and other forms of cultural autonomy to coexist within a reunited island state.

The ethnic mosaic of the Balkans provides a plethora of possibilities and a historical archetype in former Yugoslavia. For some 70 years, Yugoslavia of necessity operated a form of the pillar model to accommodate its three founding ethnic groups (Slovenes, Croats and Serbs), two more that emerged and became recognised during that period (Bosniaks and Macedonians), and a number of other 'national' minorities (Hungarians, Italians, Albanians). Its ultimate failure to survive is generally attributed to the failure of the Yugoslav state to sustain unity in the face of the rise of ethnic separatism (Glenny, 1996, 1999). Among the Yugoslavian successor states, Bosnia is perhaps the most suitable for the application of pillarisation. It currently comprises two administrative entities, one Serbian and one inhabited by both Croats and Bosniaks.

The attempted resolution of the Palestine–Israel conflict has focused exclusively in official dialogues on the idea of creating two separate states reflecting the two cultures. These attempts have generally foundered on the fear that one or other or indeed both the resulting states would be too small or too fragmented to be economically or militarily viable. Some unofficial parties on both sides espouse an alternative strategy of creating 'one state – one culture' by the forced or encouraged emigration of one of the groups. However the third possibility of 'one state – two cultures' is rarely, if ever, discussed. This would be a pillar model with presumably a Jewish and a Palestinian pillar, although

neither group is homogeneous and a religious–secular dimension might also be relevant. Cultural autonomy exercised through a variant of the 'Belgian' model could be envisaged, with a central authority performing necessary common functions. These would include security and the shared management of the otherwise insolubly contentious common heritage resource, Jerusalem. The major objection to this solution lies in misgivings about the strength of a shared consensus which would have to admit an equality of provision and esteem without permitting mutual participation. These misgivings are, of course, based upon the exceptional depth of cultural/historical dissonance in this case. Such a solution may seem hopelessly unrealistic and improbable but not necessarily more so than the alternatives.

CONCLUSIONS

Among the plural variants we consider, the pillar model may be particularly unstable and susceptible to metamorphosis. It could be argued that pillars contain the seeds of their own ultimate extinction. There may be an inherent contradiction over the long term between intrinsic 'othering' and the notion of parity of esteem. With differential demographic, economic or other substantive changes between the pillars, it is likely that one pillar will seek advantages over the other(s). Spatial separation of the pillars may permit the discrete evolution of 'two solitudes' (as English Canada and Quebec have often been described) and perhaps their eventual separation. There may, of course, be three or more longstanding parties involved in such developments. In any event, as in the Dutch case, the later intrusion of other parties can challenge the viability of pillarisation. Furthermore new dimensions of heritage, such as gender, may invalidate a rigid pillared status quo. In any case, the concept may prove out of temper with the zeitgeist of equality in diversity, propagated by globalising forces from multinational commerce to agencies of the United Nations.

It is the case, however, that all models of plural heritage identity are subject to evolution. Furthermore, although the pillar model may be unstable in the long run, it may permit the resolution of otherwise intractable political problems in particular places and times, as we have suggested in the case of Cyprus. While it lasts, the pillar model may shape a binary, or more fragmented, heritage identity, which will leave indelible traces on whatever social and heritage order succeeds it.

10 HERITAGE IN SALAD BOWL MODELS

When the adjective 'multicultural' is used to describe a culturally plural society, or the noun 'multiculturalism' is used to describe a social policy, then it generally refers to some form of what can be called the 'salad bowl model' of cultural pluralism. This model so encapsulates both the hopes of supporters and fears of opponents that it is difficult to discuss in dispassionate terms. The difficulties are further exacerbated by some lack of precision in terminology, which complicates the task of describing the ways in which heritage is used within such models. As noted in Chapter 5, a plethora of colourful metaphors is used more or less interchangeably. The salad bowl assumes that the diverse ingredients of the salad are brought together and collectively create the dish without losing their distinctive characteristics. A similar idea is contained in the cultural 'mosaic', in which the individual elements together create a pattern through their juxtapositions while each fragment remains unchanged and individually identifiable. Finally, and more recently, there is the 'rainbow' variant of the model in which different and contrasting colours produce a regular pattern, like the mosaic, but the core of each colour remains unchanged and only their edges merge seamlessly into each other to produce the rainbow.

Canada is frequently invoked as both the originator and main contemporary proponent of the salad bowl model, although the official parlance is usually the Canadian mosaic. The state's enthusiastic espousal of the idea can even be seen as part of a deliberate attempt by Canada to distance itself from its large and potentially predatory southern neighbour. The lack of a clear national core culture was transformed into a virtuous non-coercive mosaic in ostensible contrast with the more constraining US melting pot. Interestingly, however, early misgivings about the efficacy and desirability of the melting pot idea occurred in the United States. Kallen's reservations, expressed in 'Democracy versus the melting pot' (1915), were current not long after the term had been first popularised to describe what had already occurred in US

by the end of the nineteenth and beginning of the twentieth centuries (see Chapter 6). Again, the term 'cultural mosaic' was introduced into Canada as early as 1938 (Gibbon, 1938), to describe an existing ethnic variety at a time when that country exhibited a substantially more homogeneous racial and ethnic composition than did the United States. Describing Canada as a mosaic at that time, which long predated the large-scale non-British and ultimately non-white immigration of the post-war period, may seem somewhat strange to contemporary Canadians, who are led to associate their mosaic with more recent leadership (notably the Trudeau government of the 1970s). Before 1949, arrivals of British origin were officially called 'settlers' and those of non-British origin were denoted as 'immigrants', to whom different regulations applied. Already in 1938, however, the comparison with, and even assumed superiority to, the United States melting pot was quite explicit.

VARIATIONS IN MEANINGS

Before examining the roles ascribed to heritage within ostensibly salad bowl policies, it is necessary to distinguish some of the often quite wide range of meanings. The two most frequently encountered distinctions are, first, the difference between descriptive and prescriptive models and, second, between pluralistic and particularistic applications in policy.

Used descriptively, 'salad bowl' is little more than recognition that many societies are plural and can be classified into groups based upon ethnic origins or other cultural traits. The word 'mosaic' is often used and may have few policy implications, being no more than a description of a perceived reality rather than defining any desirable objective. Prescriptive models go beyond the recognition of an existing recognised demographic diversity to the realms of government policy. This jump from description to prescription occurs frequently, without justification, in some of the cases discussed below. Second, salad bowl models can be pluralist or particularist (in effect separatist) in their approach. The former approach regards diversity as a resource which, as far as possible, should be universally accessible. This idea stresses inclusion in two senses: that all cultural groups should be encouraged to contribute to the whole, and that any barriers of accessibility hindering the participation of any particular group in the benefits should be identified and removed. In contrast, separatism seeks to discover and foster cohesion within the different groups through a strengthening of their alleged differences. Pluralist approaches may range from merely

accepting the existence of diversity, through mutual respect for such differences, to an active, if selective, participation in what such diversity may have to offer. Separatist approaches, however, are concerned more with preserving the integrity and authenticity of the distinctive group than with its relationship to the whole.

It is clear from this brief review of differences in meaning, following our previous discussion, that multicultural policies cannot be equated simplistically with salad bowl models. While these may themselves be very diverse, many policies labelled as multicultural are more comfortably allocated to other models already considered in earlier chapters. In reality, many are little more than single core models within which non-threatening minority groups are tolerated. They may also be core+ models where a leading culture is enhanced, but not substantially changed, by the continued coexistence of minority groups or even pillar models that stress the integrity and separateness of the constituent groups. However, the salad bowl model as a term and an idea originated in juxtaposition to single core assimilation and melting pot models. It is generally used in contrast to these and is has to be understood in these precise terms.

CASES OF OFFICIAL POLICIES

Although it can be rather difficult to find examples of the deliberate application of salad bowl models at the national scale, there are three notable instances: Canada, Australia and contemporary South Africa. They share certain historical similarities, being viewed primarily, despite the existence of indigenous populations (which in South Africa formed a majority), as colonies of settlement. All three evolved as Dominions of the British Empire, with a strong official set of dominant political and social values (although both South Africa and Canada were bi-polar, with the settlers being divided respectively into Boer–Briton and Anglophone–Francophone). In all three cases, further diversity was added through immigration, salad bowl policies being a reaction to the recognition of this increasing ethnic complexity.

Canada: salad bowl by default

As previously intimated, the political evolution of Canada is inexplicable without reference to the United States. Simply stated, the United

States was created through the revolutionary rejection of the political status quo in 1776, which necessitated the shaping of a new citizen for a new nation. More than a century later, this process was to be given the label 'melting pot', even though there was relatively little variation to 'melt' during those first few generations (see Chapter 7). Canada came into existence later and more hesitantly, being founded initially on little more than a rejection of that revolution (Moore, 1984). After the American War of Independence, the remaining diverse and spatially fragmented British colonies and territories in North America did not require homogeneity of language, religion or social custom produced from a melting pot, but only an acceptance of the established order, expressed symbolically through loyalty to the British crown. In that sense legal recognition of the salad bowl concept of coexisting diversity goes back to the Quebec Act of 1774, which institutionalised toleration of the French language, Catholic religion and seigniorial land system within 'Lower Canada', later Quebec. The creation of the Dominion of Canada in 1867 did not reflect the emergence of a new national identity in the same sense as that of the United States. Confederation was largely a defensive measure instigated by imperial interests, to forestall US expansionism following the Civil War of 1861–65, rather than by popular sentiment. Its inherent structure, as enshrined in the British North America Act of 1867, allowed residual sovereignty to rest with the individual colonies, later provinces, rather than the federal entity. Identification was with the province, with ethnic or linguistic communities, and with the Empire, which defined the wider rights, obligations and identity of Canadians in the world.

Attention to the need for nation-building at the confederal scale was strongly stimulated by the First World War but dates really only from the Second. This was a reaction to Canada's national contribution to those conflicts concomitant with the loosening of the Empire within which the Dominion had been created, as well as to the strengthening of the cultural and economic ties with the United States, which were perceived as posing a threat to the continued separate existence of the Canadian Confederation. This self-reflection resulted in the attempt to invent a Canadian nationalism from the model of the European nation-state, including its trappings of citizenship, new anthems, flags and the like.

This search for nationhood encountered two major difficulties. First, cultural diversity and the historical experience of political evolution rendered it more realistic to discover the nation at the provincial rather than federal level. Quebec most obviously and vociferously, but

also other provinces such as Newfoundland (joining only in 1949), the Maritimes, British Columbia and even the Prairies asserted varying degrees of nationhood based upon the usual European criteria of social and historical distinctiveness. Second, a model of the nation had to be developed that was distinctly different from the United States. If the confederation was to survive, it needed both to accommodate an inherent diversity, which has come close to fragmenting the state on a number of occasions since 1945, and also to demonstrate a substantive difference from the United States in a contrasting model for a contrasting society. It was these imperatives that led eventually to the espousal of the multicultural salad bowl or the Canadian mosaic, as distinct from a melting pot.

The Canadian Multiculturalism Act (1971) has acquired the status of a global example and is referred to in almost all discussions of the topic. In fact, the creation of Canada's present official multicultural edifice results from a progressive accretion of federal policy initiatives over a generation rather than a single Act. In the 1960s, pressure from Francophones, most specifically in the province of Quebec, led to the introduction of bilingualism at the federal scale. This went further than the recognition of the French language in government by creating the idea of the two 'founding peoples' of Canada, thereby prompting strong reactions from excluded groups. These included the indigenous populations and immigrants of other than British or French origin. Ley and Hiebert (2001: 124) note that: 'the birth of an official multicultural policy in Canada followed an intense lobbying effort led by amongst others, Ukrainian- and Jewish-Canadian communities.'

In reality the Act is very ambiguous and is a carefully worded attempt to balance two, probably irreconcilable, ideas. These comprise an infinitely extendable salad bowl of mutually accessible diverse cultural groups and, simultaneously, a central core of 'Canadianness' based upon the concept of the biculturalism of the two 'founding peoples'. The five 'principles' intended to guide the application of the Act are summarised by the phrases: 'retaining identities', 'fostering a sense of belonging', 'the acceptance of others', 'the creation of harmony' and 'the discouragement of ghettoisation'. The spectrum ranges from the 'hard' separatism of group identity to the 'soft' all-inclusive mutual acceptance, harmony and de-ghettoisation, whether spatial or social, with a number of quite ambiguous ideas in between. It is questionable whether the approach discourages or implicitly encourages ghettoisation. The ideas both of 'belonging' and 'harmony' contain the implicit argument that the security of belonging to a

minority group will encourage a wider belonging to the diverse society as a whole, and that harmony at one scale is related to harmony at another.

Some of the clauses of the Act reveal an attempt to balance these approaches. For example, Clause A grants 'a freedom to preserve and share' but is silent on freedom to destroy or to exclude. Clause B claims that: 'Multiculturalism is a fundamental characteristic of Canadian heritage.' The diversity becomes itself part of the national binding element. A number of opposites are juxtaposed without making it clear how they are to be reconciled. These include: individual rights and respect for cultural diversity (Clause E); individuals and communities (Clause G); biculturalism as well as multiculturalism (Clause I).

There are other difficulties with the application of the sentiments expressed in the Act. First there is the question of scale. At what scale does a combination of distinctive elements occur? In Canada this is clearly at the federal scale. The provinces and, even more notable, the localities within them remain for the most part substantially unicultural (only the small Maritime province of New Brunswick operates an official bicultural policy, as noted in Chapter 9). The salad bowl is most in evidence when viewed from Ottawa (whose departments and ministries, variously named as Heritage, Environment, Citizenship and Multiculturalism, are engaged in this enterprise) and is experienced most particularly in Toronto, Montreal and Vancouver, the largest cities where immigrants are concentrated. Even here, a visible multiculturalism, although spreading, is most notable in specific and limited, mainly central, localities such as Queen Street in Toronto or Robson Street in Vancouver. Most of the rest of the country could be seen as substantially ethnically ghettoised. Wisely, the Canadian Register of Historic Places has adopted a system of plural values whereby all levels of government may designate the same places according to the heritage values relevant at their scale (Ricketts, 2006); while accommodating all scale perspectives, however, this may equally reveal the extent of heritage dissonance that exists between them.

Second, the question arises as to the necessity for some binding element to provide a dressing on the salad, regular structure to the rainbow or pattern in the mosaic. In Canada this was provided by the Loyalist myth (Moore, 1984; Ashworth, 1996), and it was the fading of this mythology that led to Grant's influential *Lament for a Nation* (1965). In Australia the binding element was the strong numerical and political dominance of a single cultural origin and shared values. The changing global context and ethnic composition in both countries now raises the question of whether a coreless diversity is sustainable. Ley and Hiebert observe in Canada that:

official multiculturalism has come under concerted attack from the left (for posing an equality that does not exist), from the right (for encouraging a tribalism that challenges any national unity), and from some immigrant groups themselves (who reject the implication of inherent and permanent difference from the mainstream that a hyphenated cultural identity seems to bestow upon them).

(Ley and Hiebert, 2001: 123)

They note that in the face of criticism the Liberal governments of the 1990s eased reference to multiculturalism in favour of integration. The subsequent Conservative government has no reason to reassert the multicultural policy.

The creation of heritage narratives – multicultural or otherwise – does not, however, necessarily rest in the hands of agencies responsible for the formulation of social policy. Federal heritage agencies do conform closely to official multicultural policy; whether provincial or private agencies – particularly traditional local museums – do so to the same extent is another matter. We consider below the case of Ottawa, where the National Capital Commission and the Canadian Museum of Civilization are the principal instruments moulding the capital identity as an appropriate model and receptacle for the national multicultural vision. The example of Halifax illustrates the nationwide role of the Departments of Canadian Heritage and Environment, specifically Parks Canada, in promoting that vision. However, in both Quebec and Newfoundland the provincial heritage identity retains a unicultural bias.

Ottawa

The federal capital, Ottawa, is at the centre of Canada's heritage pluralisation, even though it is only the fourth-largest Canadian city (1.05m population in 2001) and notably less multicultural than Toronto, Montreal or Vancouver. Its role, paradoxically, is to represent the plural identity, which only those cities unequivocally embody. The National Capital Region (there being no federal district) is roughly coextensive with metropolitan Ottawa and Gatineau, in Ontario and Quebec respectively. In this region the federal government moulds development through its ownership of strategic areas and corridors, notably a green belt, wilderness park, river/canal shorelines and the political/symbolic city core.

Within the core area especially, the National Capital Commission is shaping a plural Canadian iconography from an inherited Anglo-French

monumental landscape (Figure 10.1). Contemporary recognition of the Native/First Peoples as national co-founders has prioritised both new Indian monuments and modification of those considered demeaning (Tunbridge, 2006) (Figure 10.2). However, the global diversity of immigration since the 1960s cannot be monumentalised, other than by 'minimalist' representations and aspirations of identity values held in common by all Canadians. Illustrations of these assumed common values include: the Peacekeeping Monument (Tunbridge and Ashworth, 1996; Gough, 2002), the Tribute to Human Rights, and other related iconography referring, for example, to the status of women and the Terry Fox statue representing achievement overcoming disability.

Specific representations of the many strands in the Canadian heritage plurality can be achieved only in a museum setting, and then with some difficulty. The Canadian Museum of Civilization (CMC), on the Ottawa River facing Parliament, is the national apotheosis of this objective (Tunbridge and Ashworth, 1996). It represents major ethnic components within permanent exhibits, and portrays smaller cultural elements in rotating temporary displays, either in their own right or within particular heritage themes. After protracted deliberations, the museum's progressive development now includes a 'First Peoples' Hall. Citing a preceding temporary exhibit on the Plains and Plateau peoples

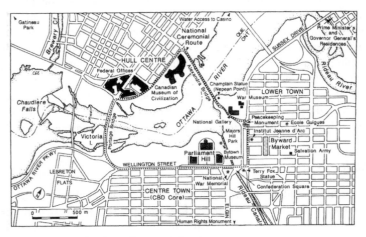

Figure 10.1 Ottawa, Canada: central area

Source: based on a map published in Tunbridge and Ashworth, 1996.

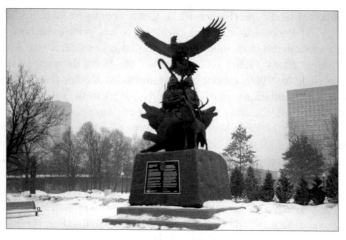

Figure 10.2 Ottawa: Aboriginal War Veterans' Memorial,
Confederation Park (2002)

and their adaptation to European incursion, Allen and Anson (2005) recognise CMC as a unique setting for multicultural encounters on equal terms and for developing the concept of museums as potential 'sacred spaces' for the negotiation of cultural differences.

Continuing revitalisation of this formerly industrial riverfront precinct is facilitating further heritage pluralisation initiatives. A relict industrial mill will be converted into an Aboriginal cultural centre, in recognition of the site's indigenous heritage primacy (Jones and Birdsall-Jones, 2003). The opening of a new Canadian War Museum nearby inevitably advances heritage pluralisation by virtue of the global reach of Canada's war experience. It does not, however, entirely eliminate the demonisation of former enemies now present in the national salad bowl, for even in the world's most avowedly multicultural society there remain influential constraining voices.

Halifax

While not a leading multicultural city, Halifax succinctly illustrates the nationwide pluralising effort by Parks Canada in the designation of three very different National Historic Sites in 1997.

Africville was a marginalised shack-town just outside the formal city and beyond its service provision (Tunbridge and Ashworth, 1996). It had

[188]

been occupied for over a century by black Haligonians, many descendants of the Loyalist migrants from the post-independence United States. In the 1960s, much of it was cleared under the rubric of urban renewal and social integration, and ultimately replaced by a park. This coercive process reflected its time but led a later Canadian generation, driven by a romanticised nostalgia for lost community life, to reinterpret Africville's fate as a racist injustice. This occasioned a temporary display at Ottawa's CMC, the erection of a memorial and, later, designation as a National Heritage Site.

By contrast the Little Dutch Church (P.B. Williams, 2005) has survived over 250 years, despite being a vernacular structure now in a poor public housing area that accommodates in part those displaced from Africville (Figure 10.3). Its origins as a German Lutheran church, dating from the city's foundation, were obscured by successive layers of ascribed meaning and intermittent neglect, although its German heritage association emerged locally in the nineteenth century. National recognition of its German origin was boosted by the German Chancellor's visit in 1995, the fiftieth anniversary of the end of the Second World War being seen as legitimising renewed celebration of German identity. However considering its non-German elements, alien present surroundings and marginality to the tourist-historic city and its information systems, its designation may soon reveal more about Canada's millennial pluralising obsession than about the particular heritage of German Canadians or of the church itself.

Figure 10.3 Halifax, Nova Scotia: Little Dutch Church (2005)

The third site, Pier 21, is divergent again as a heritage pluralising resource (Figure 10.4). It is an unprepossessing port warehouse, which provided one of Canada's main immigrant reception centres from the 1930s to the 1960s. As such it has been converted by Parks Canada into an interactive museum of immigration, where the visitor is invited to share the hopes, fears and indignities of those who sought a home in Canada, particularly in the wake of the Second World War. The quintessentially pluralising narrative is laced with sub-themes of specific heritages such as British war brides of 1945 and Hungarian refugees of 1956, while the pier's role in wartime military embarkation provides a reverse perspective on its global meaning. As the seaward anchor of an extended harbour-front boardwalk, which is a key component of the tourist-historic city, Pier 21 is likely to play a popular and enduring role in heritage pluralisation.

Other Canadian perspectives

In a country as large and diverse as Canada, and others we discuss below, scale disparities in heritage interpretation are inevitable. Federal policy is not invariably reflected at the provincial level. Subtle tensions exist between the federal and Quebec governments, especially over the heritage interpretation of Quebec City, which compromises its World Heritage status (Evans,

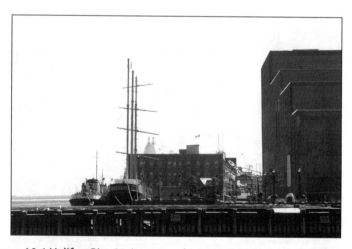

Figure 10.4 Halifax: Pier 21, in centre; historic ship, harbour walk in foreground (2005)

2002; Ashworth and Tunbridge, 2000; Tunbridge and Ashworth, 1996). Quebec tends to promote uni-cultural French/Francophone Quebecois interpretations, leaving the federal government to uphold the province's major British/Anglophone and Montreal-based 'Allophone' heritages. Again, in Newfoundland, the federal role is mainly to pluralise the otherwise strongly British provincial heritage interpretations, although this bias appears to be changing in the developing displays of the new provincial museum and archives in St. John's (Figure 10.5). The major but ambivalent Irish heritage is, however, well recognised by both provinces, albeit from their different perspectives (aided by Celtic-cross memorials sponsored by the Irish government, as elsewhere in Canada).

Across Canada, provincial and local interpretations, not to speak of public versus private ones, may depart from the official federal heritage ideology. While this is true elsewhere, the potential for varying the pluralisation message is seldom as sensitive as it is in Canada. A further, familiar, complication is the plural retrofit of formerly singular heritage messages by agencies that wish to do this. This includes the rehabilitation of villains as heroes of plural resistance to singular visions, such as the lionisation of the *Metis* (Indian-French) rebel Louis Riel a century after he was hanged for treason (Osborne, 2002).

Notwithstanding dissonances, and indeed resistance, the pluralisation

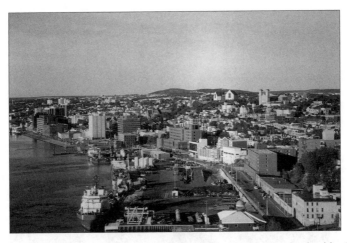

Figure 10.5 St. John's, Newfoundland: historic centre overlooked by The Rooms museum and Basilica (2005)

of the Canadian past as a deliberate contribution to the salad bowl may now be encountered in places remote from metropolitan centres, and not always through federal agency. One such is 'Uncle Tom's Cabin' in rural southwestern Ontario (currently a provincial heritage site but near other related national and local historic sites, see Pollock-Ellwand, 2006) (Figure 10.6). This preserves the settlement of the Reverend Josiah Henson, the model for Harriett Beecher Stowe's famous character, who like other slaves escaping the United States via the Underground Railroad 'followed the North Star to freedom'. Lest the contemporary national symbolism be missed, it is said that from time to time a light is still seen burning in Henson's cabin window, for all who seek freedom in Canada.

Canadian pluralisation of the past therefore gives a complex mix of signals and the salad bowl cannot be simplistically assumed. Non-federal agencies may be, may be becoming, or may not be so motivated. We cannot discount the existence or appearance of alternative plural models: Quebec, in particular, does not ignore minority heritages but may see them through the core+ lens familiar in Europe. Neither can we discount the possibility that federal Canada, unable to quell either national dissent from its plural policy or local dissonance within it, may slip into a model format other than the salad bowl of which it purports to be the standard-bearer.

Figure 10.6 Uncle Tom's Cabin historic site, SW Ontario (2004)

Australia: salad bowl with core

The formal commitment of the Australian Commonwealth government to multiculturalism as federal policy is relatively recent; earlier assimilation policies have been outlined in Chapter 7. Policy documents reveal an ambiguity in endeavouring to reconcile what are in essence three contrasting ideas that strongly echo the Canadian case. The 'positive' idea is expressed as follows. First is the acceptance of the existence of cultural and ethnic diversity; in practice, however, this is represented by little more than statistical tables of the composition of the current population by 'culture of origin', which do no more than point out the obvious. Second, there is a call for 'respect of diversity' and, third (and presumably stemming automatically from that respect), a plea for the right of diverse cultural groups to preserve and foster their cultural distinctiveness.

Each of these policy objectives is modified, however, by a 'notwithstanding' clause that places these aspirations or rights in a subordinate position within the context of current Australian identity. This is defined not only in the general terms of loyalty to existing political and social values but also specifically to the primacy of the English language and the existing constitutional structures. An enduring core identity is thus a central commitment, but the means of its reconciliation with growing diversity is not defined. The same caveats apply as in Canada to the process of heritage creation. The extent to which it is dictated by federal social policy varies among the diverse agencies involved. Also the persistence of traditional uni-cultural heritage interpretations is, as in Canada, more apparent at lower level jurisdictions and with distance from the major cities and from Canberra, the national capital.

Major national museums have increasingly assumed the multicultural mantle, most immediately with respect to re-inscribing the Aboriginal people into the national heritage. In their nation-building function, leading museums are 'Australianising' the country's past, recalling the indigenous pre-colonial period to assert the length of the nation's history. Wider efforts at pluralisation are illustrated by the Migration and Settlement Museum in Adelaide, which claims to be Australia's first multicultural museum and endeavours to portray the country as always having been a safe haven from prejudice elsewhere (Henderson, 2005).

One notable recent example of pluralisation is an 'edgier' historical reinterpretation now uneasily penetrating gold rush heritage representations in Australia, in which the experiences of Chinese immigrants, Aborigines, women and children at the human 'edge' are given more prominence. These

narratives include a more realistic portrayal of the privations, uncertain fortunes and environmental destruction underlying the traditional linkage of gold to progress (Frost, 2005). The Sovereign Hill goldfields theme park in Ballarat, Victoria, engages with pluralising initiatives that fit school curricula, Asian tourism and the need for novelty. It is aided by its proximity to the Eureka Stockade museum, which commemorates ethnically/ideologically-motivated miners who rebelled against the British authorities and now serve republican heritage purposes (Figures 10.7 and 10.8).

Canberra, like Ottawa, plays the central role in heritage salad bowl pluralisation, for example in its National Museum of Australia. However its heritage record of the country's global engagement is inevitably more equivocal at the Australian War Memorial, which with its museum is one of the principal shrines of the nation's core identity.

South Africa: the rainbow vision

Post-apartheid South Africa is a third well-known example of a salad bowl, a new past being required to reflect and support the new present, in which the old heritage created by the apartheid regime and its predecessors becomes at best irrelevant, and at worst contradictory. However, the simple argument for changing heritage to reflect and support a changed

Figure 10.7 Ballarat, Victoria, Australia: Chinese prayer house (right) at Sovereign Hill gold-mining theme park (2005)

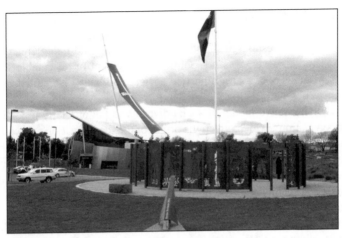

Figure 10.8 Ballarat: Eureka Stockade monument and museum (2005)

society is modified by two main constraints. First, a new heritage agenda costs time and money, and both are lacking. Second, a clear and definitive shift from the old heritage to a new would threaten the stability of the political transition. A heritage legitimating the new state needs to be created while reconciling minorities, including those who were committed to the former state idea. If the new South Africa wishes to continue to involve its white, coloured and Asian minorities in its economic, social and political life, which is its clearly stated policy, then it cannot either demonise them or write them out of the rescripting of the country's founding mythology. It needs at least their passive consent, if not their active embrace of any new official heritage narrative. The longstanding academic assumption of solidarity between coloured/Asian minorities and Africans, as a supposedly united 'black' opposition to apartheid, was invalidated by the first majority democratic election results in 1994. These groups may have had little place in the founding mythology of the apartheid state, but neither would they automatically identify with its successor.

There was nothing inevitable about the adoption of the rainbow model in post-apartheid South Africa. A reasonable apparent alternative would have been to continue with a variant of the existing pillar idea. Society was already divided into relatively clearly defined groups, even though they had been historically more fluid (Christopher, 1994, 2002); the division could, ostensibly, have been maintained with some redress in provision of

resources and facilities. Even the 'homelands' idea could conceivably have been retained, once the inequality in resources had been rectified. Some Afrikaners even espoused the idea of a new homeland being created for them. This, however, was not politically expedient or acceptable to the majority and the idea of a pillarised society had been discredited by the apartheid past.

The alternative model of social diversity is the officially proclaimed 'rainbow nation', which, given the origin of the idea of nation as a cultural homogeneity, could be regarded as an oxymoron. It is, of course, far too early to judge the success of this most far-reaching of racial and social experiments, which is founded upon the constitutional guarantees of individual rights rather than the preceding apartheid group rights. If it works it will provide a unique model for many other parts of the world: if it fails it will discourage similar experimentation. Currently the government faces quite profound racial, social, ethnic and now especially economic divisions, compounded by a recent history of tension and at times outright hostility. Although current field experience suggests more relaxed interracial relations, the recent decline in the white population may be placing the 'rainbow' in jeopardy (Cole and de Blij, 2007). The rainbow nation, faced with these uncertainties, may well have to continue to accommodate separate heritages within public heritage, however uncomfortable or even contradictory these may be.

A central dilemma both philosophically and in practical terms concerns the unequal nature of the starting point for the construction of the rainbow nation. South Africa has inherited gross inequalities such as job reservation and income differentials, from the apartheid era. These have resulted in unacceptable imbalances where the white groups have a disproportionate share of higher-paid employment, which could only be rectified in the short term by reverse discrimination. This, of course, contradicts the basic tenets of equality of respect and treatment between groups. The resulting paradox is that the rainbow model, with its central concept of equality of treatment, can only be brought into existence by the, at least temporary, implementation of unequal treatment. This however may alienate white groups and lead ultimately to emigration, a 'white flight', which, as noted, is already apparent.

Heritage policy and practice in South Africa

The heritage of resistance to apartheid is communicated through two very commonly encountered heritage narratives (Ashworth, 2004). In the

'progress thesis', the historical chronicle of events is reduced to an inevitable linear narrative of improvement from bad to better. This is the 'road to freedom' or, equally, could be the 'road' to prosperity, enlightenment, civilisation or any other such description of the completed present. It is chronologically simple, easy to comprehend, avoids the complications of contradictory or competing ideas and is also remarkably self-justifying for both producer and consumer. Second, there is the 'freedom struggle', a term that encapsulates both goal and process. It has attributes of simplicity and inevitability, combined with elements of drama and heroism, which is unifying within the group, most especially in relation to the demonised oppressor. This narrative is of course particularly relevant to the South African case.

The location of the heritage of the struggle against apartheid has three characteristics. First, it is ubiquitous in that every homeland and township is an enduring monument to the apartheid system. Second, the new heritage sites and collections are fragmented. Commemoration of events or conditions specific to apartheid are being inserted into already extant British and Afrikaner heritages and collections. Third, that heritage of the anti-apartheid movement is often ordinary in that much of it was acted out by poor people in the mundane and prosaic environments of the poor. Artefacts are sometimes too evanescent to be effectively preserved, while dramatic events, such as the Sharpeville shootings of 1960 or the Soweto school uprising of 1976, took place in unremarkable settings.

The use of heritage of the apartheid era to reflect and express the new rainbow national idea is reflected in a number of notable museums. Cape Town's District Six Museum was opened in 1994 to mark the racially mixed society that had existed there prior to the designation of the district as 'white' in 1966 and the consequent forced removal of its population. It depends upon 'autoethnography', that is personal accounts, to reconstruct a remembered past that is a somewhat romanticised vision of a racial and social harmony (McEachern, 2001; Crooke, 2005). This portrays the rainbow nation as past reality rather than only future aspiration. It represents many such uprooted communities throughout South Africa. Also in Cape Town, the Bo-Kaap museum similarly houses the artefacts and records of everyday life of the long-standing predominantly Malay community of the district. Like the District Six Museum, it concentrates on evoking the image of a lively and harmonious past community (Murphy, 1997), now susceptible to displacement through market forces. The anti-apartheid struggle is expressed in two sharply contrasting museums. The Winnie Mandela House, Orlando West, Soweto, is a small, otherwise unremarkable township house

associated with the Mandelas. Its unpretentious ordinariness stresses the struggle of the common people against an oppressive state. The Apartheid Museum in Johannesburg, opened in 2001, is large, purpose-built, architecturally notable, and professionally managed. Its didactic interpretative theme of universal injustice and resistance is intended to appeal to all racial groups in South Africa as well as to foreign visitors. If the message of the Winnie Mandela House is inseparable from its location in Soweto, the location of the Apartheid Museum on the outskirts of Johannesburg, next to the Gold Reef City historical theme and amusement park, is accessible to the largely white suburbs and international airport. Between these extremes, however, are freedom-struggle 'retrofits' to pre-existing local museums across South Africa.

The most renowned and popular museum is the Robben Island prison complex, which has been a World Heritage Site since 1998 and generates 300,000 annual visitors (Worden, 1996, 1997: Deacon, 2004). Although its meaning remains contested, it has become in many respects the centrepiece of the new heritage presentation and the main and sometimes only such experience of visitors to South Africa (see Smith, 1997). Its success depends in part upon its association with Nelson Mandela but also on its location in Table Bay, 11 km from Cape Town and accessible by boat tours from the Victoria and Alfred ('V and A') Waterfront. Robben Island reaches beyond apartheid, however, for its record as a place of educational enlightenment among inmates and even guards has permitted its non-racial heritage interpretation as the cradle of South African democracy. As an icon of national reconciliation, it thus carries a greater global message (Graham *et al.*, 2000; Graham and McDowell, 2007). Through this medium, South Africa's conflicting myths of heroic resistance, in particular Afrikaner versus African, might finally be brought into a common focus of ultimate triumph over injustice.

The 'V and A' Waterfront, the access point to Robben Island and in itself South Africa's prime tourism attraction, provides another market-oriented location for the rainbow narrative, notwithstanding its well-documented early reticence in pluralising its own past (Worden, 1996; Tunbridge and Ashworth, 1996). The freedom struggle is expounded there by the new Nelson Mandela Gateway museum at the Robben Island boat terminal (Figure 10.9); and further illustrated by the nearby Nobel Square monument which newly portrays South Africa's four Peace Prize laureates, among whom is the last white apartheid president, F.W. de Klerk (Figure 10.10). Ushaka Village, the 'V and A''s recent counterpart on Durban's waterfront, may be expected to produce rainbow heritage messages for its own multi-racial tourist/leisure patrons.

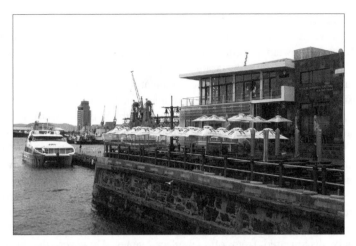

Figure 10.9 Cape Town, South Africa: Nelson Mandela Gateway museum
at Robben Island boat terminal (2006)

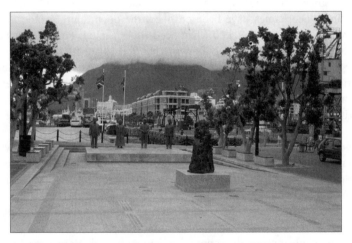

Figure 10.10 Cape Town: Nobel Square at 'V and A' Waterfront; city and
Table Mountain in distance (2006)

There are also heritage sites that merely mark events rather than being impressive structures in prominent and accessible places. 'Freedom Square' in Kiptown, Soweto, is a characterless space, given significance as the location of Walter Sisulu's declaration of the 'freedom charter'. The spaces around the Regina Mundi Catholic church at Rockville, Soweto, are where dissidents gathered in the 'Soweto parliament' in defiance of the Congregating Act. The Morris Isaacson School in Mpathi Street, Soweto, and the nearby Vilakazi Street memorial mural commemorate the reputed origins of the 1976 school protests against the introduction of Afrikaans as a medium of instruction. In addition the Hector Peterson Memorial in the Soweto cemetery commemorates an individual victim of this historical episode.

The renaming of places is a visible, cheap and easily executed form of reinterpreting public heritage. The names of some notable individuals associated with the apartheid state, such as Malan or Verwoerd, have largely disappeared from official place names. However, the historic figures associated with the founding of the original Boer/Afrikaner states, the British colonial government and the white politicians of the succeeding Union have generally remained in place names as in monuments, albeit subject to continuing attrition (Marschall, 2006). Although few existing place names have been changed, the opportunity to add a new nomenclature has been taken when needed. As capital, Pretoria has been (at least formally) changed to Tshwane but Port Elizabeth remains within the new Mandela Urban Region and the country itself remains South Africa and not, as some would prefer as a clear statement of new beginning, Azania. Street-names offer abundant opportunities for detailed heritage adjustment and these are being exploited for a limited and selective change in which the newcomers may have a pointedly rainbow flavour. Thus, after much local deliberation, Alan Paton and other white liberals now grace some important city streets in Pietermaritzburg, along with Chief Albert Luthuli and other resistance heroes, the replaced names including a few of unloved colonial associations.

The personification of heritage around a single named individual is epitomised by the planned 65m high statue of Mandela in Port Elizabeth, a monument that, it is reported (Campbell and Beresford, 2002), concerns and embarrasses the subject of this adulation. Marschall (2006) notes, however, the role of corporate enterprise and civic place marketing in this venture, creating for Port Elizabeth a heritage and tourism amenity focus comparable to the other main port cities regardless of the lack of a particular local connection with Mandela.

The tourism use of heritage is also a complication. The new heritage

of the apartheid struggle is largely an added dimension to the existing South African tourism products developed during the previous regime, such as wildlife and the vernacular traditions of the indigenous black African tribes (Goudie *et al.*, 1999). It is notable that the new attractions most visited by Western tourists (Robben Island, District Six Museum, Apartheid Museum Johannesburg) are those that fit most easily into networks of the more traditional tourism sites. The heritage most readily sold to Western tourists, and which dominates museums, monuments and place-names, remains that relating to the founding of the Afrikaner state and society and the British imperial chronicle, even if some of its resources, such as the renamed Slave Lodge in Cape Town, now serve current socio-political objectives.

A rainbow heritage?

The new South African heritage is being created within the context of the old, which allows three main policy options. The heritage of resistance to apartheid as a new national narrative could replace, accommodate or coexist with the previously dominant heritage narratives. The first of these possibilities – replacement of the old heritage of 'Boer, Briton and Bantu' by the now dominant heritage of the 'freedom struggle' – disinherits the white minority whose continued commitment to the state is essential, and also ethnic heritages (often politically sensitive such as Zulu) within the African majority. It would also discard the main existing heritage tourism assets.

The second option, accommodation, would not eradicate the past as narrated nor ignore its sites and relics but modify it and incorporate it into the new dominant interpretation. Some Anglo-Boer war memorials (Nasson, 2004) have been modified to include the roles and sacrifices of non-white participants. Examples are the Wall of Peace and Reconciliation (Figure 10.11) and Gandhi memorials added at Talana, Kwazulu-Natal, at which local community interests have commemorated, notably, the Indian role as stretcher-bearers. The 'Day of the Vow' sacred to Afrikaner Trek mythology, 16 December, has been retained but renamed as the 'Day of the Nation'. The two potentially highly divisive centenaries in 2002 – the 350th anniversary of the landing of Van Riebeeck at the Cape and the 400th anniversary of the incorporation of his employer, the Dutch East Indies Company (VOC) – were commemorated in a muted fashion as largely unspecified historical occurrences.

The third option is to add the new to a largely un-reconstituted old in a

Figure 10.11 Talana, South Africa: Wall of (racial/ethnic) Peace and Reconciliation, Anglo-Boer War battlefield (2006)

'parallel heritages model'. That raises questions about the possibility of a comfortable acceptable co-existence of what are often contradictory narratives. It should be noted here that much of the 'old' heritage is now in private (the Voortrekker Monument outside former Pretoria, and the Taal Monument, Paarl) or corporate (the Victoria and Alfred Waterfront, Kimberley Mining Museum and Kimberley Club) hands which removes it, probably intentionally, from direct state influence. This applies to the Blood River monument/museum, which is now counterpoised in a shared, co-marketed heritage site by the Ncome Zulu museum nearby across the river, to which national support has been redirected; in this case an alternative perspective is courteously offered and both institutions now acknowledge the uncertainties as well as varied interpretations of history (Figures 10.12 and 10.13).

The issue is more complex than a simple confrontation between a black heritage of victimisation and a white heritage of repression. The minority non-white heritages (coloured, Malay, Indian) suffer a degree of ambiguity in relation to resistance because of the ambivalent role of these groups as either co-victims of apartheid or, to an extent, collaborators in its imposition. Also the previous white minority regime did not 'disregard' (Timothy and Boyd, 2003: 261: Gawe and Meli, 1990), or 'exclude' (Stone and Mackenzie, 1990) black African heritage. Rather, it was

Figure 10.12 Blood River, South Africa: Boer wagon-laager monument with Zulu museum (right) on battlefield (2006)

Figure 10.13 Blood River: Ncome (Zulu) museum and curator (2006)

reduced to a 'tribal vernacular' which was and still is prominently narrated and promoted to tourists. Colourful, tribally distinctive crafts, customs and performances reinforce group identities, and also remain a valuable tourism product in overseas markets. The heritage of resistance to apartheid is, however, non-tribal and non-racial in its affiliations, political aspirations and goals of national identity.

The heritage of apartheid, its systematic imposition of suffering and of the ultimately successful resistance to it, is central to the founding narrative of the new state, the reconciliation of its rainbow constituents, and the way that state projects itself to nationals and visitors alike. It will be enhanced and expanded as the state develops and will play an increasingly significant role in extending the heritage tourism products on offer. However, its very importance in all these fields adds to the complexity of its management. This must deal with the dynamic heritage environment as post-apartheid adjustment continues (Coombes, 2003; Marschall, 2006), involving not only heated democratic debate but also both left-wing hostility to symbols of the past and persistent right-wing defacement of new monuments. The question of who is commemorated at Freedom Park, the national 'heroes' acre' under construction outside Pretoria, must be negotiated; and who and what at various other sites of remembrance around the country, some of which are stalled by compromise and inclusion issues. Heritage management must also seek to reconcile the competitive corporate heritage agenda, projected not only by major private themed tourism attractions but also by initiatives of other powerful capitalist interests such as South African Breweries (Mager, 2006).

This multifaceted negotiation must furthermore be undertaken against a background of substantial minority disinheritance from city centres no longer considered safe, resulting in deflection of much white heritage identification to such rural refuges as Greyton (Western Cape), Clarens (Free State) or the Kwazulu-Natal 'Midlands Meander'. The future, not only of a nascent tourism industry earning much needed foreign exchange but of South Africa itself, and especially of its unique multiracial and multi-ethnic experiment in nation-building, may depend upon the successful management of this past. As to the form of its reshaping for the future, however, in a continuing salad bowl or less accommodating plural model, 'much depends on how the "African Renaissance" of the Thabo Mbeki era will eventually be defined' relative to the rainbow nation paradigm (Marschall, 2006: 190).

A GLOBAL SALAD BOWL?

While we have illustrated the argument of this chapter with case material from the Anglophone world, there are other important multicultural societies elsewhere. Argentina and Brazil are prime examples, both sharing, in addition to their principal Spanish and Portuguese progenitors, a long history of immigration from other, mainly European, sources. Brazil, in particular, also has large populations of Amerindian and African descent. Neither case is well discussed to date in the English literature. Furthermore neither is a prime destination of postcolonial migration, which creates the central concern for the viability of heritage pluralisation initiatives such as the salad bowl.

It is often assumed that social inclusion through a pluralistic heritage available to all is a self-evident social benefit. This assumption is frequently implicit in the official policies of the three main cases described above, but it is challenged by particularlist, exclusivist heritages that are non-threatening to the rest. Chinese 'Saturday' schools in many European cities, Japanese theatre in San Francisco, the Polish-language daily press in London are among many examples of exclusivity that make no attempt to interest non-group members. Similarly, the rise of the idea of cultural empowerment, whereby groups are encouraged to re-establish ownership and control of their own heritages, can also be highly exclusive. Group outsiders may be given a lower priority, if any, in experiencing such heritage, while, in extreme cases, it can become a question of not being just 'ours to preserve' but also 'ours to exclude, deny and destroy'.

Heritage exclusivity is one of several caveats that question the viability of the salad bowl. In addition, aside from impediments associated with jurisdictional scale, public acceptance of such pluralisation may be lacking even where no exclusivity is actively professed. Both majorities and minorities may reject official heritage salad bowls as diminishing or trivialising their identities, however subconsciously these might usually be experienced (Osborne, 2002: Stanton, 2005).

In evaluating the importance of exclusivity and reactive rejection, it is relevant to consider the global context in which the postcolonial pluralisation of Western societies is occurring. In large measure, these initiatives are the reciprocal of pluralisation failures in the source countries of migration flows. Multicultural accommodation has failed in many such societies, including some for which multiculturalism was a founding principle (such as Guyana) and others where it was politically undermined by the dominant group (such as Sinhalese Sri Lanka replacing Ceylon). Centrifu-

gality begets diaspora: in the Sri Lankan case, civil war has resulted in Toronto emerging as the world's largest urban concentration of Ceylonese Tamils (Hyndman, 2003). The resultant conflicts transferred to the Western receiving countries are clearly a destabilising force in pluralisation policies. Thus the bombing attributed to Sikh extremists of an Air India airliner over the Atlantic in 1985, which killed 329 people, still stirs tensions among Indian Canadian groups and also with other Canadians. Such examples do not augur well for Western heritage pluralisation, particularly the salad bowl model in which the principle of 'least political constraint' is applied.

The potential for inter-group conflict in Western societies, whether locally generated or the reciprocal of global pluralisation failures, provides a necessary caution to the assumption that the salad bowl model will succeed where it has been officially proclaimed and, further, that it can be successfully extended elsewhere. Nevertheless, as the most welcoming and accommodating option available, it must remain the focus of our aspiration for the pluralisation of heritage.

11 CONCLUSION: THE FUTURE OF PLURALISING THE PAST

The central theme of this book has focused on the enduring and complex interrelationships between heritage, identity and place. It has been argued that place identity continues to be important in the world and that the continuing privileging of the national provides a potent source of conflict in a world being transformed by plurality. Nor are transnational identities 'placeless'. Rather they complicate the relationships between heritage and place by linking migrant communities to the identity constructs of their source societies. Our concern throughout has focused upon the significance of these interconnections as they are played out in official public policy and also in private conceptualisations of identity. It is important to reiterate, however, that we have consciously eschewed a detailed discussion of policy management.

It has been argued that, if there is a single lesson to be drawn from this book, it is that words such as 'heritage' and its cognate, 'identity', must nearly always be pluralised, although this remains an elusive goal, most particularly in public policy. 'Heritage' is a word more widely used than understood in terms of its multiple qualities discussed in this book. It is often simplistically and singularly applied, and pluralised more commonly in rhetoric than reality. Moreover pluralism is itself an elusive concept, as are multiculturalism and many related contested terms.

A basic difficulty is that as a communicative practice, heritage and its messages are multi-vocal, relayed simultaneously from many sources, both public/official and private/unofficial, and at many scales. While there are clearly authorised discourses of heritage in societies, the messages being transmitted are likely to be interpreted in numerous diverse ways,

not least because of the very plurality of those societies. Indeed, this factor ensures that many heritage messages are not received at all. Thus it is no more likely that 'progressive' pluralist narratives will be received more effectively than are regressive accounts of ethnic and racial differences. Nowhere is this more relevant than in the United States, where the constitutional division of public power is a cardinal principle and where regional divergences of identity and heritage values (albeit locally contested) linger more than 150 years after the Civil War of 1861–65 which was motivated by these very issues.

Furthermore, pluralising the past must focus on a moving target. The past is in continuous creation and so are perspectives upon it. Mainstream heritage perspectives in public policy creation may be marked by tensions emanating from concurrent traditional (and perhaps obsolescent) and innovative perceptions and impulses, even among decision makers on the same policy team. The continuous renegotiation of the past in the present demands that places carry more layers of meaning, which enhances the potential for dissonance and conflict and for resistances to authorised discourses. One of the best examples of the weight created by a succession of conflictual pasts and their ideologies is provided by the 'new' Berlin (Till, 2005). Here, the protracted debate on a plurally sensitive reinterpretation of Germany's past has led, for example, to the siting of the highly contested Holocaust Memorial close to the refurbished Reichstag. Together with other key sites such as Daniel Libeskind's Jewish Museum and the German Historical Museum, the Holocaust Memorial is part of an 'emerging memory district' (Till, 2005: 7) that attempts to reposition the German past and German identity. The idea of layers of heritage is invoked quite literally in the 'Topography of Terror' site on the Prinz Albrecht Terrain, the location of the former SS headquarters and juxtaposed to a surviving section of the Berlin Wall. Evolving values may indeed favour such heritage pluralisation, but it is inescapable that these processes are accompanied by complicating tensions and conflicts.

As this book has demonstrated, pluralising the past is itself a plural process: there is no simple multicultural panacea. Different models of plurality have been identified, demonstrating different motives and different degrees of awareness of the complexities of multiple culture societies. These models are rarely unambiguous or static and they are certainly not consistent through time or, indeed, in any one place and time. All the models are characterised by change in response to evermutating circumstances: thus, they are variously manifested and seldom

unproblematic. This diversity will certainly continue as an inescapable condition of pluralist models and their multiplicity of geographical conditions. In such processes, evolution will undoubtedly occur; indeed, is occurring between some of the five sets of models discussed here and their heritage scenarios, or hybrids of them. It cannot be assumed, however, that such evolution will necessarily take a progressive direction from the perspectives of minorities concerned. Multiculturalism has many faces and can be separatist as well as pluralist in intent.

Implicit here is the issue of groups antagonistic to models of multiculturalism. They can express their hostility to the idea of pluralising heritages unofficially, as in the sporadic violence surrounding the successive Hindu–Moslem–Hindu contestation of Ayodhya (with its connotations of replacing 'theirs' with 'ours' in Hindu nationalist India). Such hostility can even be official policy, as in 2001 when the Taliban government ordered the destruction of the statutes of Bhudda at Bamyan, Afghanistan, on the grounds that they were idolatrous (Barry, 2001; Ashworth and Aa, 2003). The idea of 'heritage as target' and consciously seeking to destroy the heritage of the 'Other' or 'Others' constitutes the ultimate rejection of pluralising pasts. Perhaps the key events embedding this idea in Western consciousness occurred during the civil wars in the former Yugoslavia during the 1990s. These included the Serb bombardment of the Croatian city of Dubrovnik (a World Heritage Site) in 1991, the destruction in 1993 of the sixteenth-century Ottoman bridge in Mostar – an act which literally divided the Bosnian city's Muslims and Croats – and the destruction in 1992 by artillery fire of the National Library of Bosnia and Herzegovina in Sarajevo. 'Ethnic cleansing' employed 'cultural cleansing' (as in UNESCO usage), the destruction of heritage being a conscious instrument of altering place identity and, specifically, eradicating the claim by an ethnic group to a particular place.

If the former Yugoslavia focused wider attention on these issues, they are by no means new. The temples of the 'Other' have long been supplanted by those of the victors. In Europe, the sites of pagan Roman temples became Christian shrines; in Iberia, mosques were built on the sites of Christian churches after the Moorish invasions that began around 711, only themselves to be replaced after the medieval *Reconquista*, the reconquest of the peninsula, by Christian churches and cathedrals. One of Europe's most famous heritage sites, the *Mesquita* in Córdoba, where the Christian cathedral is quite literally built into the Grand Mosque, is the most extraordinary example of this process. In turn, the European colonisers routinely built shrines and implanted subsequent heritage values on the

foundations of, or even within the actual sanctuaries of defeated deities. Such processes, and even the reversal of ownership evident at Ayodhya and Córdoba, point not just to the supremacy of the victor but also to the idea of heritage, not as target, but as redoubt. In some circumstances, especially when allied to a politics of territoriality, shrines can be seen as last bastions of defence, as in the Sikh Golden Temple at Amritsar in 1984, and Iraq since the US-led invasion of 2003. The events in Iraq are obviously interconnected with the wider and potentially global confrontation of Islamic and Western value systems. While this is bedevilled by misunderstandings, political misrepresentations, the demonisation of Islam and the conflation of its many different (and often opposed) sects under one heading, it does point to the idea that the contestation between religious and (often supposedly) secular values and interests may constitute the single most important impediment to realising less conflictual pluralisations of the past.

In assessing the potential for more optimistic outcomes, our discussion has depended heavily on leading (and predominantly Anglophone) examples of societies such as Canada and South Africa that have developed through more than one of the models. This evolutionary process demonstrates that the siting of a particular society in a spectrum of heritage pluralisation depends on the time in question, and will continue to so depend. Both Canadian and South African societies, identities and heritages have been moved in progressive directions for marginalised and/or minority groups, defined not only by race or ethnicity but by all other relevant social parameters. This latter point can be easily overlooked in South Africa's case because of its heavily racialised history, and also because of the primacy, more generally, of 'race' in much recent literature concerned with multiculturalism. Canada has achieved change gradually, South Africa much more dramatically so during the 1990s.

In neither case, however, has the professed multicultural salad bowl/mosaic/rainbow model been achieved without contestation. Particularly in South Africa, this can be attributed to the continuing socio-economic disadvantages of many of those formerly marginalised politically and culturally under apartheid. In these and other progressive exemplars, one cannot discount the possibility of regressive adjustments in heritage pluralising models. As discussed in Chapter 2, the tensions created by asylum, labour needs and multicultural citizenship, which have become dominant since the late 1990s, are clearly impacting on multicultural political and policy approaches (Lewis and Neal, 2005). The revival of the traditional stress on nationalism and older discourses of assimilationism, through an emphasis

on cultural integration, social cohesion and the notion of national identity, has been readily apparent in some of the examples discussed here. The research agenda stemming from this book is largely self-evident. Multiculturalism is neither a sufficiently robust term nor concept because plural societies are inherently complex and contested, and open to restructuring through an array of pluralist policy options that would not necessarily be regarded as 'multicultural'. Pluralising the past, both to direct and to respond to the endless renegotiations of identity through time and across space, involves an array of policy possibilities that are shaped less by the demands of multiculturalism than multiple cultures. In developing the typology of models employed here, the limitations of our empirical material is readily apparent, not least its almost total exclusion of the Hispanic world. Nevertheless, we have established the key generality that wherever the study of pluralising the past is pursued, it must be from a dynamic perspective: end states, progressive or otherwise, can never be assumed. Such a study also needs to be informed internationally because there are many nuances in the pluralising of the past and no one model can fit all societies.

We have also stressed that heritage can be, contradictorily, an instrument for social fragmentation as well as cohesion. There is no shortage of examples of fragmentation in this book or in the other literature on contested heritages. Ultimately, however, all societies have to strive for social and cultural cohesion, which will depend upon the attainment of locally acceptable formulae for the pluralisation of the past. These require the negotiation of composite identities that involve – at best – equality of esteem, at worst apathetic or even sullen acceptance of the other's right to be different. Furthermore this attainment must be materially grounded: collective participation in the local economic enterprise is essential to both effective minority inclusion and optimum overall productivity. Nowhere is this more relevant than in the process of 'selling the past'. In the particular context of heritage, the tourist-historic city is surely the ultimate beneficiary of diversifying both the pasts it can sell and the workforce collectively motivated to sell them. The tourist-historic city, and heritage tourism more generally, whatever their limitations, have become a cornerstone of the contemporary world service economy (Ashworth and Tunbridge, 2000).

In closing, it is necessary to revisit one key global dimension of pluralising the past. We have explored the scale issue and noted the enduring dominance of the national scale in policy orientation, and the concomitant limits to international policy. The interconnections between heritage, identity and place, however, are nothing less than globally grounded. The

central racial/ethnic/religious components of pluralisation are intimately linked to the most fundamental of all contemporary globalisation forces, international migration. The failures or successes of 'multicultural' policies have everything to do with the need for them in the migrant-receiving Western world. Crucially, however, migration does not decouple identity from place. The making of new places by migrants in the receiving countries is a potentially potent form of discord. So too are the linkages between these migrant places and their countries of origin. The identity politics of the latter will help shape the strategies for pluralising the pasts of receiving societies.

We end as we began by emphasising that in these questions of place and identity in diverse and hybrid societies, wherein lie some of the crucial political questions of our time, heritage is, contradictorily, a key force for cohesion but also fragmentation. Pluralising the past is an unavoidable condition of postmodern societies, but this book has demonstrated that it is a complex and ambiguous process that goes far beyond what are very often the platitudes of the multicultural debate. Despite the fragmented means of achieving an effective pluralisation of the past, and the constantly evolving nature of that goal, the interconnections between heritage, place and identity are at the core of the continuous renegotiation of plural, hybrid and diverse societies worldwide.

REFERENCES

Abercrombie, N., Hill, S. and Turner, B.S. (1980) *The Dominant Ideology Thesis*. London: Allen and Unwin.

Agnew, J. (2002) *Making Political Geography*. London: Arnold.

Alderman D.H. (2000), 'A street fit for a king: naming of places and commemoration in the American South', *Professional Geographer* 52: 672–84.

Alderman D.H. (2002), 'School names as cultural arenas: the naming of US public schools after Martin Luther King Jr.', *Urban Geography* 27: 601–26.

Alderman D.H. (2003), 'Street names and the scaling of memory: the politics of commemorating Martin Luther King Jr.', *Area* 35: 163–173.

Alibhai-Brown, Y. (2000) *After Multiculturalism*. London: Foreign Policy Centre.

Allen, G. and Anson, C. (2005) *The Role of the Museum in Creating Multi-Cultural Identities: Lessons from Canada*. Lewiston, N.Y.: Edwin Mellen Press.

Amin, A. (2004), 'Multi-ethnicity and the idea of Europe', *Theory, Culture and Society* 21: 1–24.

Amin, A. and Thrift, N. (2002), 'Guest editorial: cities and ethnicities', *Ethnicities* 2: 291–300.

Anderson, B. (1991) *Imagined Communities: Reflections on the Origins and Spread of Nationalism*, 2nd edn. London: Verso.

Anderson, J. (1995), 'The exaggerated death of the nation-state', in J. Anderson, C. Brook and A. Cochrane (eds), *A Global World? Reordering Political Space*. Oxford: Open University/Oxford University Press: 65–112.

Ashworth, G.J. (1996) 'Heritage and identity in Canada: the changing roles of the loyalists', in F.J. Toppen and J. van Weesep (eds), *People and Places: Changing Relations in Canada*. Utrecht: Canada Cahiers 9: 31–42.

Ashworth, G.J. (1998) 'The conserved European city as cultural symbol: the meaning of the text', in B. Graham (ed.), *Modern Europe: Place, Culture, Identity*. London: Arnold: 261–86.

Ashworth, G.J. (2004) 'Tourism and the heritage of atrocity: managing the heritage of South African apartheid for entertainment', in T.V. Singh (ed.), *New Horizons in Tourism: Strange Experiences and Even Stranger Practices*. Wallingford: CABI: 95–108.

[213]

REFERENCES

Ashworth, G.J. (2007) '1848 and all that', *International Journal of Heritage Studies* 13: in press.

Ashworth, G.J. and Aa, B.van der (2003) 'Bamyan: whose heritage was it and what should we do about it?' *Current Issues in Tourism* 5: 447–57.

Ashworth, G.J. and Graham, B. (1997) 'Heritage, identity and Europe', *Tijdschrift voor Economische en Sociale Geografie* 88: 381–8.

Ashworth, G.J. and Graham, B. (eds) (2005) *Senses of Place: Senses of Time*. Aldershot: Ashgate.

Ashworth G.J. and Howard, P. (2000) *European Heritage Planning and Management*. Bristol: Intellect.

Ashworth, G.J. and Larkham, P.J. (eds) (1994) *Building a New Heritage: Tourism, Culture and Identity in the New Europe*. London: Routledge.

Ashworth, G.J. and Tunbridge, J.E. (2000) *The Tourist-historic City: Retrospect and Prospect of Managing the Heritage City*. London: Pergamon/Elsevier.

Ashworth, G.J. and Tunbridge, J.E. (2004) *Malta Makeover: Prospects for the Realignment of Heritage, Tourism and Development*. Groningen: URSI report 304.

Ashworth, G.J. and Tunbridge, J.E. (2005) 'Moving from blue to grey tourism: reinventing Malta', *Tourism Recreation Research* 30: 45–54.

Askew, M. and Logan, W.S. (1994) 'Introduction: urban tradition and transformation', in M. Askew and W.S. Logan (eds), *Cultural Identity and Urban Change in Southeast Asia*. Geelong: Deakin University Press.

Atkinson, D. (2005) 'Heritage', in D. Atkinson, P. Jackson, D. Sibley and N. Washbourne (eds), *Cultural Geography: A Critical Dictionary of Key Concepts*. London: I.B. Tauris: 141–7.

Atkinson, D. (2007) 'Kitsch geographies and the everyday spaces of social memory', *Environment and Planning A*: in press.

Augier, F.R., Gordon, S.C., Hall, D.G. and Reckord, M. (1960) *The Making of the West Indies*. Trinidad and Jamaica: Longman Caribbean.

Barnes, T.J. and Duncan, J.S. (1992) 'Introduction: writing worlds', in T.J. Barnes and J.S. Duncan (eds), *Writing Worlds: Discourse, Text and Metaphor in the Representation of Landscape*. London: Routledge: 1–17.

Barry, B. (2001) *Culture and Inequality: An Egalitarian Critique of Multiculturalism*. Cambridge: Polity.

Barry, M. (2001) 'The destruction of Bamyan'. *World Heritage Review* 20: 4–13.

Bauman, Z. (2004) *Identity*. Cambridge: Polity.

Beckett, C. and Macy, M. (2001) 'Race, gender and sexuality: the oppression of multiculturalism', *Women's Studies International Forum* 24: 309–19.

Belvedere Memorandum (2000). The Hague: Netherlands Government.

Benhabib, S. (2002) *The Claims of Culture: Inequality and Diversion in the Global Era*. Princeton, N.J.: Princeton University Press.

Bernières, L.de (2004) *Birds Without Wings*. London: Secker and Warburg.

Berry, B.J.L. (1993) 'Should UG become PC?' *Urban Geography* 14: 315–16.

Bhabha, H.K. (1994) *The Location of Culture*. London: Routledge.

Bibby, R. (1990) *Mosaic Madness: Pluralism Without a Cause*. Toronto: Stoddart.

Bissoondath, N. (1994) *Selling Illusions: The Cult of Multiculturalism in Canada*. Toronto: Penguin.

Borchert, J. (1998) 'Ghetto', in N.L. Shumsky (ed.), *Encyclopedia of Urban America: The Cities and Suburbs*. Santa Barbara: ABC-CLIO: 322–5.

Boswell, D. and Evans, J. (eds) (1999) *Representing the Nation: A Reader*. London: Routledge.

Bourdieu, P. (1977) *Outline of a Theory of Practice*. Cambridge: Cambridge University Press.

Branigan, W. (1998) 'Immigrants shunning idea of assimilation', *Washington Post* 25 May: A1.

Brunero, D. (2006) 'Archives and heritage in Singapore: the development of "Reflections at Bukit Chandu", a World War II interpretive centre', *International Journal of Heritage Studies* 12: 427–39.

Buciek, K., Baerenholdt, J.O. and Juul, K. (2006) 'Whose heritage? Immigration and place narratives in Denmark', *Geografiska Annaler B* 88: 185–97.

Campbell, D. and Beresford, D. (2002) 'Mandela: a giant among men', *Guardian Weekly* 26 December: 2.

Castells, M. (1996) *The Rise of the Network Society*. Oxford: Blackwell.

Castells, M. (1997) *The Power of Identity*. Oxford: Blackwell.

Castells, M. (1998) *End of Millennium*. Oxford: Blackwell.

Cheung, S.C.H. (2005) 'Rethinking Ainu heritage: a case study of an Ainu settlement in Hokkaido, Japan', *International Journal of Heritage Studies* 11: 197–210.

Christaller, W. (1933) *Die Zentralen Orte in SüdDeutschland*. Jena: Gustav Fischer.

Christopher, A.J. (1994) *The Atlas of Apartheid*. London: Routledge.

Christopher, A.J. (2002) '"To define the indefinable": population classification and the census in South Africa', *Area* 34: 401–8.

Clarke, D.B. and Doel, M.A. (2004) 'Zygmunt Bauman', in P. Hubbard, R. Kitchin and G. Valentine (eds), *Key Thinkers on Space and Time*. London: Sage: 33–9.

Cohen, S.B. (2003) *Geopolitics of the World System*. New York: Rowman & Littlefield.

Cole, R. and de Blij, H.J. (2007) *Survey of Subsaharan Africa: A Regional Geography*. New York/Oxford: Oxford University Press.

Coombes, A.E. (2003) *History after Apartheid: Visual Culture and Public Memory*. Durham: Duke University Press.

Cosgrove, D. (1993) *The Palladian Landscape: Geographical Change and its Cultural Representations in Sixteenth-century Italy*. London: Leicester University Press.

Council of Europe (2002) *Report to the Council of Europe from the Republic of*

Poland on the Provisions of the Framework Convention for the Protection of National Minorities. Strasbourg: Council of Europe.

Crang, M. (2001) *Cultural Geography.* London: Routledge.

Cresswell, T. (1996) *In Place/Out of Place.* Minneapolis: University of Minnesota Press.

Crooke, E. (2000) *Politics, Archaeology and the Creation of a National Museum: An Expression of Everyday Life.* Dublin: Irish Academic Press.

Crooke, E. (2005), 'Dealing with the past: museums and heritage in Northern Ireland and Cape Town, South Africa', *International Journal of Heritage Studies* 11: 131–42.

Dalrymple, W. (1997) *From the Holy Mountain.* London: Harper Collins.

Daniels, S. (1993) *Fields of Vision: Landscape Imagery and National Identity in England and the United States.* Cambridge, Polity.

Day, R. (2000) *Multiculturalism: The History of Canadian Diversity.* Toronto: University of Toronto Press.

DCMS (2006), www.culture.gov.uk.

Deacon, H. (2004) 'Intangible heritage in conservation management planning: the case of Robben Island', *International Journal of Heritage Studies* 10: 309–19.

de Oliver, M. (2001) 'Multicultural consumerism and racial hierarchy: a case study of market harmonization of contradictory doctrines', *Antipode* 33: 228–59.

D'Souza, D. (1991) *Illiberal Education.* New York: Vintage Books.

Dicks, B. (2000) *Heritage, Place and Community.* Cardiff: University of Wales Press.

Donald, J. and Rattansi, A. (eds) (1992) *'Race', Culture and Difference.* London: Sage/Open University.

Douglas, N. (1997) 'Political structures, social interaction and identity changes in Northern Ireland', in B. Graham (ed.), *In Search of Ireland: A Cultural Geography.* London: Routledge: 151–73.

Duncan, J.S. (1990) *The City as Text: The Politics of Landscape Interpretation in the Kandyan Kingdom.* Cambridge: Cambridge University Press.

Duncan, J.S. and Duncan, N.G. (2004) 'Culture unbound', *Environment and Planning A* 36: 391–403.

Dwyer, O.J. (2000) 'Interpreting the Civil Rights Movement: place, memory and conflict', *Professional Geographer* 52: 660–71.

Dyson, L. (2005) 'Reinventing the nation: British heritage and the bicultural settlement in New Zealand', in J. Littler and R. Naidoo (eds), *The Politics of Heritage: The Legacies of 'Race'.* London: Routledge: 115–30.

Eagleton, T. (2000) *The Idea of Culture.* Oxford: Blackwell.

Edensor, T. and Kothari, U. (1994) 'The masculisation of Stirling's heritage', in V. Kinnaird and D. Hall, D. (eds), *Tourism: A Gender Analysis.* London: Wiley: 115–34.

Eisenberg, A. (2005) 'The limited resources of liberal multiculturalism: a response to Patrick Loobuyck', *Ethnicities* 5: 123–7.

Elliott, P. (1980) *The Cross and the Ensign: A Naval History of Malta, 1798–1979.* Cambridge: Patrick Stephens.

English Heritage (2000a) *The Power of Place.* London: English Heritage.

English Heritage (2000b) *England's Heritage – Your Heritage.* London: English Heritage.

Ennen, E. (1999) *Heritage in Fragments: The Meaning of the Past for City Centre Residents.* Groningen: Rijksuniversiteit Groningen.

Etzinger, H, (2003) 'The rise and fall of multiculturalism: the case of the Netherlands', in C. Joppe and E. Morwaska (eds), *Toward Assimilation and Citizenship: Immigrants in Liberal Nation-States.* Basingstoke: Palgrave Macmillan: 59–86.

European Union Education/Training Directorate (2004) *Report Minority Policies in Poland.* Brussels: CEC.

Evans, G. (2002) 'Living in a world heritage city: stakeholders in the dialectic of the universal and particular', *International Journal of Heritage Studies* 8: 117–35.

Felski, R. (1994) 'The gender of modernity', in S. Ledger, J. MacDonagh and J. Spencer (eds), *Political Gender: Texts and Contexts.* New York City: Harvester Wheatsheaf: 144–55.

Flint, C. (2004) 'Introduction: spaces of hate: geographies of discrimination and intolerance in the U.S.A.', in C. Flint (ed.), *Spaces of Hate: Geographies of Discrimination and Intolerance in the U.S.A.* New York City: Routledge: 1–20.

Foote K. (1997) *Shadowed Ground: America's Landscapes of Violence and Tragedy.* Austin: University of Texas Press.

Fortier, A-M. (2005) 'Pride, politics and multiculturalist citizenship', *Ethnic and Racial Studies* 28: 559–78.

Frost, W. (2005) 'Making an edgier interpretation of the gold rushes: contrasting perspectives from Australia and New Zealand', *International Journal of Heritage Studies* 11: 235–50.

Fukuyama, F. (2005) *Wall St Journal* 2 November.

Gallaher, C. (2000) 'Global change, local angst: class and the American Patriot Movement', *Environment and Planning D: Society and Space* 18: 667–91.

Gallaher, C. (2003) *On the Fault Line: Race and Class in the US Patriot Movement.* Lanham, Md.: Rowman and Littlefield.

Gallaher C. (2004) 'Mainstreaming the militia', in C. Flint (ed.), *Spaces of Hate: Geographies of Discrimination and Intolerance in the U.S.A.* New York City: Routledge: 183–208.

Gard'ner, J.M. (2004) 'Heritage protection and social inclusion: a case study from the Bangladeshi community of East London', *International Journal of Heritage Studies* 10: 75–92.

Gawe, S. and Meli, F. (1990) 'The missing past in South Africa', in P. Stone and R. Mackenzie (eds), *The Excluded Past: Archaeology in Education*. London: Unwin Hyman: 98–108.

Genet, J. (ed.) (1991) *The Big House in Ireland: Reality and Representation*. Dingle: Brandon Books.

Gibbon, J.M. (1938) *Canadian Mosaic: The Making of a Northern Nation*. Toronto: McClelland and Stewart.

Giddens, A. (1990) *The Consequences of Modernity*. Cambridge: Polity.

Giddens, A. (1991) *Modernity and Self-identity*. Cambridge: Polity.

Gilroy, P. (1997) 'Diaspora and the detours of identity', in K. Woodward (ed.), *Identity and Difference*. London: Sage/Open University: 299–346.

Goldberg, D.T. (1994) 'Introduction', in D.T. Goldberg (ed.), *Multiculturalism: A Critical Reader*. Blackwell: Oxford: 1–45.

Glenny, M (1996) *The Fall of Yugoslavia*. Harmondsworth: Penguin.

Glenny, M. (1999) *The Balkans, 1804–1999: Nationalism, War and the Great Powers*. London: Granta.

Glover, J. (1999) *Humanity: A Moral History of the Twentieth Century*. London: Pimlico.

Golding, L. (1938) *The Jewish Problem*. Harmondsworth: Penguin.

Goudie, S.C., Khan, F. and Kilian, D. (1999) 'Transforming tourism: black empowerment, heritage and identity beyond apartheid', *South African Geographical Journal* 81: 22–31.

Gough, P. (2002) '"*Invicta Pax*": monuments, memorials and peace: an analysis of the Canadian Peacekeeping Monument, Ottawa', *International Journal of Heritage Studies* 8: 201–24.

Government of Australia (2003) *Multicultural Australia: United in Diversity*. Canberra: Department of Immigration, Multiculturalism and Indigenous Affairs.

Graham, B. (1998) 'The past in Europe's present: diversity, identity and the construction of place', in B. Graham (ed.), *Modern Europe: Place, Culture, Identity* London: Arnold: 19–49.

Graham, B. (2002) 'Heritage as knowledge: capital or culture?', *Urban Studies* 39: 1003–17.

Graham, B, Ashworth, G.J. and Tunbridge, J.E. (2000) *A Geography of Heritage: Power, Culture and Economy*. London: Arnold.

Graham, B, Ashworth, G.J. and Tunbridge, J.E. (2005) 'The uses of heritage', in G. Corsane (ed.), *Heritage, Museums and Galleries: An Introductory Reader*. London: Routledge. 26–37.

Graham, B. and McDowell, S.P. (2007) 'Meaning in the Maze: the heritage of Long Kesh', *Cultural Geographies* 14: in press.

Graham, B. and Nash, C. (2006) 'A shared future: territoriality, pluralism and public policy in Northern Ireland', *Political Geography* 25: 253–78.

Graham, B. and Shirlow, P. (2002) 'The Battle of the Somme in Ulster memory and identity', *Political Geography* 21: 881–904.

Grant, G. (1965) *Lament for a Nation: The Defeat of Canadian Nationalism.* Ottawa: Carleton University Press.

Gruffudd, P. (1995) 'Remaking Wales: nation-building and the geographical imagination, 1925–50', *Political Geography* 14: 219–39.

Guibernau, M. (1996) *Nationalisms: The Nation State and Nationalism in the Twentieth Century.* Oxford: Polity.

Gutman, R. (1993) *A Witness to Genocide.* New York: Macmillan.

Habermas, J. (1973) *Legimationenprobleme in Spätkapitalismus.* Frankfurt am Main: Suhrkamp.

Hague, E., Giordano, B. and Sebesta, E.H. (2005) 'Whiteness, multiculturalism and nationalist appropriation of Celtic culture: the case of the League of the South and the *Lega Nord*', *Cultural Geographies* 12: 151–73.

Halbwachs, M. (1992) *On Collective Memory.* Chicago, Il./London: University of Chicago Press.

Haliburton, G. (1957) 'The Nova Scotia settlers of 1792', *Sierra Leone Studies* 3: 16–25.

Hall, S. (ed.) (1997) *Representation: Cultural Representations and Signifying Practices.* London: Sage/Open University.

Hall, S. (2005) 'Whose heritage?', in J. Littler and R. Naidoo (eds), *The Politics of Heritage: The Legacies of 'Race'.* London: Routledge: 23–35.

Hannerz, U. (1992) *Cultural Complexity: Studies in the Cultural Organization of Meaning.* New York: Columbia University Press.

Harrison, D. (2005) 'Levuka, Fiji: contested heritage?', in D. Harrison and M. Hitchcock (eds), *The Politics of World Heritage: Negotiating Tourism and Conservation.* Clevedon: Channel View: 66–89.

Hastings, M. (2004) *Armageddon: The Battle for Germany 1944–5.* London: Macmillan.

Haylett, C. (2001) 'Illegitimate subjects? Abject whites, neoliberal modernisation, and middle-class multiculturalism', *Environment and Planning D: Society and Space* 19: 351–70.

HELM (2004) *Local Area Agreements and the Historic Environment* London: English Heritage.

Hemminga, P. (1999) 'Language policy in Germany and the Netherlands', *Ethnos-Nation* 7: 81–94.

Henderson, J.C. (2001) 'Conserving colonial heritage: Raffles Hotel in Singapore', *International Journal of Heritage Studies* 7: 7–24.

Henderson, J.C. (2005) 'Exhibiting cultures: Singapore's Asian Civilisations Museum', *International Journal of Heritage Studies* 11: 183–95.

Hickey, M. (2006) 'Negotiating history: Crown apologies in New Zealand's historical Treaty of Waitangi settlements', *Public History Review*: 13: 108–24.

Hill, B.O. (1993) *Making and Remaking Asian America through Immigration Policy, 1850–1990.* Stanford: Stanford University Press.

Home, R. (1997) *Of Planting and Planning: The Making of British Colonial Cities.* London: E. & F.N.Spon.

Howard, P. (2003) *Heritage: Management, Interpretation, Identity.* London: Continuum.

Huntingdon, S. (2002) *The Clash of Civilisations and the Remaking of World Order.* New York: Free Press.

Hutnyk, J. (2005), 'Hybridity', *Ethnic and Racial Studies* 28: 79–102.

Hyndman, J. (2003) 'Aid, conflict and migration: the Canada–Sri Lanka connection' *Canadian Geographer* 47: 251–68

Jackson, P. (1989) *Maps of Meaning: An Introduction to Cultural Geography.* London: Allen and Unwin.

Jackson, P. and Penrose, J. (eds) (1993) *Constructions of Race, Place and Nation.* London: UCL Press.

Johnston, R.J., Gregory, D., Pratt, G. and Watts, M. (eds) (2000), *The Dictionary of Human Geography*, 4th edn. Oxford: Blackwell.

Jones, R. and Birdsall-Jones, C. (2003) 'Native or manufactured? A comparison of indigenous–industrial heritage conflicts in Perth and Ottawa', *Australian-Canadian Studies* 21: 73–106.

Jones, R. and Shaw, B.J. (2006) 'Palimpsests of progress: erasing the past and rewriting the future in developing societies – case studies of Singapore and Jakarta', *International Journal of Heritage Studies* 12: 122–38.

Kallen, H.M. (1915) 'Democracy versus the melting pot', *The Nation* 18 February: 53–61.

Karpat, K.H. (1982) 'Millets and nationality', in B. Brad and B. Lewis (eds), *Christians and Jews in the Ottoman Empire.* New York: Holmes and Meier: 141–70.

Kim, C.J. (2004a) 'Imagining race and nation in multiculturalist America', *Ethnic and Racial Studies* 27: 987–1005.

Kim, C.J. (2004b) 'Unyielding positions: a critique of the "race" debate', *Ethnicities* 4: 337–55.

Kong, L. (1993) 'Political symbolism of religious building in Singapore', *Environment and Planning D: Society and Space* 11: 23–45.

Kong, L. (2001) 'Mapping "new" geographies of religion: politics and poetics in modernity', *Progress in Human Geography* 25: 211–23.

Kuipers, M-J. (2005) *Living in the Recent Past.* Groningen: Geo Press.

Kuipers, M-J. and Ashworth, G.J. (2001) 'Conservation and identity: a new vision of pasts and futures in the Netherlands', *European Spatial Research and Policy* 8: 55–65.

Kymlicka, W. (1995) *Multicultual Citizenship: A Liberal Theory of Minority Rights.* Oxford: Oxford University Press.

Kymlicka, W. (2001) *Politics in the Vernacular: Nationalism, Multiculturalism and Citizenship*. Oxford: Oxford University Press.

Kymlicka, W. (2003) 'Multicultural states and multicultural citizens', *Theory and Research in Education* 1: 147–69.

Landzelius, M. (2003) 'Commemorative dis(re)membering: erasing heritage, spatializing disinheritance', *Environment and Planning D: Society and Space* 21: 195–221.

Lasansky, D.M. (2004) 'Tourist geographies: remapping old Havana', in D.M. Lasansky and B. McLaren (eds), *Architecture and Tourism: Perception Performance and Place*. Oxford/New York: Berg: 165–86.

Lewis, G. and Neal, S. (2005) 'Introduction: contemporary political contexts, changing terrains and revisited discourses', *Ethnic and Racial Studies* 28 (special issue on migration and citizenship): 423–44.

Ley, D. and Hiebert, D. (2001) 'Immigration policy as population policy', *Canadian Geographer* 45: 120–5.

Lijphart, A (1968) *The Politics of Accommodation: Pluralism and Democracy in the Netherlands*. Berkeley Calif.; University of California Press.

Ling, O.G. and Shaw, B.J. (2004) *Beyond the Port City: Development and Identity in 21st Century Singapore*. Singapore: Pearson Prentice Hall.

Little, A. (2004) *Democracy and Northern Ireland: Beyond the Liberal Paradigm?* Basingstoke: Palgrave Macmillan.

Littler, J. (2005) 'Introduction: British heritage and the legacies of "race"', in J. Littler and R. Naidoo (eds), *The Politics of Heritage: The Legacies of 'Race'*. London: Routledge: 1–19.

Littler, J. and Naidoo, R. (2004) 'White past, multicultural present: heritage and national stories', in H. Brocklehurst and R. Phillips (eds), *History, Nationhood and the Question of Britain*. Basingstoke: Palgrave Macmillan: 330–41.

Logan, W.S. (2000) *Hanoi: Biography of a City*. Sydney: University of New South Wales Press.

Loobuyck, P. (2005) 'Liberal multiculturalism: a defence of liberal multiculturalism measures without minority rights', *Ethnicities* 5: 108–35.

Lowenthal, D. (1985) *The Past is a Foreign Country*. Cambridge: Cambridge University Press.

Lowenthal, D. (1998) *The Heritage Crusade and the Spoils of History*. Cambridge: Cambridge University Press.

Macdonald, S. (2003) 'Museums, national, postnational and transcultural identities', *Museum and Society* 1: 1–16.

McEachern, C. (2001) 'Mapping the memories: politics, place and identity in the district six museum', in A. Zegeye (ed.), *Social Identities in the New South Africa*. Cape Town: Kwela: 223–47

Mackinder, H.J. (1902) *Britain and the British Seas*. London: Heinemann.

McLean, F. (2005) 'Guest editorial: museums and national identity', *Museums and Society* 3: 1–4.

McLean, F. (2006) 'Introduction: heritage and identity', *International Journal of Heritage Studies* 12: 3–7.

MacLeod, G. (2000) 'The learning region in an age of austerity: capitalizing on knowledge, entrepreneurialism and reflexive capitalism', *Geoforum* 31: 219–36.

Mager, A. (2006) 'Trafficking in liquor, trafficking in heritage: beer branding as heritage in post-apartheid South Africa', *International Journal of Heritage Studies* 12: 159–75.

Marschall, S. (2006) 'Commemorating "Struggle Heroes": constructing a genealogy for the New South Africa', *International Journal of Heritage Studies* 12: 176–93.

Mason, R. (2004) 'Conflict and complement: an exploration of the discourses in forming the concept of the socially inclusive museum in contemporary Britain', *International Journal of Heritage Studies* 10: 49–74.

Melosh, B. (1994), 'Introduction', *Gender and History* 6 (special issue on public history): 315–19.

Mitchell, D. (2000) *Cultural Geography: An Introduction.* Oxford: Blackwell.

Mitchell, D. (2002) 'Cultural landscapes: the dialectical landscape – recent landscape research in human geography', *Progress in Human Geography* 26: 381–9.

Mitchell, D. (2003) 'Cultural landscapes: just landscapes or landscapes of justice?', *Progress in Human Geography* 27: 787–96.

Mitchell, K. (1993), 'Multiculturalism, or the united colors of capitalism?', *Antipode* 25: 263–94.

Mitchell, K. (2003) 'Educating the national citizen in neoliberal times: from the multicultural self to the strategic cosmopolitan', *Transactions of the Institute of British Geographers* 28: 387–403.

Mitchell, K. (2004) 'Geographies of identity: multiculturalism unplugged', *Progress in Human Geography* 28: 641–51.

Modood, T. (2005) *Multicultural Politics, Racism, Ethnicity and Muslims in Britain.* Edinburgh: Edinburgh University Press.

Moore, C. (1984) *The Loyalists: Revolution, Exile, Settlement.* Toronto: Macmillan of Canada.

Murphy, D. (1997) *South from the Limpopo.* London: Murray.

Naidoo, R. (2005) 'Never mind the buzzwords: "race", heritage and the liberal agenda', in J. Littler and R. Naidoo (eds), *The Politics of Heritage: The Legacies of 'Race'.* London: Routledge: 36–48.

Nash, C. (2000) 'Historical geographies of modernity', in B. Graham and C. Nash (eds), *Modern Historical Geographies.* Harlow: Pearson: 13–40.

Nash, C. (2003) 'Cultural geography: anti-racist geographies', *Progress in Human Geography* 27: 637–48.

Nash, C. (2004) 'Post-colonial geographies', in P. Cloke, P. Crang and M. Goodwin (eds), *Envisioning Human Geography*. London: Arnold: 104–27.

Nasson, W. (2004) 'Commemorating the Anglo-Boer War in postapartheid South Africa', in D.J. Walkowitz and L.M. Knauer (eds), *Memory and the Impact of Political Transformation in Public Space*. Durham: Duke University Press: 277–94.

Newman, A. and McLean, F. (2004) 'The impact of museums on identity', *International Journal of Heritage Studies* 12: 49–68.

Nora, P. (1996–1998) *Realms of Memory I-III*. New York City: Columbia University Press.

Okin, S. (1999) *Is Multiculturalism Bad for Women?* Princeton: Princeton University Press.

O'Regan, G. (2006) 'Regaining authority: setting the agenda in Maori heritage through the control and shaping of data', *Public History Review* 13: 96–107.

Osborne, B.S. (2002) 'Corporeal politics and the body politic: the re-presentation of Louis Riel in Canadian identity', *International Journal of Heritage Studies* 8: 303–22.

Paasi, A. (2003) 'Region and place: regional identity in question', *Progress in Human Geography* 27: 475–85.

Papoulias, C. (2004) 'Homi H. Bhabha', in P. Hubbard, R. Kitchin and G. Valentine (eds), *Key Thinkers on Space and Place*. London: Sage: 52–8.

Peckham, R.S. (2003) 'Introduction: the politics of heritage and the public culture', in R.S. Peckham (ed.), *Rethinking Heritage: Cultures and Politics in Europe*. London: I.B. Tauris: 1–13.

Pendlebury, J., Townshend, T. and Gilroy, R. (2004), 'The conservation of English cultural built heritage: a force for social inclusion', *International Journal of Heritage Studies* 10: 1–31.

Perry, M., Kong, L. and Yeoh, B. (1997) *Singapore: A Developmental City State*. Chichester, Wiley.

Phalet, K. and Swyngedouw, M. (2003) 'Measuring immigrant integration: the case of Belgium', *Migration Studies* XL 152: 773–803.

Phillips, J. (2005) 'Race and New Zealand national identity', in N. Garnham and K. Jeffery (eds), *Culture, Place and Identity (Historical Studies XXIV)*. Dublin: UCD Press: 161–77.

Pollacco, J. (2003) *In the National Interest: Towards a Sustainable Tourism Industry in Malta*. Malta: Fondazzjoni Tumas Fenech.

Pollock-Ellwand, N. (2006) 'Travelling the route from designation to local action: the case of the Underground Railroad settlement in Buxton, Ontario, Canada', *International Journal of Heritage Studies* 12: 372–88

Poole, M.A. (1997) 'In search of ethnicity in Ireland', in B. Graham (ed.), *In Search of Ireland: A Cultural Geography*. London: Routledge: 128–47.

Pratt, G. (2004) 'Feminist geographies: spatialising feminist politics', in P. Cloke,

P. Crang and M. Goodwin (eds), *Envisioning Human Geography*. London: Arnold: 128–45.

Pred, A. (1984) 'Place as historically-contingent process: structuration and the time-geography of becoming places', *Annals of the Association of American Geographers* 74: 279–97.

Rand, A. (1957) *Atlas Shrugged*. New York: Random House.

Ratzel, F. (1898) *Deutschland: Einführung in die Heimatkunde*. Leipzig: Grunow.

Ravitch, D. (2003) *The Language Police: How Pressure Groups Restrict What Students Learn*. New York: Knopf.

Raz, J. (1994) 'Multiculturalism: a liberal perspective', in J. Raz (ed.), *Ethics in the Public Domain*. Oxford: Clarendon: 170–91.

Reitman, O. (2005) 'Multiculturalism and feminism: incompatibility, compatibility, or synonymity?', *Ethnicities* 5: 216–47.

Ricketts, S. (2006) 'Who decides? The Canadian Register of Historic Places' *Heritage* IX: 50–5.

Riedlmayer, A.J. (2002) *Destruction of Cultural Heritage in Bosnia-Herzegovina 1992–1996*. Report Commissioned by the Office of the Prosecutor of the International Criminal Tribunal for the Former Yugoslavia.

Risse, T. (2003), 'European identity and the heritage of national cultures', in R.S. Peckham (ed.), *Rethinking Heritage: Cultures and Politics in Europe*. London: I.B. Tauris: 74–89.

Roep, T. and C. Loerakker , C. (1984–94) *Van Nul Tot Nu* (4 Vols). Amsterdam: Oberon Press.

Rose, G. (1993) *Feminism and Geography: The Limits of Geographical Knowledge*. Cambridge: Polity.

Sack, R. D. (1986). *Human Territoriality: Its Theory and History*. Cambridge: Cambridge University Press.

Sack, R.D. (1992) *Place, Modernity and the Consumer's World*. Baltimore, Md.: Johns Hopkins University Press.

Said, E. (1978) *Orientalism*. New York: Columbia University Press.

Samuel, R. (1994) *Theatres of Memory; Vol. 1: Past and Present in Contemporary Culture*. London: Verso.

Saunders, K.J. (2005) 'Creating and recreating heritage in Singapore', in D. Harrison and M. Hitchcock (eds), *The Politics of World Heritage: Negotiating Tourism and Conservation*. Clevedon: Channel View: 160–8.

Schama, S. (1987) *The Embarrassment of Riches: An Interpretation of Dutch Culture in the Golden Age*. New York: Knopf.

Scott, J. (2002) 'World heritage as a model for citizenship: the case of Cyprus', *International Journal of Heritage Studies* 8: 99–115.

Sewell, W. (1999) 'The concept(s) of culture', in V. Burnett and L. Hunt (eds), *Beyond the Cultural Turn*. Berkeley, Calif.: University of California Press: 35–61.

Seymour, S. (2000) 'Historical geographies of landscape', in B. Graham and C. Nash (eds), *Modern Historical Geographies*. Harlow: Pearson: 193–217.

Shaw, B.J., Jones, R. and Ling, O.G. (1997) 'Urban heritage, development and tourism in Southeast Asian cities: a contestation continuum', in B.J. Shaw and R. Jones (eds), *Contested Urban Heritage: Voices from the Periphery*. Aldershot: Ashgate: 169–96.

Sillitoe, K. and White, P.H. (1992) 'Ethnic group and the British census: the search for a question', *Journal of the Royal Statistical Society A* 155: 141–63.

Smith, C. (1997) *Robben Island*. Struik: Cape Town.

Smith, L. (2004) *Archaeological Theory and the Politics of Cultural Heritage*. London: Routledge.

Smith, L. (2006) *The Uses of Heritage*. London: Routledge.

Smith, M. (2003) *Issues in Cultural Tourism*. London: Routledge.

Smith, P.C. (1970) *Pedestal: The Convoy that Saved Malta*. London: William Kimber.

Stanton, C. (2005) 'Serving up culture: heritage and its discontents at an industrial history site', *International Journal of Heritage Studies* 11: 415–31.

Statham, P., Koopmans, R., Giugni, M. and Passy, F. (2005) 'Resilient or adaptable Islam: multiculturalism, religion and migrants' claim-making for group demands in Britain, the Netherlands and France', *Ethnicities* 5: 427–59.

Stenning, A. (2000) 'Planning (post) socialism: the making and remaking of Nowa Huta, Poland', *European Urban and Regional Studies* 7: 99–118.

Stone, P. and Mackenzie, R. (eds) (1990) *The Excluded Past: Archaeology in Education*. London: Unwin Hyman.

Taylor, P.J. (1996) *The Way the Modern World Works: World Hegemony to World Impasse*. Chichester: Wiley.

Till, K.E., (2005) *The New Berlin: Memory, Politics, Place*. Minneapolis: University of Minnesota Press.

Timothy, D.J. and Boyd, S.W. (2003) *Heritage Tourism*. London: Pearson Education.

Tunbridge, J.E. (1998) 'The question of heritage in European cultural conflict', in B. Graham (ed.), *Modern Europe: Place, Culture, Identity*. London: Arnold: 236–60.

Tunbridge, J.E. (2005) 'Penal colonies and tourism with reference to Robben Island, South Africa: commodifying the heritage of atrocity?', in G.J. Ashworth and R. Hartmann (eds), *Horror and Human Tragedy Revisited: The Management of Sites of Atrocities for Tourism*. New York: Cognizant Communication Corporation: 19–40.

Tunbridge, J.E. (2006) 'Empire, war and nation: heritage management perspectives from Canada and Malta', *Public History Review* 13: 4–22.

Tunbridge, J.E. and Ashworth, G.J. (1996) *Dissonant Heritage: The Management of the Past as a Resource in Conflict*. Chichester: Wiley.

Van Dam, K.I.M. (2005) 'A place called Nunavut: building on Inuit past', in G.J. Ashworth and B. Graham (eds), *Senses of Place: Senses of Time*: Aldershot: Ashgate: 105–18.

Van der Aa, B.J.M. (2005) *Preserving the Heritage of Humanity? Obtaining World Heritage Status and the Impacts of Listing*. Groningen: Netherlands Organisation for Scientific Research.

Vance, J.E. (1977) *This Scene of Man: The Role and Structure of the City in the Geography of Western Civilisation*. New York: Harper Row.

Wal, C. van der (1997) *In Praise of Common Sense: Planning the Ordinary: A Physical Planning History of the New Towns of the IJsselmeerpolders*. Rotterdam: Uitgeverij.

Wallenstein, P. (1998) 'Chinatown', in N.L.Shumsky (ed.), *Encyclopedia of Urban America: The Cities and Suburbs*. Santa Barbara: ABC-CLIO: 164–5.

Werbener, P. and Modood, T. (eds) (1997) *Debating Cultural Hybridity: Multicultural Identities and the Politics of Anti-racism*. London: Zed Books.

Whelan, Y. (2003) *Reinventing Modern Dublin: Streetscape, Iconography and the Politics of Identity*. Dublin: University College Dublin Press.

Williams, C. H. (1998) 'Room to talk in a house of faith: on language and religion', in B. Graham (ed.), *Modern Europe: Place, Culture, Identity*. London: Arnold: 186–209.

Williams, P. (2005) 'A breach on the beach: Te Papa and the fraying of biculturalism', *Museum and Society* 3: 81–97.

Williams, P.B. (2005) *Multiple Layers of Meaning in the Biography of Place: The Little Dutch Church Site, Halifax, Nova Scotia*. Unpublished Ph.D.Thesis, Dept. of Geography, Queens University, Kingston, Ontario, Canada.

Windschuttle, K. (2002) *The White Australia Policy*. Sydney: MacLeay Press.

Windschuttle, K. (2004) *The Fabrication of Aboriginal History*. Sydney: MacLeay Press.

Winter, T. (2004) 'Landscape, memory and heritage: New Year celebrations at Angkor, Cambodia', in D. Harrison and M. Hitchcock (eds), *The Politics of World Heritage: Negotiating Tourism and Conservation*. Clevedon: Channel View Publications: 50–65.

Wirth, L. (1928) *The Ghetto*. Chicago: University of Chicago Press.

Worden, N. (1996) 'Contested heritage at the Cape Town waterfront, *International Journal of Heritage Studies* 2: 59–75.

Worden, N. (1997) 'Contesting heritage in a South African city: Cape Town', in B.J. Shaw and R. Jones (eds), *Contested Urban Heritage: Voices from the Periphery*. Aldershot: Ashgate: 31–61.

Worden, N. (2001) '"Where it all began": the representation of Malaysian heritage in Melaka', *International Journal of Heritage Studies* 7: 199–218.

Wright, P. (1985) *On Living in an Old Country: The National Pasts in Contemporary Britain*. London: Verso.

Yeoh, B. (1996) *Contesting Space: Power Relations and the Urban Built Environment in Colonial Singapore*. Kuala Lumpur: Oxford University Press.

Yeoh, B. and Kong, L. (1996) 'The notion of place in the construction of history,

nostalgia and heritage in Singapore', *Singapore Journal of Tropical Geography* 17: 52–65.

Yiftachel, O. (2002) 'Territory as the kernel of nationalism: space, time and nationalism in Israel/Palestine', *Geopolitics* 7: 214–48.

Zimmerman, L.J. and Clinton, R.N. (1999) 'Kennewick Man and Native American Graves Protection Act woes', *International Journal of Cultural Property* 8: 212–25.

SUBJECT INDEX

INDEX OF PLACES